Culture, Innovation and the Economy

This is a handbook for the cultural entrepreneur, offering some of the best examples on practice, franchises, research, innovation and business opportunities in the cultural sector. The key theme is the contribution and possibilities of the cultural economy as a business, with a strong supporting subtext on innovative practice.

The book illustrates this theme by providing multiple practice-based and empirical examples from an international panel of experts. Each contribution provides an accessible and easily accessed bank of knowledge on which existing practice can be grown and new projects undertaken. It provides an eclectic mix of possibilities that reinforce and underscore the full innovative and complex potential of the cultural economy. Topics include a review of the global and regional economic benefits of the cultural economy, evidence-based analysis of the culture industries, and an outline of the top ten cultural opportunities for business. This collection transcends the space between theory and practice to combine culture and innovation and understand their importance to a wider economy.

This is essential reading for researchers and practitioners interested in entrepreneurship, non-profit management, art and visual culture, and public finance.

Biljana Mickov is a cultural researcher, editor and consultant. She is responsible for the Creative Industries programme at the Institute of Culture Vojvodina, Serbia. Her work is primarily dedicated to researching and developing cultural policies and contemporary arts management internationally in cities.

James E. Doyle is an expert adviser on Arts & Cultural Policy and Strategic Development in Guinea-Bissau, West Africa. He is a former Arts Officer for Dublin City Council, advised on the music hub for Parnell Square Cultural Quarter and coordinated the start-up of Dublin's bid to be the European Capital of Culture 2020. James has extensive managerial experience in the arts, culture and events sectors, he has held positions in research & education, and at regional and national level in event industry training.

Culture, Innovation and the Economy

Edited by
**Biljana Mickov and
James E. Doyle**

LONDON AND NEW YORK

First published 2018
by Routledge
2 Park Square, Milton Park, Abingdon, Oxon OX14 4RN

and by Routledge
711 Third Avenue, New York, NY 10017

Routledge is an imprint of the Taylor & Francis Group, an informa business

British Library Cataloguing-in-Publication Data
A catalogue record for this book is available from the British Library

Library of Congress Cataloging-in-Publication Data
Names: Mickov, Biljana, editor. | Doyle, James E., editor.
Title: Culture, innovation and the economy / edited by Biljana Mickov and James E. Doyle.
Description: Abingdon, Oxon ; New York, NY : Routledge, 2018. | Includes bibliographical references and index.
Identifiers: LCCN 2017020919 | ISBN 9781138219007 (hardback) | ISBN 9781138219014 (pbk.) | ISBN 9781315436418 (ebook)
Subjects: LCSH: Cultural industries. | Culture—Economic aspects. | Diffusion of innovations. | Economic development.
Classification: LCC HD9999.C9472 C885 2018 | DDC 658.4/063—dc23
LC record available at https://lccn.loc.gov/2017020919

ISBN: 978-1-138-21900-7 (hbk)
ISBN: 978-1-138-21901-4 (pbk)
ISBN: 978-1-3154-3641-8 (ebk)

Typeset in Bembo
by Apex CoVantage, LLC

Contents

Figures

Tables

Contributors

Oihab Allal-Chérif (PhD) is Professor of Information System Management and Purchasing Management. He has headed the Operations Management and Information Systems Department of KEDGE Business School in France since 2010. His research and teaching interests are in the areas of serious games, casual games, change management, innovative learning, e-business and information systems for supply chain management, as well as in the firms Google, Apple, Facebook and Amazon. His work has been published both in France and internationally.

Louise Allen is the Head of Innovation and Development at the Design & Crafts Council of Ireland and from 2014 was the Head of International Programmes for Irish Design 2015. Her experience ranges across design, enterprise, contemporary arts, education, curation and innovation. In her various roles she has led the strategic development for the design and craft sector, forged relationships nationally and internationally and has delivered several EU-funded programmes. Louise most recently co-curated *Liminal – Irish Design at the threshold*, the flagship exhibition for Irish Design 2015 that toured to design weeks in Milan, New York and Eindhoven and in 2016 to the *Global Irish Design Challenge*. Louise is President of the World Crafts Council Europe.

Luca Antoniazzi (PhD) is a Teaching Assistant at the School of Media and Communication (SMC) at the University of Leeds (UK). He holds a BA in Anthropology (University of Bologna) and an MSc in Economics and Management of Arts and Cultural Organisations (EGART – Ca' Foscari University Venice). Before joining SMC, he undertook internship experiences at the Haghefilm Foundation (Amsterdam) in 2011 and at the Royal Belgian Film Archive (Brussels) in 2015. Between 2010 and 2012 he collaborated with *Le Giornate del Cinema Muto* (the Pordenone Silent Film Festival). He has also worked at the Film Restoration and Archiving Department at ARRI Film & TV (Munich) in 2012. During his research at SMC he undertook an exchange programme at the Erasmus University Rotterdam, joining the research group in cultural economics. His research focuses

on the managerial and curatorial responses of film heritage institutions to digitalisation.

Jörn Bühring (PhD) is Assistant Research Professor at the Hong Kong Polytechnic University, School of Design, where he is advancing a research culture that is cooperative, innovative and highly impact focused. This collaborative approach brings academia, designers and business stakeholders together to develop high-impact design knowledge, concepts and solutions. To this end, Jörn leads the Ignite Innovation program, specifically aimed at fostering industry-university collaboration through tailored program initiatives. He lectures on product and service innovation, experience design and entrepreneurship subjects at master degree levels, and acts as coach for master's students and their individual Capstone Thesis projects. Jörn gained international work experiences through various industry, company and project initiatives that include innovative start-ups, new business formations and new market entries. He earned a BA-equivalent degree in the field of Tourism Management, an MBA (VU) majoring in Entrepreneurship and Innovation, and a PhD in Consumer Engagement Innovation at Swinburne University of Technology in Melbourne, Australia.

Aurélien Decamps (PhD) has been a Professor of Economics at KEDGE Business School since 2012. His research activities are specialized in Urban, Territorial and Real Estate Economics and are focused on two main themes: the impact of CCI (Cultural and Creative Industries) on regional and territorial development; and the impact of sustainability and CSR (Corporate Social Responsibility) on urban dynamics and territorial attractiveness. His professional activity also includes active contribution to HESI (the UN Higher Education Sustainability Initiative) as General Secretary and Academic Coordinator for a flagship initiative: the SULITEST (Sustainability Literacy Test), an international open online assessment tool endorsed by several UN agencies and academic networks. His work has been published both in France and internationally.

Marc Glaudemans (PhD) is Professor of regional and urban strategies at Fontys School of Fine and Performing Arts (FHK) in Tilburg. He combines this position with the position as Head of the MSc programmes in architecture and urbanism (MA+U Master of Architecture/Master of Urbanism) at Fontys School of Fine and Performing Arts. In 2006 Marc founded Stadslab European Urban Design Laboratory, as a postgraduate international program. Marc graduated in Architecture and Urbanism and holds a PhD in Architectural Theory and History from Eindhoven University of Technology. He lectured at several Dutch and international universities and participated in many international conferences.

Anne Gombault (PhD) is Professor of Organisational Behaviour and Management at KEDGE Business School where she heads the Creative Industries

Culture Research Center (CIS) and is also the Arts, Culture and Management in Europe (ACME) Chair. Her research covers organisational identity, behaviour and strategy of artistic and cultural organisations and creative industries in general, including museums, heritage, creative tourism, wines and spirits, and creative regions. She has been involved in research for various bodies – including the European Union, the French Ministry of Culture and Communication, national museums such as the Louvre Museum and Orsay Museum, regions and cities in France and Europe, cultural organisations and businesses. Her work has been published both in France and internationally.

Claire Grellier is a doctoral student in management working on innovative entrepreneurs in creative tourism. She has been associated with the research center for Creative Industries Culture of KEDGE Business School since 2012. Her research and teaching interests are in the areas of innovation, digital, entrepreneurship, tourism and creative industries.

Jordi Tresserras i Juan earned a PhD in Geography and History (speciality in archaeology) at Universitat de Barcelona. Since 1999, he has been academic coordinator of the postgraduate course in Cultural Tourism and the postgraduate course in Cooperation and International Cultural Management at Universitat de Barcelona, and since 2006 has been Associate Professor of Heritage and Cultural Tourism at the Cultural and Heritage Management Doctorate and Postgraduate Programme at Universitat de Barcelona. He was Assistant Professor of Cultural Tourism in the Center for Latin American and the Caribbean Studies at New York University (2001). In the same year, he was a founder and delegate member for the UNESCO Chair/UNITWIN-UNESCO Network "Culture, Tourism, Development" coordinated by Université Paris 1 – Panthéon Sorbone. He is a consultant for cultural heritage management (mainly World Heritage sites), cultural tourism, gastronomy tourism, religious/spiritual tourism, creative economy, cultural routes and sustainable tourism for international organizations. He is also the President of IBERTUR – Network of Heritage, Tourism & Sustainable Development – and is a member of other important networks for sustainable tourism.

Penelope Kenny is Executive Director of Arts Governance. She is a chartered accountant. Penelope holds a master's degree in cultural policy and arts management from University College Dublin; the subject of her thesis and subsequent book was corporate governance for the Irish arts sector, with focus on the funding landscape. She is a non-executive director and currently sits on two state boards where she is also chair of finance, audit and risk committees. She is an experienced Chief Finance officer and specialist in change management, corporate governance and compliance.

Miroslav Keveždi was born in 1976 in Novi Sad, Yugoslavia. He graduated in philosophy and religious culture, Faculty of Philosophy of the Society of Jesus in Zagreb in 2001. After that he continued his education in the specialized academic studies in Novi Sad, in the Department of Media and

Multiculturalism. Since then he has undertaken media research, dealing with content analysis of electronic and print media. He completed his master's degree in 2012 at the UNESCO Chair University of Arts in Belgrade, majoring in Cultural Policy and Management. Areas which he explores and is active in are media, culture, religion and minority rights. He has published dozens of scientific and professional papers in these areas.

Milica Kostreš (PhD) is an Assistant Professor in the Department of Architecture and Urbanism at the Faculty of Technical Sciences in Novi Sad. She completed the Architecture BSc at the same Faculty, defended her master's thesis and later earned a doctoral degree in the field of Architecture and Urbanism. Milica teaches courses in bachelor's, master's and doctoral academic programmes at the Faculty of Technical Sciences in Novi Sad, as well as courses in Architecture and Urbanism, Geodesy and Geomatics, Urban Engineering and Regional Development Planning and Management at the Faculty of Engineering in Kragujevac. As a visiting professor she taught at the Technical Universities of Vienna and Vilnius. She is the author of a number of different publications, including chapters in monographs and papers that have been presented in national and international magazines and at conferences.

Priyatej Kotipalli is a Cultural Economist at Erasmus University, The Netherlands, as a PhD Scholar. He holds a bachelor's degree in heritage management and an MBA in Tourism and Hospitality. He is also a program director at the Center for Research in Arts and Economics (CREARE). He is part of the core team that conducts summer schools in cultural economics at Amsterdam and has previously also organized programs in Uganda and India. He is currently in the process of establishing new programs in United States and Pakistan. He also lectures at top institutes and universities in India and The Netherlands. He has previously consulted for the World Bank and currently is the member of the International Scientific Committee for Intangible Cultural Heritage in India. He also serves on the board of nonprofits and think tanks in The Netherlands, Italy and India. He is currently engaged as a co-editor for a book titled *A Cultural Economic Analysis of Craft*.

Elisabetta Lazzaro (PhD) is Professor of Creative Economy at HKU University of the Arts Utrecht. She has formerly been professor at the Free University of Brussels, Belgium, at Southern Methodist University, Dallas, USA, and at Padua University, Italy. She holds a PhD in Economics jointly from the Free University of Brussels and Paris 1-Panthéon-Sorbonne University, after degrees and fellow studies in economics, business, music, art and design in Italy, Europe, USA and Australia. Her publications and research focus on cultural economics, management, and policy analysis and design, including value, innovation and valorisation of the creative process; socio-economic impact and capacity building of culture and the creative sector; business models, stakeholders, structures and regulation of art markets and

creative industries; cultural participation and audience development; culture, regional development and cohesion; and culture in international relations. She regularly sits on scientific and steering committees of major European and national institutions and projects.

Callum Lee is an expert in the cultural and creative industries. He is a Director at BOP Consulting (www.bop.co.uk). BOP Consulting is an international consultancy specialising in the cultural and creative industries, with offices in London, Edinburgh and Shanghai. His recent assignments have ranged from the evaluation of Creative Europe to research into the impact of the Liverpool Biennial. Current clients range from the Royal Opera House, the Design Council, Innovate UK, the Digital Catapult and the British Film Institute. Between 2013 and 2015, he was also the Deputy Director of the European Creative Business Network (ECBN). He has an MA in Public Art from the Royal Melbourne Institute of Geography and an MA in Geography from the University of Edinburgh.

Freek Lomme is a mediator, debater, lecturer and catalyst in cultural positions. He is an (in)dependent curator, writer, editor, lecturer and moderator for diverse commissioners ranging from museums to independent spaces, assorted art schools in several countries and continents, various magazines and more. Nevertheless, he is primarily known as the founding director of exhibition space and publisher of *Onomatopee*, which he founded in 2006. He studied arts and science at the University Maastricht and holds an MA in art policy and cultural identity. He is particularly interested in visual culture within the experience economy, modes of collaboration and organisation.

Emmanuelle Marion is Head of Administration of the European Union Delegation to Guinea-Bissau. She was Library Director of the Alliance française Dublin until July 2015, where she implemented new digital policies and outreach programmes. She was also co-founder of d.ploy Dublin, a support structure for cultural and creative micro-enterprise that spanned the five years of economic crisis in Ireland. Emmanuelle pioneered processes and linkages internationally between creative entrepreneurship, sustainable development and behaviour change. She is the recipient of social entrepreneurship and green design awards for various initiatives such as Creative Green (sustainable strategies consultancy), Designing Dublin (sustainable urban development), Hot or Not (behaviour change on climate change mitigation), and Eco Creations (green design). She is a former curator and Arts Manager for the French Embassy to Ireland. She holds an MPhil in International Cultural Engineering, a bachelor's degree in Information Science, a diploma in International Business Relations, and an MA in Anglo-Irish Literature. She currently lives in Bissau, Guinea-Bissau.

Liz McGettigan is Director of Digital Library and Cultural Experiences at SOLUS UK. She is one of Scotland's Top Tech 100 2015 driving the digital agenda in Scotland – putting libraries, information and innovative

technology on the map. Prior to this role, Liz was Head of Libraries and Information Service for the City of Edinburgh where she led the team to deliver Edinburgh's first fully online council service, social media suite and 24/7 interactive portals and apps. Passionate about digital inclusion Liz also initiated Edinburgh's innovative digital participation project. She is an award-winning Digital Library and Information Specialist and a leader in the future library and transformation movement. Liz is recognized for integrating technology, people, social and business strategies into effective new business models. She is Vice President of the UK Chartered Institute of Library and Information Professionals, a Fellow of Royal Society of Arts, a Senior Member of Society of IT Managers and a former Member of the Institute of Informatics and Digital Innovation Advisory Board at Edinburgh Napier University. Liz is an Advisory Board member for Internet Librarian International, and is passionate about the future and potential of libraries. She has been nominated for five Connect awards, a Public Sector Digital Award and Best UK Library Service.

Naïk M'sili is co-director of Instants Vidéo Numériques et Poétiques in Marseilles (www.instantsvideo.com). After several years of experience in the social field, she is now involved in the cultural sector. Holding a European degree in cultural management, she is involved in the association's reflection on issues related to international cultural and artistic exchanges, especially in the Mediterranean region (Palestine, Syria, Lebanon, Egypt, Algeria et al.). This interest has facilitated the co-foundation of new video art festivals particularly in Palestine, Syria or Egypt. Another special issue she has been exploring for years is the relationships between the cultural and the social fields, which has led to experimental projects (like the Popular art galleries).

Pau Rausell Köster (PhD) is Lecturer in the Department of Applied Economics at the Universitat de València. Since 1995, he has been Director of the Research Unit for the Economics of Culture (Econcult), which has been attached to the Inter-University Institute for Local Development (IIDL) since 2008. He is the author of numerous publications on topics related to the relationship between culture and development, as well as issues of information economy and communication. He is a regular professor of postgraduate proposals related to cultural and heritage management in different Spanish and Latin American universities, as well as required for numerous conferences and invited papers.

Darko Reba (PhD) was born in 1968 in Novi Sad, where he completed his secondary education in Civil Engineering. He graduated from the Faculty of Architecture in Belgrade in 1995 and earned his master's degree in 2001 and his doctoral degree in 2005 at the Faculty of Technical Sciences. He was promoted to Assistant Professor in 2005, and in 2013 was appointed an Associate Professor, teaching courses in Urban Design in bachelor's, master's and doctoral degree programmes in the Department of Architecture

and Urbanism. In cooperation with students and colleagues he completed a number of urban design studies and projects. He facilitated various urban development research studies and exhibitions for smaller communities in Vojvodina, such as Irig, Bačka Palanka, Novi Bečej, Banatsko Aranđelovo, and Sombor, that dealt with the issue of urban transformations. He currently works for Gardi, an architectural design firm.

David Smith founded Micromedia, an advertising company specializing in the promotion of music, culture and the arts through print media. He also founded and curated Kings of Concrete, an urban sports and arts festival that ran for seven years. This creative pursuit led directly to the formation of Mabos, a dynamic cultural event space in Dublin's Docklands. Through Mabos and his involvement in such meaningful projects related to urban culture and the arts, he has since rebuilt Micromedia into a more contemporary and holistic company specializing in digital networks.

Sara Terzić is an international consultant, with broad experience in cultural tourism development, heritage management and international cultural cooperation projects. She has participated as a lead cultural tourism expert in different international cooperation projects in Spain, Montenegro and Turkey. She has worked as an evaluation expert for the Council of Europe, European Institute of Cultural Routes, evaluating applications for the Cultural Route of the Council of Europe certification. As a member of University of Barcelona, LABPATC Lab of Heritage and Cultural Tourism, she was a guest lecturer at University of Barcelona Postgraduate Programs in International Cultural Cooperation. Sara is cofounder of Kulturis – a non-profit cultural organization, based in Serbia, dedicated to international cultural cooperation, audience development and heritage management. She holds a BA in Spanish Language and Hispanic Literature from the University of Belgrade and an MA in Cultural Management, with a specialization in Heritage Management, and a postgraduate diploma in Cultural Tourism, both from the University of Barcelona.

Jean-Michel Tobelem (PhD) is the Director of Option Culture (Studies and Research Institute) and Associate Professor at Paris 1 Panthéon-Sorbonne University. He also teaches at the École du Louvre and at several universities and business schools in France and abroad. He has a PhD in Management (HDR/Habilitation à diriger des recherches), is a graduate of the Paris Institute of Political Sciences, graduated in Public Law, and held a Lavoisier Fellowship from the French Ministry of Foreign Affairs. He is the editor of a blog dealing with cultural management issues (option-culture.com). A former member of the board of the INTERCOM (management) committee of ICOM, he is director of the series "Cultural Management" at l'Harmattan. Jean-Michel is also the author or editor of many important books in field of cultural management.

An introduction to the cultural economy

James E. Doyle

With this book we hope to change perceptions, ever so slightly, in favor of the "Cultural" economy. We hope it will provide you, the cultural entrepreneur, a handbook that will entice you with some of the best examples in current practice in the cultural economy and an idea of what a cultural franchise might be. We will cite the research that underpins these opportunities, sample some innovative practices and provide an idea of the business opportunities that will enable you to succeed in the cultural sector. The key theme is one of possibilities, of the potential contained within the cultural economy as a business, a business sector that, by its nature, is based in innovation and imagination. We will illustrate these opportunities by providing multiple practice-based and empirical examples from an international panel of experts and respected professionals. Each contribution will provide an accessible and easily understood bank of knowledge − knowledge which we believe can enhance and grow existing practice as well as aid in the development of new projects. These core themes remain consistent throughout the book, and to enhance the experience we have purposefully chosen an eclectic mix of possibilities that will reinforce and underscore the innovative and complex potential of the cultural economy. We hope we have created a book that can be read in part or in whole, as an abstract for a cultural entrepreneur, as a reference for an academic or in the context of planning and development for resilient and sustainable economic growth. And we hope that in doing so these "astounding" opportunities available in the cultural economy will help you capitalize and grow your business.

And truly these cultural opportunities are astounding. In 1919 Robert Ripley developed a cartoon with the title "Believe It or Not!" featuring strange and unusual facts with which to astound the world. His syndicated comic strip wooed over 80 million annually, and the format is still in use today. His facts were no less astounding than those you will find in the cultural economy and in this book. As an example let us look at the literary and cinematic phenomena of the Harry Potter franchise and its effect on tourism. Of course it was a massive literary success with 400 million books sold in 68 languages across the globe. But its cinematic exposure was even more astounding in its success. Box office returns were huge at over $7,952,789,305 worldwide to date and counting. Even more astounding is the spillover to other more traditional cultural resources. The benefit to built heritage has also been significant. Alnwick

Castle in Northumberland, England, used as the location for Hogwarts School of Magic in the Harry Potter films, reaped a windfall beyond expectations. As a result of being featured in those movies, visitor numbers at Alnwick Castle more than doubled between 2001 and 2002, from 61,000 in 2001 to 139,000 in 2002. To date, visitor numbers exceed 250,000 annually. Revenues from tourism at Alnwick Castle also increased to almost €13 million per year in 2002 (and may be currently as much as €50 million per year). This in itself would be interesting to any businessperson; however, what adds value is the spin-off that nearby Alnwick Gardens have experienced: their website shows visitor numbers in excess of 800,000 annually, and turnover of €50 million per year in 2011 (from where the above estimate is made). While clearly there is some disparity in the numbers available, the growth and benefits to the heritage, tourism and in this case the local industries are impressive, and all because of a good book. As Ripley's byline said, "Believe It or Not!"

As a footnote to this story and before we continue I would like to pose the following questions to you: Was the Duchess of Nothumberland's plan to host a televised cage fighting event at Alnwick Castle and Gardens in November 2011 a cultural opportunity? Or just good businesses? And how are they different? To start your thinking, let's see what the Duchess said when challenged about the suitability of such an event from this historic venue:

> "I'd have failed here if this was just a garden for garden-lovers," the Duchess tells me. "My job is to provide a venue for people who want to do all kinds of things. And this is for 16- to 30-year-old men who wouldn't normally come to a garden."

But should we really be that astounded? Perhaps not, after all tourism is a big industry and the effect of film-led visitor tourism has been growing rapidly. From a 2015 report, of the £21 billion of tourism spent by overseas visitors to the UK in 2013, an estimated £840 million can be attributed to film-induced tourism (Olsberg•SPI and Nordicity, 2015).

For this is slightly old news; in fact Europe is the most-visited destination in the world. In 2005 it recorded 443.9 million international arrivals and 55% of global tourist visits. But why? If you still can't see how and why tourism depends on culture, let's see what the experts say:

> The tourism sector is the "industry" that uses cultural heritage to the greatest extent as support for its backbone activities like hotel accommodation, transport and catering. It is the "industry" that uses cultural heritage to the greatest extent.
>
> (Nypan, 2003:13)

As this is to be a handbook, let's give you a little ammunition in the tourism field – something you can refer to, some data to back up your case for the cultural economy – The following are 20 astounding facts that will help you

remember the words of Dr. Nypan above: "The tourism sector is the 'industry' that uses cultural heritage to the greatest extent".

1 Culture is a main driving force for tourism, and is one of Europe's most successful industries, representing 5.5% of the EU GDP.

2 In 2005, 1.171 million were employed in the sector of cultural tourism.

3 In 2004, 5.885 million people worked in the cultural and cultural tourism sectors, equivalent to 3.1% of the active employed population across the entire EU.

4 The average annual growth in cultural employment is higher than in total employment.

5 When taking into account other industries that produce tourism characteristic products, tourism's contribution to the economy is even higher: over 10% of EU GDP.

6 The tourism sector employs more than 9 million people.

7 In France, the most important castles and abbeys alone are responsible for €15.1 billion a year.

8 Tourism in the heritage sector accounted for 176,800 spin-off jobs, 43,880 direct jobs and 41,714 conservation/maintenance jobs.

9 Documenta, a modern art exhibition that takes place every five years in the city of Kassel, with 194,176 inhabitants and a €22 million budget, attracted 650,000 visitors, or over three times the population of the city. The overall direct impact of Documenta on the city of Kassel is estimated at €58,185,000.

10 Since it opened its doors in 1997, the Guggenheim Museum Bilbao has recorded over 8 million visitors, out of which more than 60% are foreigners. The total amount generated indirectly to feed the tourism sector represented over €139 million in 2005.

11 Berlin is the most important destination for city tourism in Germany. In 2004 it was valued at €13 million, providing employment to 145,000 people.

12 The total operating expenditure reported by all European Capitals of Culture (ECoC) is €737 million and the total capital expenditure €1.4 billion, making total expenditure over €2 billion. Taking this total expenditure into account, the most conservative estimate of the total expenditure attributable to ECoC in the period 1995–2004 would be €3 billion.

13 According to recent estimate, more than 8 million jobs are directly and indirectly sustained by the cultural heritage sector in Europe.

14 In 2011, travel and tourism generated $2 trillion in direct GDP.

15 The travel and tourism sector is three-quarters the size of the global education, communications and mining sectors.

16 With the addition of indirect and induced economic impacts, the total GDP impact of travel and tourism was $6.3 trillion in 2011.

17 In terms of employment, the importance of travel and tourism is even more pronounced, with 98 million people directly employed in 2011.

18 The travel and tourism industry GDP will grow at an average of 4.2% per year over the next decade, greater than the 3.6% average annual growth expected for the total global economy.
19 Tourism generated 10% of all UAE exports (including oil) and 15% of Turkey's exports in 2011.
20 And finally my own favourite statistic: the contribution of the cultural sector to global GDP is… wait for it… more than double that of the automotive industry and one-third larger than the global chemicals industry.

So there we have it, just one part of the €ultural Economy with a big €.

References

Nypan, T. (2003). Cultural Heritage Monuments and historic buildings as value generators in a post-industrial economy, page 13. Available from: http://www.jcyl.es/web/jcyl/binarios/265/934/IICH.pdf?
Olsberg•SPI and Nordicity. (2015). Economic contribution of the UK's film, high-end TV, video game, and animation programming sectors. Available from: www.independentcinema office.org.uk/media/Advice/economic-contribution-of-the-uks-film-high-end-tv-video-game-and-animation-programming-sectors-report-2015-02-231.pdf

Introduction to culture, innovation and the economy

Biljana Mickov

This edited volume explores new angles on the concept of cultural development on a global scale. The essays in this book offer a theoretical analysis of the contemporary approach to culture and innovation, as well as to the development of cities, with culture being a pivotal factor in the developmental processes. A special emphasis is put on the relationship between culture, innovation and economy as an indispensable sustainability factor, while it is being clearly stated that a cultural ecosystem contains the economy.

> Appraisal and evaluation of cultural projects in cities is based on realistic and practical experiences of international organizations, universities and activists. They represent a dedication of city councils to integrate culture into the process of sustainable development, both on local and global levels.[1]

To attain sustainability, an economy must produce values on which it is based, and which take into account the culture of the specific environment. The economy has a great legitimacy and dynamic when it is adapted to local sources. Cultural activism plays an important role in sustainable economic development and creates economic activities, entrepreneurship and jobs, adding to the attractiveness of cities and contributing to the development of tourism. However, economic models that prioritize quick development do not work in the long run and are not beneficial to local environments. Cultural and economic factors of the environment must be taken into account and developed in parallel. Economic models that aim at cultural sensitivity need to engage in practice that includes collaboration, cooperation, trade and donations. All economic models are based on specific cultural values.

An effective link between the public, market and cooperative economy, together with the reciprocity among them, is essential to achieving a centralized, environmentally balanced development.

A cultural ecosystem should not be treated as merely a segment of the economy, but rather as a system that contains the economy. Therefore, interconnectedness of cultural systems and other segments of sustainable development must be taken into account.

It is essential to distinguish artists and professionals in the cultural sector, ensure access to their work, promote corporate responsibility and implement

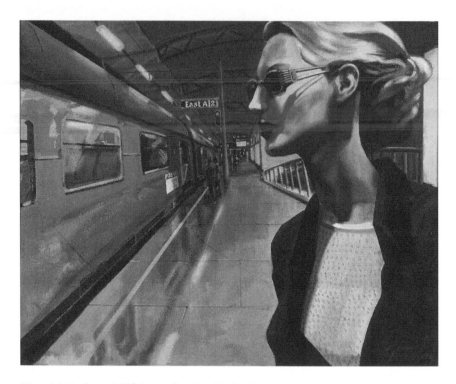

Figure I.1 Radovan Jokić, Art in the City (*Midnight Express*, painting, 2003)

The painting belongs to the exhibition of artist Radovan Jokić called "Passengers". A human being on the streets of the metropolis. The times have their symbols. The art on the streets bringing the spirit in citizens' lives.

adequate support for cultural projects. There are mechanisms for cultural project support, such as microloans and sponsorships. Cities should maintain mixed economic programs that maximize donations for cultural projects. Partnership between people from the culture and business fields is also important, together with systemic innovations and knowledge transfer. "Tourism needs to be linked to this cultural ecosystem, by means of implementing cultural routes. Business organizations such as chambers of commerce possess special programs related to cultural politics of cities."[2]

When it comes to developing cities, priority should be given to restoring public spaces for cultural happenings and art-related activities, which would represent the social unity of a city, as well as strengthening the city's cultural identity based on a network of cultural entities and associations. Clearly, it is this firm network that forms a basis for the promotion and implementation of ambitious cultural policies on a city level. As a key factor in the promotion of urban change, an innovative cultural profile of the city should be defined,

together with the transformation and opening of new cultural institutions. This would help the cultural sector stimulate economic growth.

In Chapter 1 of this book titled "Culture, Creativity and Economic Progress", Pau Rausell Köster states,

> in the last few decades, much has been written about the effect of culture and creativity on economic performance. Before the crisis, some enthusiastic voices predicted that culture and creativity would quickly become the new drivers for economic growth in the post-industrial era.
>
> Although it is true that cultural and creative sectors have shown greater resilience than the whole of economic activity, the depth of the crisis and the subsequent fiscal consolidation policies struck with force, reducing the size and momentum of these sectors.

In the second chapter, Penelope Kenny writes that her vision is to

> become an enabler for arts organisations to approach potential funders and stakeholders in a visible and transparent way. Through great governance, we will enable arts organisations to showcase their accountability, transparency and stewardship, and through this alignment to produce great art that inspires.
>
> I work from a conviction that our society needs to enable both the arts and business sectors to truly fulfil the needs of its citizens. I believe that both sectors can enhance each other's performance, by enabling thinking from both left and right sides of the brain.

Marc Glaudemans in Chapter 3 writes about the future of the city of Eindhoven. The chapter

> reflects on the method and some outcomes of an international design-research project that was conducted by Stadslab European Urban Design Laboratory in the city of Eindhoven. . . Eindhoven is a mid-sized city in the Southern Netherlands with an industrial background and currently one of the main drivers of the Dutch high-tech and R&D industries.

In Chapter 4, Professor Darko Reba and assistant professor Milica Kostreš from the University of Novi Sad, Architectural Department, write about the city of Novi Sad that culture is certainly an area of human life with the greatest significance to its quality. They state,

> It has always been the one resisting and surviving the longest throughout the entire history of building cities and through the lives of prior civilizations. In order for the culture to occur and develop, conditions – spaces, both open and closed – are a prerequisite, and one of the important tasks of urban planning is the formation of an ambience for as much culture-related content as possible, with its numerous layers and manifestations. The

spaces need to be properly deployed throughout the entire territory, thereby directly raising the living conditions of the population to a higher level.

In Chapter 5, expert Callum Lee explains,

> in the UK, much of the recent debate around the creative industries has focused on the shortage of young talent with the skills and creativity to fuel the sector's growth. . . . The Creative Industries Federation, an industry body, reports that education – and specifically the supply of talent available to the sector – is the chief concern for nearly nine in ten of their members.

Jordi Tresserras i Juan and Sara Terzić write about "orange tourism" in Chapter 6. They state,

> In the last two years, there's been a vivid debate on the importance of the cultural and creative economy, popularly called "the Orange Economy". In October 2013, Pedro Felipe Buitrago and Ivan Duque Marquez presented the manual "The Orange Economy: An Infinite Opportunity" http://www.iadb.org/en/news/announcements/2013-10-30/the-orange-economy-an-infinite-opportunity,10622.html published by the Inter-American Development Bank. In the discussion the authors had with Buitrago, they agreed that if the cultural and creative economy is the orange economy, the cultural and creative tourism had to be the orange tourism. The proposal was presented at the XII Congress of the Organization of UNESCO World Heritage Cities held in Oaxaca (Mexico) in 2013, where the process of defining and articulating it was initiated.

Professor Elisabetta Lazzaro explains in Chapter 7 that

> in an era of change, increased complexity and big challenges accompanied by a contraction of public support to the cultural and creative sector, the figure of the cultural and creative entrepreneur becomes particularly relevant in the arts, culture and creative industries. Furthermore, as we discuss in this chapter, cultural and creative entrepreneurs bear idiosyncrasies that can be of significant interest not only for other more general entrepreneurs but also for their overall impact on the wider economy and society.

In Chapter 8, Emmanuelle Marion writes about creativity and libraries. She says,

> When we talk about cultural and artistic entrepreneurship, we seldom think about libraries. And yet, they have globally become key platforms for the development and dissemination of cultural and artistic practice and entrepreneurship. Typical "third places", libraries had to re-invent themselves in the late nineties when faced with the advent of digitalization. They now hold center stage at every level of creative practice.

Liz McGettigan talks about the digital library in Chapter 9. She writes,

> What a time of opportunity for libraries and librarians! We can seize the opportunity to underpin the "Smart City" agenda, but to do this we must find our voice! . . . In the digital age, libraries are transforming maximising community connections and expertise alongside new technologies to promote citizenship, new world skills, entrepreneurship and business development.

In Chapter 10, titled "The Economic (and Other) Benefits of Losing", James E. Doyle writes,

> The founder of the Olympics, Baron Pierre de Coubertin, said, "The most important thing – is not winning but taking part." In practice most people seem to think otherwise, to win is everything, even to come second is for many to leave with nothing. Of course in life this is false and in the cultural field it is double false, from dance to dialectics, from gastronomy to Glastonbury, in culture it's the taking part that matters perhaps more than the success. Culture is, and always has been about the experience, but that's not to say it can't be competitive and there are losers. So what's it like to lose in the competitive world of culture? What is to be gained from failure? In terms of economic benefit, the European Capital of Culture is one of the most financially rewarding competitions for any city to win. "The total operating expenditure reported by all European Capitals of Culture is €737 million and the total capital expenditure €1.4 billion, making total expenditure over €2 billion."

In Chapter 11, Miroslav Keveždi in " Breathing Information" analyses that

> Getting information from the Internet has been a phenomenon for several decades now, but it is simultaneously a completely new phenomenon due to the technical development of platforms on which the *online* media and media products appear. Negroponte wrote back in 1996, "The economic models of media today are based almost exclusively on 'pushing' the information and entertainment out into the public. Tomorrow's will have as much or more to do with 'pulling,' where you and I reach into the network and check out something the way we do in a library or video rental store today."

In Chapter 12, media expert David Smith states,

> The rise of the machine and the impact of this more intelligent and more integrated force in our lives is deeply significant. Furthermore, the continuing crossover of our physical reality and technology is as alarming as it is awesome. . . . From an advertising point of view, with both outdoor and online combined, we are now bombarded with an average of 5,000 advertising messages a day, a monumental level of incomings. Digital billboards

can now scan you and based on your age/sex/location will deliver content accordingly. Online your known profile directly leads to the content in your feed. We are surrounded by unseen algorithms bubbling below the surface working out how best to interact with us. Maths, the one true universal language, is the mover and shaker of our times and we literally make up the numbers.

Jörn H. Bühring, in Chapter 13, writes,

> There are any number of market drivers that affect consumption in society: important market drivers such as globalization, innovation, and technology. From a business perspective, these market drivers have greatly impacted the development of economies of scale, as seen in manufacturing and even within the service economy. As a result, industries often place their primary focus on innovation linked to the efficiency and improvements of the overall delivery performance. While these strategies undeniably produce benefits, the economic achievements most often translate into the erosion of value of many goods and services to the point where they are becoming increasingly commoditized.

In Chapter 14's "Developing an Eco-system of Support for the Creative Sector" by Louise Allen, the author explains,

> While it is true that much has changed over the past decade, Europe's recognition of the creative sector as an economic driver has led to the development of infrastructure in major cities. The rise of communities of practice is breaking down silos between sectors and disciplines, opening up the potential for integration and collaboration. Europe recognises the critical importance of SMEs to rural and national economies. Recent research by the World Economic Forum has found that revenue from creative industries exceeds those of telecommunications services. The impact of the creative industries globally cannot be understated. However, as the economic contribution of the sector is not yet matched by investment, cultural organisations responsible for developing and delivering programmes on a national basis are often challenged. The task of educating and changing the mind-set of existing support mechanisms whether in education, enterprise or government can seem daunting on many levels. In order to embed culture and creativity in the fabric of society, developing an eco-system of support for creatives and those working in cultural sectors is essential. What I present in the following text is the approach I took to develop an eco-system to provide mutually beneficial supports in education, enterprise and international contexts.

Jean-Michel Tobelem writes in Chapter 15,

> The boundaries between cultural sites and the world of leisure-time activities has for some time given the appearance of blurring, with the increasing

use of managerial techniques by cultural sites, their rapprochement with the sphere of tourism, and their development of earned income. Using a multidimensional approach (from interviews to an international review of the literature as well as case studies), our methodology seeks to pinpoint the interaction between cultural sites and the leisure market. From a theoretical point of view, this research proposes a consideration of the notion of "Major Facility of Cultural Leisure" as a further development of the previously introduced concept of "Market-responsive Cultural Organization". In this chapter, we argue that if cultural institutions must show their management capabilities, their success should nevertheless not allow it to be forgotten that their missions, based on the general interest, are not for profit and consequently will continue to call upon the intervention of public authorities and/or donors.

In Chapter 16, Anne Gombault and her colleagues Claire Grellier, Aurélien Decamps, and Oihab Allal-Chérif write about the innovation of heritage from Research Group Creative Industries, KEDGE Business School.

Heritage and tourism organizations have had to cope with two important changes: first, the move to an experience and entertainment economy . . . and second, the digital revolution and the resulting participatory culture . . . Tourism was quick to seize the opportunities to be gained from the spread of the Internet. This was a chance to simplify the connection between partners, a strategic asset for a sector dominated by packaged offers. Information and communication technology (ICT) also made it possible to do away with intermediaries and facilitate the relationship with customers, who were themselves empowered by the advent of Web 2.0 . . . Tourism became by far the first sector to use ICT as a major source of innovation, especially in the e-commerce field.

James E. Doyle in Chapter 17 draws together

many proven ideas and processes that will aid you in developing innovative process as applied through the design thinking model. However, and I hope this doesn't disappoint you too soon, the goal here is to raise more questions for the reader than answers. The inspiration for this chapter was in part the Designing Dublin project, whose goal, amongst others, is "Engaging citizens in conversation and participation using Dublin as a living laboratory". While the project achieved many successful outcomes, it seemed at times superficial and too inwardly focused, which may account for one of its early tag lines: "Learning to lean". In retrospect, the project was undertaken during a time of acute austerity in Ireland, and many of the team, myself included, were perhaps looking for the project to provide economic and social solutions that were way beyond the capacity of the project. In retrospect the project may have appeared to lack a greater goal, while it did say that it would engage citizens in conversation and participation, it didn't offer them anything beyond

that. In this chapter, we will explore the "beyond" or the added value; a greater purpose beyond, but not to the exclusion of the solely economic. In the following chapter, we will explore what that purpose might look like, with a focus on socio-cultural benefit, sustainability and responsible practice, pathways to innovative practice for economic benefit and social good. For the purposes of brevity and clarity, this chapter will use the term "design thinking" as a shorthand for and interchangeable with innovative thinking.

In Chapter 18, Priyatej Kotipalli asks,

> What is important to you? Is it money, is it economic growth or is it about cities that want to be viewed as being creative? The question gets various answers depending upon whom you ask and from what institutional setting.
>
> What matters while answering this question depends upon the framing from which his/her worldview is informed. Of the various framings that are possible, economic framing is the important institutional setting from which we approach this chapter.
>
> The framing for economics is informed by the conversation among economists in their conferences. In such conferences topics related to economics is debated, talked about and disseminated where the underlying theory and assumptions that form the understanding of economics remains static, whereas the methodological underpinnings to explain and make sense of the economic world keeps getting more sophisticated.

Luca Antoniazzi in Chapter 19 introduces the topics of film heritage and innovation.

> The debate about arts and innovation revolves around the contribution that creativity can potentially make to strengthen the cultural economy and the economy *tout court*. In recent times, European Film Heritage Institutions (FHIs) have been affected by such ideas in relation to the digitisation of their holdings. In this chapter, I will explore the potential contribution that the digitisation of film heritage (FH) can bring about in order to enhance innovation and competitiveness within the film industry. In this introduction, I start by defining what FH is; I then briefly explore the debates surrounding technological innovation and the arts; finally, I shall put forward my own arguments and observations. In the subsequent sections of the chapter, I shall provide some evidence to support these arguments.

Naïk M'sili, co-director of the association Les Instants Vidéo Numériques et Poétiques from Marseilles, notes in Chapter 20 that " the line of attempt is implausibly utopian. It certainly dreams. It dreams with open eyes....An attempt is a small premature event. While significant political events require a certain maturation, regarding a very particular element of the State's time-making

and of the strategy of assumption of power in developing political projects, emerges an extremely precarious initiative that takes form and persists" (Fernand Deligny).

In Chapter 21, artist and curator Freek Lomme he wants to discuss

the way truths are sourced and how this sourcing reflects the foundation of our contemporaneity, consider its vitality and, accordingly, consider how to approach this.

First of all, I will do so by proposing two forms of truth, the "innovative truth" and the "open truth" as a think model to think through and re-experience the motivation wherein we are inclined to portray and engage our reality. As such, it anticipates to the gut of our lower belly, in an attempt to inform and inspire.

In Chapter 22, the last chapter of the book, James E. Doyle provides the top 10 cultural and creative economy facts and 10 questions that you might ask.

Notes

1 *Culture 21 action*, www.agenda21culture.net/images/a21c/nueva-A21C/C21A/C21_015_en.pdf
2 Ljiljana Mickov, geography professor, theoretician, Novi Sad 2016.

Part I

Culture and economy – the cultural economy

1 Culture, creativity and economic progress

Pau Rausell Köster[1]

Introduction

In the last few decades, much has been written about the effect of culture and creativity on economic performance. Before the crisis, some enthusiastic voices predicted that culture and creativity would quickly become the new drivers for economic growth in the post-industrial era.

Although it is true that cultural and creative sectors have shown a greater resilience than the whole of economic activity, the depth of the 2008 financial crisis and the subsequent fiscal consolidation policies struck with force, reducing the size and momentum of these sectors.

Emerging territories such as Brazil[2] and China have significantly transformed the view of the cultural and creative field in large-scale development processes. In 2010, China's government decided to promote cultural industries as a key economic sector in its 12th five-year strategic plan, offering abundant opportunities for the industry (Jianfei, 2011). Despite this strong and strategic show of support, data indicate that in 2015, the weight of the cultural industry represented no more than 3,5% of the country's GDP, an appreciable number that is nonetheless still far from becoming the driver of the post-industrial growth model. The statements made in *How Creativity Is Changing China* (Wuvei, 2011) are, at least for the time being, more a wish than a reality.

Cultural and creative sectors and the economy

Although the initial expectations have not been realised, there is increasing evidence that the size of our cultural and creative sectors has a greater influence on the capacity to generate growth in the regions (Marco-Serrano and Rausell Köster, 2014), cause significant increases in the productivity of the economic system (Boix Doménech, Soler and Marco, 2014), constitute one of the fastest routes to overcome the crisis (Rausell Köster, 2013) and define one of the most plausible vectors of European specialization in a framework of global competitiveness (Rausell Köster and Abeledo Sanchís, 2013).

Now is the time to admit that the relationships between the cultural ecosystem and the economic model are much more sophisticated than we previously

thought and that they are connected in ways that go way beyond market exchanges.

Summarising the main interactions, we have:

- Cultural and creative activities and heritage density improve territories' attractiveness (Rausell Köster et al., 2012): culture and creativity attract attention and determine the flow of people (beyond tourism), capital and ideas (Florida, Mellander and Stolarick, 2008).
- An approach that has been scarcely studied in the literature is the role of demand. The number of people employed in the cultural and creative sector determines the power of a solvent demand that is very prone to innovation and therefore becomes a promoter of social and political innovation. This is not only due to an income effect, as the "creative class" is also manifested through a particular lifestyle that involves consuming more innovative products and services and creative content.
- Cultural actions and events generate spaces that facilitate serendipity and cross-fertilization, leading to new projects, sparking innovation and highlighting the value of public spaces as spaces for social interaction.
- The human capital described in traditional growth theories interacts with cultural capital at different levels (Sacco et al., 2013), generating a multiplying effect that better explains growth models. The cultural capital accumulated in a community is a relevant factor for growth.
- The cultural and creative sector, defined by a tendency to work on a project-by-project basis, poor standardization of production processes, low entry barriers and a variety of working relationships, is structured in a much more flexible way than most economic activities. These characteristics may have some buffering effect on variations and tensions in the economy and consequently those regions that have a larger cultural and creative sector show higher levels of resilience to shocks in supply or demand.
- Finally, as J. Potts (Potts, 2011) states, cultural and creative sectors are the foundations of innovation in the whole socioeconomic system.

The public policy perspective

As we have seen, the complex framework of causal relationships between regional development and cultural and creative activities is related to factors of demand and supply, depends on exogenous and endogenous dynamics, affects the structural and systemic situational dimensions, in the short and the long term through macro, meso and micro processes and is linked both to global dynamics and processes related to the specific characteristics of the territories.

This complex connection requires special attention, because if we can understand the cause-effect relationships and assess their magnitude, we will be able to transform a reality that can have a significant influence on the living conditions and well-being of millions of Europeans.

From the point of view of policies that truly attempt to transform reality through the relationship between cultural and creative activities and regional

development, it is quite clear that they are far away from traditional cultural policies. However, their goal remains the same: to satisfy citizens' cultural rights and improve their well-being.

The complexity of the relationship between culture and development requires these policies to be formulated using a comprehensive approach that combines innovation, communication, education and industrial and urban policies.

In a scenario of global competitiveness, Europe does not have many more options for specialization. As the green paper "Unlocking the Potential of Cultural and Creative Industries" stated some years ago (COM, 2010):

> For Europe and other parts of the world, the rapid roll-out of new technologies and increased globalisation has meant a striking shift away from traditional manufacturing towards services and innovation. Factory floors are progressively being replaced by creative communities whose raw material is their ability to imagine, create and innovate. In this new digital economy, immaterial value increasingly determines material value, as consumers are looking for new and enriching 'experiences'. The ability to create social experiences and networking is now a factor of competitiveness.

Some final considerations

As Cooke and De Propis (Cooke and De Propris, 2011) argue, the EU's economic growth takes little account of the opportunities and potential of creative and cultural industries, favouring hard technologies and services. However, if Europe wants to remain competitive in the changing global environment, it needs to create the right conditions for creativity and innovation to flourish within a new entrepreneurial culture but also within a new policy framework.

If culture is a driver for change, policies oriented towards the cultural and creative sectors become the strategic tool to engineer such transformation. This tool requires high doses of instrumental rationality, knowledge, quality information and research. However, if we are talking about the management of emotions, feelings, senses and meanings, we also need emotional intelligence, intuition, beauty and authenticity.

This is the moment where political practice needs to adapt to the web of economic agents who participate in the cultural and creative ecosystem. What we need to remember is that these agents are intelligent and sensitive, they react to emotions and they have their own values. Their motivations go beyond profitability and their creative and innovative actions can substantially change the lives of millions of people.

Notes

1 Econcult, University of Valencia, Pau.rausell@uv.es
2 Nowadays, the creative economy is recognized in Brazil as an atypical political and social innovation field. It has been the most original transversal project of the Ibero-American

cultural policy over the past few years, and is one of the transforming axes of the reformation process that this new emerging power is living (Sierra Caballero, 2014).

References

Boix Doménech, R., and Soler i Marco, V. (2014). Creative industries and the productivity of the European regions. *International Conference on Regional Science* (pp. 1–36).

COM. (2010). *Unlocking the potential of cultural and creative industries*. Green paper.

Cooke, P., and De Propris, L. (2011). A policy agenda for EU smart growth: The role of creative and cultural industries. *Policy Studies*, 32(4), 365–375. doi:10.1080/01442872.2011.571852

Florida, R., Mellander, C., and Stolarick, K. (2008). Inside the black box of regional development – human capital, the creative class and tolerance. *Journal of Economic Geography*, 8(5), 615–649. doi:10.1093/jeg/lbn023

Jianfei, Y. (2011). The Chinese understanding of cultural industries. *Santalka: Filosofija, Komunikacija*, 19(2), 90. doi:10.3846/coactivity.2011.18

Marco-Serrano, F., and Rausell Köster, P. (2014). Economic development and the creative industries: A Mediterranean tale of causality. *Creative Industries Journal*, 7(2), 81–91.

Potts, J. (2011). *Creative industries and economic evolution*. Cheltenham. UK: Edward Elgar.

Rausell Köster, P. (2013). Understanding the economics of culture as a way to overcome the crisis. *El profesional de la información*. EPI SCP, 22(4), 286–289.

Rausell Köster, P., and Abeledo Sanchís, R. (2013). La cultura, la innovación y la creatividad como retos y oportunidades para el futuro de Europa. In A. Martinell (ed.), *Impactos de la dimensión cultural en el desarrollo* (pp. 101–126). Girona: Cátedra UNESCO de Políticas Culturales y Cooperación de la Universidad de Girona: Documenta Universitaria.

Rausell Köster, P., Abeledo Sanchís, R., Blanco Sierra, Oscar (Econcult, U., Boix Doménech, R. (Economic Structure Department, U., De Miguel Molina, B. (UPV), Hervás Oliver, J. L. (UPV), . . . Vila Lladosa, L. (MC2, U.)). (2012). *Culture as a factor for economic and social innovation*. Project, Sostenuto.

Sacco, P. L., Ferilli, G., Blessi, G. T., and Nuccio, M. (2013). Culture as an engine of local development processes: System-wide cultural districts I: Theory. *Growth and Change*, 44(4), 555–570. doi:10.1111/grow.12020

Sierra Caballero, F. (2014). Política cultural y economía creativa en Brasil: Una perspectiva crítica de la cultura para el desarrollo local. *Telos: Cuadernos de Comunicación E Innovación*, 35–44(99), 35–44. ISSN: 0213-084X, No. 99 (Octubre-Enero), 2014 Págs.

Wuvei, L. (2011). *How creativity is changing China*. London: Bloomsbury Academic.

2 The business of arts consultancy

A personal analysis of the history, growth and opportunities for business in arts consultancy

Penelope Kenny

One of the key roles for the board includes establishing the culture, values and ethics of the company.

(UK Corporate Governance Code, 2016)

My vision is to become an enabler for arts organisations to approach potential funders and stakeholders in a visible and transparent way. Through good governance, we will enable arts organisations to showcase their accountability, transparency and stewardship, and through this alignment to produce great art that inspires.

I work from a conviction that our society needs to enable both the arts and business sectors to truly fulfil the needs of its citizens. I believe that both sectors can enhance each other's performance, by enabling thinking from both left and right sides of the brain.

My book *Corporate Governance for the Irish Arts Sector* was published in 2014 by Chartered Accountants Ireland,[1] and some of the ideas and sentences below come from the book. However, we have moved on from the darker recessionary times and funding for the arts is being discussed again in terms of funding increases. Today funding comes with demands for greater transparency and better corporate governance. Corporate governance requirements are one of the intersection points between culture and business; this intersection point is where common principles and practices can be used and enhanced by both sectors.

Producing and enabling good art is the primary goal and measure of success for all arts and cultural organisations, and certainly this should never change. Attempts to quantify the output of arts organisations or to identify value for money indicators are of limited benefit and burdensome to many arts organisations. What is important, however, is that arts organisations in receipt of public monies can justify the expenditures and show some transparency and accountability. This is useful for those same organisations when they are seeking further funding. It is vital for the arts sector as a whole to show that it is well run, with a minimum of financial mistakes or scandals.

Table 2.1 What good corporate governance looks like – some basic standards

Basic standards
1 A functioning board of independent directors
2 A timely annual report
3 Frequent board meetings
4 A declared strategy vision and mission
5 Demonstration of good legislative compliance
6 Statement of adherence to a corporate governance code of practice
7 Financial statements which are synchronous with the story shown in the annual report, website, and vision and mission
8 Financial statements compliant with generally accepted accounting practices
9 Identification of major stakeholders and funders
10 Transparent information on the company website

To think of or to treat the cultural economy as a business would be to deny it inestimable intrinsic importance as a producer of art for its own sake – as a making of meaning in modern society and as a way of helping people find meaning in their individual lives.

It is important for arts organisations to optimise their ability to attract funding. In all cases the funder was less concerned with artistic output (this was a prerequisite for application) than they were that their funding would be well used, and used for the purpose for which it was given, in a fully transparent way.

Therefore, good governance has very specific advantages for the arts sector. First, the sector as a whole needs to avoid scandals such as those we have suffered in the for-profit sectors. This is important because almost the entire arts and cultural sector depends either partially or wholly on some external funding, and funders demand value for money.

While the principles may be the same, there are particular problems, concerns and issues in implementing and maintaining a good governance programme that is specific to arts organisations. For example, arts organisations do not use profit as a primary measure of success. Instead, the quality and impact of the artistic output, or the achievement of *values and mission*, may often be used. These success criteria require that arts organisations need special treatment in the consideration of corporate governance.

I continue to work with the conviction that the arts business sectors not only can use each other but that they can learn from each other's thinking and work practices. Certainly this has led to the conclusion that corporate governance is necessary, even for small companies. It is especially necessary in a sector which receives funding from public funds. Public funding demands accountability and particularly transparency; recent scandals have made it clear that funders and taxpayers lose confidence in the whole sector when any lack of transparency occurs. Many talented and creative people work in the arts sector. It is through

best standards for corporate governance that these people will get funding, and indeed, additional funding, for their organisations. Arts and cultural organisations can be small by global standards and the level of sophistication of corporate governance for these organisations can be low because governance standards are basic; nevertheless the same principles apply, and only the implementation varies. The public are demanding of governance standards and of accountability, and this is clearly demonstrated by the vociferous reactions to any improprieties or wastage of monies within the funded sectors.

The future is bright for arts organisations. There is a growing interest in the sector and what it can contribute to thinking, which may pull the world out of cyclical recessions and into a more sustainable model. The sector experienced growth in the boom years. There is a growing interest in the arts as change agents in modern society, and the works of authors such as Elliot Eisner,[2] Howard Gardner[3] and Mihaly Csikszentmihalyi[4] are examples of studies on creativity and how creativity can be appropriated in other disciplines. Can the arts in fact show us the way to move forward from postmodernism, which arguably sowed the seeds for recession in its consumerism and mass-media-defined culture and its rejection of modernist "grand narratives," allowing a roller coaster of boom and recession in the economic marketplaces and into a new paradigm? It would be game-changing for business to engage with the arts to use the arts as "the making of meaning in modern society."[5] Perhaps in the future, we can "unlock the full potential of the critical and complex connection between culture, and business."[6]

Notes

1 Kenny, P. (2014). Corporate Governance for the Irish Arts Sector, Chartered Accountants Ireland.
2 Eisner, E. W. (2002). *The arts and the creation of mind.* New Haven, CT: Yale University Press.
3 Gardner, H. E. (2006). *Multiple intelligences: New horizons in theory and practice.* New York: Basic Books.
4 Csikszentmihalyi, M. (1998). *Finding flow: The psychology of engagement with everyday life* (Masterminds Series). New York: Basic Books.
5 A phrase used by Declan McGonigle at the Theatre Forum conference in June 2013.
6 Department of Foreign Affairs, 2010.

3 Urban innovation for resilient cities

Eindhoven 2050

Marc Glaudemans[1]

This chapter reflects on the method and some outcomes of an international design-research project that was conducted by Stadslab European Urban Design Laboratory in the city of Eindhoven (Glaudemans and Venne, 2014; Figure 3.1).[2] Eindhoven is a mid-sized city in the Southern Netherlands with an industrial background and currently one of the main drivers of the Dutch high-tech and R&D industries. Also known as the 'brainport' region, *Forbes* nominated Eindhoven the 'most inventive city in the world' in 2013 (Pentland, 2013). The city was recognized in 2016 by the Dutch government as the third 'mainport' of the Netherlands, next to Schiphol, Amsterdam (airport) and Rotterdam (seaport).

Eindhoven 2050

'How do we foster urban innovation and give shape to a sustainable future for the city of Eindhoven?' was the central question of the city's vice mayor Mrs Mary-Ann Schreurs when she approached us for a design-research project. Thinking in scenarios and testing these scenarios was the central objective for us. Through a research-by-design approach, we conceptualized and visualized the spatial impact of urban innovations. We set a distant date – 2050 – to distance ourselves from current mind-sets and avoid extrapolative solutions. Assuming that 30 years from now, society and its spatial containers in the form of the city will be a magnified reflection of the current situation seems idle. That prospect is all the more implausible given that we are witnessing a period of profound changes that might radically alter our cities and societies.

The process of 'creative destruction' in conjunction with a continuing globalization will result in unrecognizable changes both in the visible side of the economy (applications, products and services) and in the invisible side (business models and innovation strategies). These innovations are in the first instance often technological and not spatial, but will eventually, as is our argument, always have a spatial impact, thus enabling urban innovations.

Disruptive changes

An iconic historical reference of such a disruptive technological invention was the invention of the modern elevator by Elisha Otis, in 1852 (Goodwin, 2001).

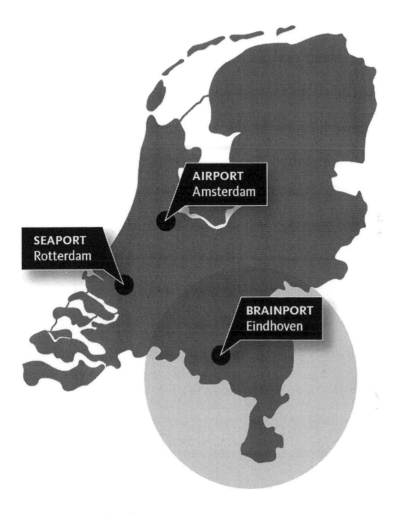

Figure 3.1 Positioning of Eindhoven

Source: www.brainport.nl

Before elevators could be used reliably for the vertical transport of goods and people, all cities were essentially flat bodies, with an average building height of three to four storeys. The invention and widespread use of elevators in buildings enabled new high-rise building typologies to appear, which nowadays are so widespread that they came to symbolize urbanity itself.

A more recent example is the invention and mass distribution of smartphones. This technological invention has a great impact on our use of urban space. Near infinite information about our routes or places to visit is permanently available to all, affecting our movements and productivity. This combination of disruptive innovation and the democratization of technology – in the

sense of mass availability – is an important contribution to the disintegration of the office and to a redefinition of work in general.

Automobile-related mobility is a third example with an urban impact that is hard to overestimate and is increasingly considered for its negative impact. Access to individual car mobility initially had a positive and democratizing influence on the lives of ordinary people and caused an unprecedented increase of accessibility of places. Now we witness that all those cars together have a significant impact on the quality of our urban environment. The development of clean, quiet and autonomous vehicles may eliminate some of the negative consequences. In any case, such inventions will have a tremendous spatial impact on our cities (Rodoulis, 2014).

Numerous other examples can be given of the combined effects of technological innovation and democratization and decentralization of technology. The rise of 3D printing technologies might overthrow our entire industrial paradigm, with unprecedented spatial consequences (Petrick and Simpson, 2013). Why would we continue to produce large quantities of products in one place and then distribute these all over the world if the production can also be local and in an extreme form of mass customization? Consider the consequences such a shift in manufacturing practices may have for the logistical networks in the world, from ports to highways and railway lines.

Designing for 2050?

The brief summary above indicates that even separately each of such developments could have a very profound impact on our lives, our economy and our cities. The combined effect is potentially disproportionally larger. And these are not the only changes that are occurring. In a scenario-based study, we can safely assume not to be very successful in predicting the future. It is very unlikely to really know which technologies will lead to future breakthroughs. We certainly do not know what kind of technologies will be developed in ten, twenty or thirty years from now. From the design scenarios we presented to the city of Eindhoven, we can be fairly sure that none of our proposed interventions will ever be realized. But then, why commit such studies? What is the importance of future-oriented design research as the future cannot be known?

Future ambitions

The objective of the design research we conducted was not to make perfect predictions, but to explore ambitions for some domains and formulate strategic spatial agendas. In consultation with the municipal authorities we came to six strategic areas that we examined both separately and in conjunction. This took place during an international Master Class in which three local planners and some twenty international participants focused on spatial research and design. For each domain the workshop resulted in a brief analysis of the current state of affairs and some ideas about how this domain contributes to the performance of the city. On the basis of this analysis we initiated a design process

based upon a speculative extrapolation of emerging innovations. These design exercises often started from fairly one-dimensional standpoints, but were later complemented by taking into account the findings and results of the studies in other domains. Ultimately, this led to a comprehensive and multi-layered design study based on an accumulation of insights and intelligent connections. Innovations in one area can have major consequences in one or more other domains.

An example we used in our study is the investigation of conceivable innovations in the field of mobility. Research has shown that in the most favourable case an intelligent system of clean, shared and continuously moving vehicles could lead to a 90% reduction in the number of vehicles (McKenna, 2016). Such a revolutionary reduction of vehicles would result in dramatically less road and parking capacity, while the remaining smart vehicles would still be able to deliver the same mobility performance. This would result in radical savings in surface space for the municipality and equally huge savings in maintenance costs (Figure 3.2). These spatial and economic gains could consequently result in a redesign of the entire road network of the region. Smaller streets can often be completely stripped of their transport function and be returned to other

Figure 3.2 Eindhoven current roadmap (above) and 2050 roadmap (below)
Source: Eindhoven 2050

Figure 3.2 (Continued)

Table 3.1 The six domains and the main ambition formulated in each domain

Domain	Eindhoven Ambition
Conceptual city model	From central city to an archipelago of campus villages
Water	From geographic given to strategic bearer of identity
Green	An innovative and design-inspired vision on green
Living	From expats to international community
Mobility	Revolutionary reduction of road and parking capacity
Light	Light is the image of the city and contributes to all domains

users and the space used for other functions, thus contributing to achieving ambitions in adjacent domains (green, housing, air quality, etc.).

Roadmaps and actors

After mapping and visualizing the individual and interrelated ambitions within the six domains, it became possible to develop roadmaps, as integrated spatial

agendas that aim to influence our current actions in the interest of the aspired future qualities. These roadmaps further help to indicate how networks and alliances of actors (initiators, legislators, finance providers and users) may collaborate to reach the goals and which actions are required. Developing such roadmaps in a process of co-creation requires solid supervision and should be supplemented by design research and social and economic investigations.

The desired future state itself should not be some fixed image but should serve as a visualized spatial ambition that acts as a platform for developing shared interests and shared goals. From Actor-Network Theory (ANT) we know that actors in the spatial domain are mainly driven by their own interests (Latour, 2005). By focusing on those interests – and not on a desired spatial image, which designers often do – the result is not given in advance and plenty of room for alternative solutions will be available. As long as these alternatives also meet the common interests, all parties will endeavour to obtain results, which after all serve their own interests. This might seem a cynical view of reality, but it rather reflects a belief in the power of processes driven by intrinsic values.

What will we do tomorrow?

To follow up on such relatively noncommittal roadmaps we proposed some concrete pilot projects which may act as first steps of development. Also, these pilot projects can help to bring about the Eindhoven of which we have sketched some inspiring outlines. These projects were defined on the overlay of several strategic developments which requires both a spatial translation (design) and an action plan (actors).

One example of a pilot project is the concept of 'citizen streets' (Figure 3.3). As previously reported, we expect a large spatial impact of technological developments in the field of autonomous vehicles. In time, the entire road network will have to be revised, resulting in large quantities of streets losing their traffic function. Returning this reclaimed road-space to residents provides unforeseen opportunities for increasing the quality of life in old neighbourhoods. How can this reclaimed space be given back to the community in a meaningful way? What is the new business model? The city, after all, no longer needs to maintain such streets as traffic space. Perhaps residents would purchase the land, or other models might be invented to contribute to the ambitions of the city. The recently announced experimental space for testing self-driving cars on Dutch roads provides a great opportunity for Eindhoven – as a centre of the automotive industry – to sign up as a pilot project. In such testing it is not just about the technology itself, but also that it provides a space for speculative design research into the broad social and environmental consequences of such innovations.

The future has just begun.

Notes

1 PhD, Professor of Urban Strategies and director of Stadslab European Urban Design Laboratory, Fontys School of Fine and Performing Arts, Tilburg, The Netherlands. m.glaudemans@fontys.nl

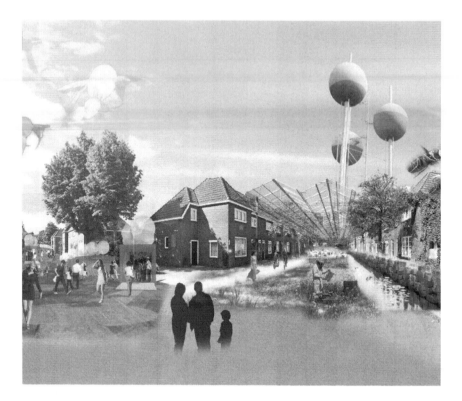

Figure 3.3 Citizen streets
Source: Eindhoven 2050

2 This article is a partly revised and updated version of an essay published in the Eindhoven
 2050 publication. Further information on Stadslab can be found at www.stadslab.eu

References

Glaudemans, M., and Venne, C. v. d. (2014). Scenarios for the resilient city: Eindhoven 2050.
 In M. Glaudemans (ed.), *Master class Eindhoven 2050* (pp. 30–33). Tilburg: Fontys Univer-
 sity of Applied Sciences.
Goodwin, J. (2001). *Otis: Giving rise to the modern city.* Chicago: Ivan R. Dee Publisher.
Latour, B. (2005). *Reassembling the social: An introduction to actor-network-theory.* Oxford: Oxford
 University Press.
McKenna, P. (2016). Urban transit's uncertain future, Jan 13. Available from: www.pbs.org/
 wgbh/nova/next/tech/cities-autonomous-vehicles/
Pentland, W. (2013). World's 15 most inventive cities, July 9. Available from: www.forbes.
 com/sites/williampentland/2013/07/09/worlds-15-most-inventive-cities/
Petrick, I. J., and Simpson, T. W. (2013). 3D Printing disrupts manufacturing: How economies
 of one create new rules of competition. *Research, Technology Management*, 56(6), 12–16.
Rodoulis, S. (2014). The impact of autonomous vehicles on cities. *Journeys*, November 12–20.
 Available from: www.lta.gov.sg/ltaacademy/doc/J14Nov_p12Rodoulis_AVcities.pdf

4 Planning the allocation of culture in Novi Sad

Darko Reba[1] *and Milica Kostreš*[2]

The chapter will analyze and evaluate planning practice in the allocation of culture – institutions and open spaces – in the territory of Novi Sad. This presents an important element of city life in the cultural sense, as well as concerning planning in economic and transport terms. The aim of the chapter is to establish the extent of attention that has been devoted in the current planning practice to the adequate scheduling and allocation of culture-related events; analyze and present the current division of spaces for culture in the city area; define the criteria for the evaluation of culture-related programs; and determine appropriate strategies and concepts for the adequate planning due to the deficit of such programs in some parts of the city. The topic's main idea is the decentralization of culture, i.e., the importance of planning adequate culture-related and urban processes in all parts of Novi Sad, since they directly initiate economic activities which are always in close contact with the places of socialization, as well as contribute to lessening the traffic congestion in the city center, which is perhaps the greatest problem of contemporary cities.

Introduction

Culture is certainly an area of human life with the greatest significance to its quality. It has always been the one resisting and surviving the longest throughout the entire history of building cities and through the lives of prior civilizations. In order for the culture to occur and develop, conditions – spaces, both open and closed – are a prerequisite, and one of the important tasks of urban planning is the formation of an environment for as much culture-related content as possible, with its numerous layers and manifestations. The spaces need to be properly deployed throughout the entire territory, thereby directly raising the living conditions of the population to a higher level. An essential goal of every modern society is to provide adequate availability of culture-related programs to all citizens and visitors, which can emerge in numerous and diverse forms and at various places and environments. Simultaneously, culture and creativity are considered to be among the primary drivers of economic development of cities within contemporary urban strategies (Romein and Trip, 2011).[3] In this sense, the representation of the content of culture, and consequently the proper vitality and social climate, presents the strategic orientation in cities focusing on the improvement of the local social and economic situation (Florida, 2002).

The specific area of this research will be the city of Novi Sad, where there is a strong demand for redefining the relationship towards the planning of the space devoted to culture and its diverse manifestations, since the improvement of this aspect of planning should contribute not only to more active cultural, economic and commercial programs, but also to the new identity of the city areas.

Planning concepts in modern urban planning

With the advent of modern technologies that have changed the lives of people in the 19th, and especially in the 20th and 21st centuries, cities have begun to spread to a much larger territory than in previous periods of history. Development in the 20th century increasingly moved the place of residence away from the city center, where, as a rule, cultural institutions became concentrated, as were open spaces where culture took place. This situation is typically present in most European cities that have developed under the planning influence of the Athens Charter and modern urban planning. The basic concept of this period in urban planning consisted in the distribution of the city functions within the mono-functional zones.

The strategy that the place of residence should not be in vicinity of the contents of culture, as well as near any other programs that would allow business or other economic activities, has greatly contributed to the inadequate cultural development of a great number of residents who used to live in these blocks. The situation has rarely been analyzed in the theory of urban planning. In this sense, the availability or the accessibility to culture-related programs occurs as an essential theme of this research, especially in terms of the manner to bring these programs equally close to all residents in mono-functional residential areas of the city. Contemporary studies also emphasize the availability of culture-related content as one of the most important aspects in the development of creative industries, which should particularly be based on walking distances and motorized traffic reduction, in compliance with the strategies for sustainable urban development (Romein and Trip, 2011).

Typology of urban spaces of Novi Sad

To adequately analyze the current situation on the territory of Novi Sad, the city should be divided into typological units that have common characteristics. In this respect, the typology of space will depend on the position – the location of individual parts of the city in relation to the distance from the center area where most culture-related institutions and programs are situated:

1 The first type is the central area where there are all kinds of cultural institutions and spaces where culture takes place;
2 Transitional areas form the second type; they are in direct contact with the center, i.e., within walking distance from culture-related institutions (within the radius of one kilometer);

3 Suburban areas of the city constitute the third spatial type. These parts
 will be the subject of the research and analysis in this chapter, since one
 of the important strategic planning concepts is decentralization, with the
 adequate allocation of culture-related programs being one of its essential
 topics.

Decentralization as a concept for contemporary city development

The spaces in city centers originated at the beginning of the settlement's
development, where the means of movement and transportation were not as
advanced as they are today. Unfortunately, the concept of mono-centricity has
lingered for a long time in the planning regulations of settlements, creating
numerous problems that have directly affected the quality of people's lives.

The greatest drawback of this concept is the fact that almost all city institu-
tions, such as the government, cultural institutions and all forms of economic
activities, are largely concentrated in a small space of the center, causing a num-
ber of problems as a consequence. Traffic is certainly one of the largest issues,
followed by pollution, noise, loss of time due to daily arrivals to and departures
from the center, and many others. Hence, the decentralization of all important
city functions and institutions occurs today as a vital and necessary planning
strategy for every European city, including Novi Sad.

Even though this concept has long been adopted in modern planning, very
little has been done to realize this important planning strategy, specifically in
the areas of Novi Sad.

Criteria for the evaluation of culture on the area of Novi Sad

For the evaluation of culture-related programs in Novi Sad, criteria for the
analysis of the quality of the space intended for culture-related processes have
been determined. Numerous cultural events happen in the city; however, they
are mostly concentrated in the center. Criteria for the analysis of the division of
culture-related programs in the city in this chapter are as follows:

1 The area in which the culture-related programs happen – Most commonly,
 open spaces where programs in the cities are organized are squares and
 streets, though there are other areas where public events take place, as well
 as certain indoor spaces. Physically creative space as a framework for events
 has great significance in this context as a social space for personal encoun-
 ters as well (Romein and Trip, 2011).[4]
2 Character of the culture-related programs, which can be music, cinema,
 education, art, entertainment, sports, etc.[5]
3 Duration and frequency – The high value of a particular program or event
 is in its duration. It is essential for programs to be sustainable over a longer

time period, which increases the importance and quality of activities (Reba and Kostreš, 2015). The frequency and the event intervals (weekly, monthly, annually, etc.) are also important characteristics of cultural events.

4 Visitations to the culture-related programs – An important factor in the culture-related programs is the number of participants who perform it, and more importantly, the number of visitors who come to be introduced to its meaning and messages.

5 The significance of the culture-related programs – An important fact for every program taking place in the city is whether its significance is recognized at the local, regional or broader level, such as European or even worldwide.

6 Final grade of valorization – which should summarize and manifest the value of the analyzed types of culture-related spaces and programs being performed in them. This should indicate spatial flaws and potentials, which should then contribute to the better development of cultural ambience in Novi Sad.

Analysis of spaces for culture in the parts of Novi Sad

Petrovaradin Fortress

Petrovaradin Fortress is one of the best-preserved fortifications in Europe. It offers great opportunities for organizing programs based on the cultural values of the area and the people who have used it, and it should also be, in economic terms, the space that brings profit to the city. In addition to built structures that create it, great value is formed by undeveloped areas with diverse characteristics and proportions.

In the area of the fortress, two programs are organized regularly, both of a musical character. First, much better known and more significant is the festival Exit, which is organized once a year. Started in 2000, it has become one of the most important events of its kind in Europe, with visitors coming from all over the world.

Another music event accommodated by the fortress is the Tamburica fest, held since 2012. This international music program is linked to the tradition of the Pannonian Plain region and it contributes to the spirit of past times, nurturing a distinctive kind of music.

Petrovaradin Fortress also hosts the City Museum of Novi Sad, whose exhibitions contribute to the cultural offerings of this historical unit.

Central area

Novi Sad developed on the dry berms of the swampy terrain constantly being flooded by the Danube throughout history. Today, the narrowest section of the city center includes the streets Dunavska and Zmaj Jovina and the square Trg Slobode, as well as the open spaces of streets, squares and inside-block spaces in

contact with these three most important urban elements. In this area, one can reach the most important cultural institutions – Matica Srpska and the Serbian National Theatre, as well as the Youth Theatre, Theatre Ben Akiba, Museum of Vojvodina, Novi Sad City Museum, Museum of Contemporary Art, Gallery of Matica Srpska, the Pavle Beljanski Memorial Collection, Memorial Collection of Rajko Mamuzić, Cultural Center, Arena Cineplex, French Cultural Centre, American Corner, and other culture-related organizations and institutions. Open spaces of the center host numerous culture-related programs, usually once a year, the most important certainly being the festival Zmaj Children Games, Street Musicians Festival, Festival of Honey, and many others. The space of the city center, in terms of culture, creates the most significant area in the city and therefore, in accordance with the set aim of the research, its analysis is less detailed (Figure 4.1).

Liman 1, 2, 3 and 4

The spaces of the blocks of flats called Liman were the first residential blocks built after the Second World War in the city. Today, due to their position in relation to the center and the river, they present very attractive places for housing, settling a large population. The plans for this city area did not include institutions and spaces for culture; hence, these were never built.

Today, there is a cultural center "factory" established in the space of the former production hall "Petar Drapšin" in the so-called Chinatown. Apart from the cultural center, a similar hall houses the Manual Forgotten Arts Museum, the only private museum in Novi Sad.

It can be concluded that the Liman blocks do not have any ambience or institutions planned for culture; culture happens in the former industrial area, demonstrating the necessity to proceed with this vital issue for Novi Sad.

Figure 4.1 Central area of Novi Sad with significant culture-related institutions

Detelinara

The residential block Detelinara is located on the northeastern part of the city territory and consists of two parts – the old Detelinara, built as a housing area for labor population in the 1960s and 1970s, and the new Detelinara, transformed in the 21st century, from a single-family to a multi-family housing development.

In the area of Detelinara, no institutions or spaces have been planned for culture. This situation has arisen in the old part as a direct expression of modern urban planning, while the new part, transformed by building on private land, has not left any space for any other programs or content other than residential housing. Given that a great number of people live in this area, it is necessary, as soon as possible, to plan and implement culture-related spaces and institutions for the area's residents within walking distance.

Bistrica – former Novo Naselje

This new residential area, built almost entirely during the second half of the 20th century, has different types of residential structures from different decades of this period. Despite a long period of building, this large segment of Novi Sad has no institutions or spaces adapted for culture-related programs. New programs were introduced in the 1990s, which were supposed to reduce the mono-functionality of this area; however, they were mostly intended for economic activities such as manufacturing, commerce, services and trade. Culture-related institutions and spaces are not found in this new part of the city. A group of young residents who noticed this gap organized the association "Novo kulturno naselje,"[6] implementing a great number of interesting and diverse activities for people of all ages, especially for children (Figure 4.2).

Figure 4.2 Theatrical festival "Applause Fest" on the open spaces of the city area Bistrica, organized by the association "Novo kulturno naselje"

Klisa and Telep

Urban areas Klisa and Telep, predominately founded around family housing, are grouped into a single entity in the research, as the situation regarding culture-related institutions, programs and spaces is completely the same. In these large residential areas, unfortunately, there are no culture-related spaces or institutions.

Conclusion

> The work and development of cultural institutions is in the function of economic development. Culture is not a profitable activity; however, it is dependent on the earnings that cultural institutions can achieve, i.e. of the living standard of the population and the amount of funds allocated from the budget.
>
> (J. Adamović, 2000, in Bogdanović and Stojkov)

It is clear that culture-related institutions and open spaces to which they are oriented not only contribute to this aspect, but also allow for economic and industrial development; in addition, they establish the identity and recognition in the wider city area. The analysis of different types of urban areas of Novi Sad in terms of the presence of culture-related programs can lead to the conclusion that the situation is a direct expression of the mono-centric development of the city; that is, that there are no planned spaces for culture outside the central area. It is a logical strategy that if the society wishes to develop the culture of its population, which should be the goal of all those involved in planning and decision-making, culture should be equally close to everyone. The best way to achieve such a goal is to plan spaces, both open and closed, for culture, within walking distance of the place of residence or business. Such an approach would not only raise the level of urban culture of residents and the economic activity in mono-functional areas, but it would also improve traffic conditions and the microclimate in all parts of the city, due to the fact that city residents would arrive on foot to culture-related programs in a much greater number, consequently increasing their number and occurrence as well.

Notes

1 PhD, University of Novi Sad, Department of Architecture and Urban Planning, Serbia, rebad@uns.ac.rs
2 PhD, University of Novi Sad, Department of Architecture and Urban Planning, Serbia, kostresm@uns.ac.rs
3 The connection between economic development and culture, understood in the broadest sense, is increasingly being considered in the context of criticism of consumer culture production, where, within the urban strategies, it is treated as any other product on the local, global or regional market (Cuthbert, 2011).
4 Romein and Trip determined the analytical framework for the development of a creative cultural milieu in the cities, which incorporates diverse parameters–building density, liveliness and crowds as important properties, cultural and social diversity, and the existence of authentic cultural heritage (Romein and Trip, 2011).

5 Sports programs will not be analysed in this paper, since they utilize specific spaces that are completely adopted to the function of the program.
6 A word play, where the name "Novo naselje" became "Novo Culture-Related Naselje".

References

Adamović, J. (2000). *Ekonomsko upravljanje kulturnim ustanovama u Beogradu* [Management of economy in cultural institutions in Belgrade]. In R. Bogdanovic and B. Stojkov (eds.), Kulturne vrednosti kao osnov prostorne integracije podunavskih zemalja [*Culture as a values base for spatial integration of Danube countries*], 137–140. Beograd: UUS.
Cuthbert, A. (2011). *Understanding Cities*. New York: Routledge.
Florida, R. (2002). *The Rise of the Creative Class: And How It's Transforming Work, Leisure, Community, and Everyday Life*. New York: Basic Books.
Reba, D., and Kostreš, M. (2015). *Savremeni programi istorijskog grada* [Cultural programs of historical towns], Međunarodna konferencija "Očuvanje i unapređenje istorijskih gradova" [Proceedings of the Second International Conference "Preservation and improvement of historic towns"], Sremski Karlovci, 14–15.maj [May 14–15].
Romein, A., and Trip, J.J. (2011). *The creative city – a sustainable city?*, Second discussion paper written in the framework of WP6 Activity 5 of the NSR INTERREG IVB project Creative City Challenge, file nr. 35-2-07-09, TU Delft.

5 The UK's national shortage of talent and the networks that can address it

A national shortage of talent?

Callum Lee

In the UK, much of the recent debate around the creative industries has focused on the shortage of young talent with the skills and creativity to fuel the sector's growth. The Creative Industries Council, a representative body of government and industry, has set out a strategic priority of ensuring "a talented, skilled, and productive creative workforce".[1] An influential report, *Imagi-Nation*,[2] explained that the

> UK's Creative Industries are suffering from skills shortages, particularly in internet-related disciplines . . . these skills shortages exist across a spectrum of core management, entrepreneurship and technical skills – the very skills that are essential for any creative business to thrive in today's modern economy.

The Creative Industries Federation, an industry body, reports that education – and specifically the supply of talent available to the sector – is the chief concern for nearly nine in ten of their members.[3]

Young people still aspire to careers in the creative industries

This concern seems contradictory to data that suggests that, for many young people, the creative industries are among the most popular career options. For young people at age 16, around 15% aspire to careers in the sector. Top of the list is acting, followed by graphic design and becoming an artist. Advertising and architecture are also popular.[4] If these young people realise their aspirations, this is much more than the sector needs.

But underneath the skill shortage are acute issues in two areas. First, the "workforce readiness" of the young people and graduates entering the sector. Employers report that young people do not have the appropriate attitudinal characteristics and the technical skills for a career in the sector. Second, a workforce lacking in diversity, and in particular lacking talent from working-class backgrounds or black, Asian and other non-white minority ethnic backgrounds (BAME), where there is now strong evidence of systematic exclusion. One

recent study looked at acting, outlining the "profound occupational advantages afforded to actors who can draw upon familial economic resources, legitimate embodied markers of class origin (such as Received Pronunciation) and a favourable typecasting".[5] Another looked at the role of admissions tutors in art colleges, finding that a lack of clarity around how assessments were being made, and tutors' own understanding of what "potential" means, were systematically excluding young people from groups that were not white and middle class.[6]

In other words, a range of *cultural* factors exclude young people from the creative industries. Given the education system seems to be failing them, how can the creative industries themselves develop the young diverse talent it needs?

The most effective programmes tackle this cultural challenge

A range of industry-led programmes try to support young people to enter the sector. One, Creative Access, provides paid internships for BAME young people, and has now placed its 600th intern since being established in 2012.[7] Another, AdMission, run by the Institute of Practioners in Advertising (IPA), aims to place STEM and BAME undergraduates in agencies so they can gain experience.[8] Many of these programmes tend towards "brokerage", in that they act as a dating agency, making introductions between interns and agencies.

We have evaluated a range of these programmes for clients and, in general, the more effective programmes are those that try take on more than this brokering role. Programmes that try to address the cultural barriers that are stopping young people from entering these careers (whether this is a barrier stopping the young person or stopping the employer) tend to have a stronger longer-term impact.

The BFI[9] Film Academy is a strikingly effective example. We have been evaluating the programme since 2012, a rare opportunity to track young people through a programme and into their early careers. The programme aims to support 16 to 19 year olds who are considering a career in film and so aims to give better insight into how this career might work, a fairly modest aspiration. As a career in film is complex and unclear, unlike a career in dentistry which has a straightforward route, young people need support to navigate and understand their options.

The programme funds courses across the country where participants spend most of their time making films, guided by close contact with industry experts. Each course takes relatively little time – around seven mid-week evenings and a few weekends. For some participants, there is a dramatic and emotional screening event at the end of each year. Although it is not targeted at BAME participants, the programme managers ensure it has strong representation from these groups.

The first 250 participants graduated in 2013 and, three years on, the impact of the programme has been impressive. First, the programme has a very high number of participants who go on to make or engage with film after the

programme ends (around 90%).[10] For these, the vast majority aspire to a career in film at some point (more than when they started the programme). And even three years on, around half of participants say that the programme had a major impact on their career choices.

Strong, connected networks can help young people overcome the cultural challenge

Part of the success of the programme is in the way it helps young people address cultural barriers as part of a group. As they work intensively together over a short period and are bonded by a shared interest, participants develop a sense of collective identity with other participants. Well over half of participants continued to use their networks that they built in the programme to collaborate on film projects after it had ended. Here is one quote from a participant who describes the impact the course had on her:

> Making the film with the group was great, we were all from different places and had different backgrounds so we all had different ideas and mind sets which we could combine to make the film branch out to a wider audience and to make it more interesting. Everyone was also very devoted and I got some great contacts and friends.

Another, from a small rural community in the North of England, described how the programme was the first time he had met others who were interested in a career in film. As well as providing new collaborators, it also made him feel less isolated in his interests.

This sense of identity as a filmmaker and belonging in a sector should not be underestimated. The effectiveness of the programme fits into theory around "connected learning networks". Connected learning is a type of learning that integrates academic achievement, personal passion, and peer relationships. These networks are a response to the new media technologies that can help reinforce these connections – for the BFI's programme, most of the participants are connected by Vimeo, YouTube, or Facebook. These are groups bonded by interest, rather than by demographics or age (as you might be in your community or school).[11] These supportive networks are forged on the BFI Film Academy, taken online, and appear to remain strong as participants enter their careers.

The future of support

At the start of this chapter I set out two challenges for the sector which underpin the skills shortage. First, the workforce readiness of young people and, second, the cultural barriers stopping young people from diverse backgrounds entering the sector. Programmes like the BFI Film Academy address these in a holistic way. First, they focus on building a cohort or network of participants who can work together and reinforce each other's learning. These networks

are particularly important for young people from groups which typically may not be found in the creative industries. Second, by operating in a pseudo-professional environment, young people are given their first steps into a career in film, which starts to address the workforce readiness issues. Access to professionals helps young people to pick up much of the tacit expertise needed and, for a number of participants, has helped them to find contacts and go on to further internships. They may still face the cultural barriers that are stopping diverse talent reaching the sector, but by supporting aspiring young professionals to progress as part of tight-knit networks, they can help overcome these barriers together, not alone.

Notes

1 Creative Industries Council. (2016). *Creativity is great: A creative industries council for cross industry collaboration*

2 Livingstone, I., and PWC. (2015). *Imagi-nation: The business of creativity*, p. 14. Available from: www.pwc.co.uk/industries/entertainment-media/insights/imagi-nation.html

3 Creative Industries Federation. (2016). Available from: www.creativeindustriesfederation.com/

4 Mann, A., Massey, D., Glover, P., Kashefpadkel, E. T., and Dawkins, J. (2013). *Nothing in common: The career aspirations of young Britons mapped against projected labour market demand (2010–2020)*. Available from: www.educationandemployers.org/wp-content/uploads/2014/06/nothing_in_common_final.pdf

5 Friedman, S., O'Brien, D., and Laurison, D. (2016). 'Like skydiving without a parachute': How class origin shapes occupational trajectories in British acting. *Sociology*, 1–19. DOI: https://doi.org/10.1177/0038038516629917

6 Burke, P. J., and McManus, J. (2009). *Art for a few*. Available from: www.heacademy.ac.uk/sites/default/files/naln_art_for_a_few.pdf

7 Creative Access. (2017). Available from: creativeaccess.org.uk

8 IPA AdMission. (2017). Available from: www.theadmission.co.uk

9 British Film Institute. (2017). Available from: www.bfi.org.uk

10 BOP (2014) Evaluation of the BFI Film Academy, Year Two

11 See the Connected Learning Network: https://dmlhub.net/publications/connected-learning-agenda-for-research-and-design/

6 Orange tourism

The color of the strategic alliance between culture, creativity and tourism

Jordi Tresserras i Juan[1] and Sara Terzić[2]

What is orange tourism?

In the last two years, there's been a vivid debate on the importance of the cultural and creative economy, popularly called "the Orange Economy". In October 2013, Pedro Felipe Buitrago and Ivan Duque Marquez presented the manual "The Orange Economy: An Infinite Opportunity," published by the Inter-American Development Bank. In the discussion we had with Buitrago, we agreed that if the cultural and creative economy is the orange economy, cultural and creative tourism had to be orange tourism. The proposal was presented at the XII Congress of the Organization of UNESCO World Heritage Cities held in Oaxaca (Mexico) in 2013, where the process of defining and articulating it was initiated.

Orange tourism is sustainable tourism which generates economic and social development through responsible tourism management of cultural heritage, artistic production and cultural and creative industries.

The orange tourism destination is a territory with cultural identity, a destination with cultural and creative resources that has the orange economy as one of its axes of endogenous development. The orange tourism destination must have a portfolio of products derived from the creative action of the local community, or its interaction with tourists. It consists of a destination with imagery, icon/s, brand, price and a place in the market and with a community that participates, identifies and acts as host, and has throughout the year a stream of visitors and tourists numerous enough to turn the tourism into one of the bases of its economy.

Territories with cultural identity have great potential to become an orange tourism destination. Destinations and tourism promotion agencies, collaborating with the cultural and creative sector, promote tourism by segmenting and incorporating products and services of the orange economy as a differentiating element of their destination. They usually create specific offers structured by the type of destination, business activity, principal or complementary activity, or audience segment.

It is indicative that even the traditional mass tourism destinations are realizing the importance of including their cultural and creative resources into tourism

development plans. Tossa de Mar is a small municipality on Costa Brava, with well-developed tourist activity, based on sea and sun. Its picturesque scenery makes it one of the most photographed places in Costa Brava, and its beaches are year by year stated among the world's 20 best beaches by prestigious publications. In spite of having well-developed tourist activity, Tossa de Mar opted for integrating new concepts into its tourism development based on its long history and strong cultural identity, aiming to achieve more sustainable, year-round tourism activity. A network of various public and private institutions was created to develop and promote joint projects of cultural and gastronomic tourism, including the Municipality of Tossa de Mar, the Laboratory of Heritage, Creativity and Cultural Tourism from the University of Barcelona and the University of Girona Tourism Department. As a result, TossaLab was created as an inter-university hub for the research and development of tourism and gastronomy. It is a space for discussion and networking with the public, private and academic sectors. One of the first joint projects of TossaLab was the creation of the Gastronomy Museum of the Catalan Coast (*Museu de la Cuina de la Costa Catalana – Tossa de Mar – Costa Brava*), which has already developed tourism and gastronomic experiences that combine tradition and innovation (trekking and walking food tours).

And the orange tourists?

When we talk about orange tourists, the main focus is to analyze their primary and secondary motivations; the cultural and creative activities carried out, in particular their number and duration; their consumption of products and services of the orange economy; the degree of direct and indirect benefit it generates for the community; and especially their travel organization habits (before, during and after their trip). As developers of orange tourism destinations we must be demanding, as tourists are increasingly more educated, more prepared and usually well experienced. They have visited other destinations and can compare not only the price but the content and experiences as well. Their satisfaction in the form of positive evaluation will become a key promotional tool.

Orange tourism's niches showing the greatest development are the ones linked to heritage tourism, artistic tourism, festival tourism and especially those related to cultural and creative industries with specific niches like craft tourism, film tourism, language tourism, literary tourism, gastronomic tourism, music and dance tourism, etc. It is worth highlighting creative tourism, as it implies greater participation and interactivity by tourists who often want to be travelers or feel like locals and develop their creative potential through learning, experimentation, creation or showing their talent through unique tourist experiences. "Painting holidays", where tourists paint or learn to paint, are a clear example. Regarding the networking between destinations, the *Creative Tourism Network* (www.creativetourismnetwork.org) deserves a special mention.

The Challenges and the Future

The future holds many challenges. The key is networking among public institutions, the organized private sector, professional associations, universities and international organizations, which are jointly working on articulating this process. UNESCO already plays a key role in the development of orange tourism with the initiatives such as the World Heritage List, the List of Intangible Cultural Heritage in Need of Urgent Safeguarding and the Creative Cities Network.

Equally important for the successful development of orange tourism is to (re)define a destination's cultural identity. Often mistaken as simply creating a powerful slogan and logo, defining cultural identity of a place and creating a brand is a long and complex process. It requires inclusive strategy involving the engagement not only of principal stakeholders but also of different sectors of the community, resulting in a representation of the community's essence. Only if the community accepts that identity can it be used as a basis for creating sustainable tourism products.

The new generation of tourists, who prefer to be called travelers or explorers, are increasingly seeking new, authentic and often customized experiences. This has brought changes even to the traditional hospitality industry. Looking to attract "millennials", the major international hotel chains are creating new brands of hotels inspired by destinations, which includes customizing local experiences and avoiding uniformity. They define their guests as "fun-hunters" who are looking for new experiences, beginning with their hotel room.

Nevertheless, this search for authenticity and "real" experience can represent a big challenge for orange tourism development as it often leads to intrusion into local communities' lives and customs and even to the fabrication of traditions. One of many examples occurs daily in Mandalay (Myanmar), where traditional "eating lunch in the morning" in the Buddhist monastery has become a big tourist attraction, gathering thousands of tourists watching and taking photos of monks eating. In order to be sustainable, the orange tourism destination must find that difficult balance between offering an authentic experience to the visitors and respecting local communities and their traditions.

It is necessary to develop creative projects in its conceptualization, with a strong dose of imagination and not subject to existing models. Proof of this is the consolidation of experiences in different stages of development, mainly in the cities we have analyzed, such as Barcelona, Gaziantep, Buenos Aires, Cartagena de Indias, Havana and Quito, as well as in tourist areas that have managed to maintain their cultural identity, such as Tossa de Mar on the Costa Brava, or initiatives related to cultural routes and itineraries, such as the Camino de Santiago.

Notes

1 Academic coordinator of the Postgraduate Course in Cultural Tourism and the Post-graduate Course in Cooperation and International Cultural Management at Universitat

de Barcelona and Associate Professor of Heritage and Cultural Tourism at the Cultural
and Heritage Management Doctorate and Postgraduate Programme at Universitat de
Barcelona
2 LABPATC – Laboratory for Heritage, Creativity and Cultural Tourism, University of Bar-
celona/IBERTUR; KulturIS

References

Buitrago, P. F., and Duque Márquez, I. (2013). *La economía naranja: una oportunidad infinita.*
Washington, DC: Banco Interamericano de Desarrollo.
Couret, C. (2012). Barcelona creative tourism. *Journal of Tourism Consumption and Practice*,
Special Issue on *Creative Tourism*, 4(2), 123–132.
López Morales, F., and Vidargas, F. (eds.). (2013). *Convenciones UNESCO: Una visión articulada
desde Iberoamérica* (300 p.). México: Instituto Nacional de Antropología e Historia.
Molina, S. (2011). *Turismo creativo: el fin de la competitividad.* Calera de Tango, Chile: Escritores.
cl.
Panosso Netto, A., and Gaeta, C. (orgs.) (2010). *Turismo de experiência.* São Paulo: SENAC.
Richards, G. (2011). Creativity and tourism: The state of the art. *Annals of Tourism Research*,
38(4), 225–1253.
Tresserras Juan, J. (2003). La tematización cultural de las ciudades como estrategia de desarrollo
a través del turismo. *en Boletín GC*, 6. Disponible en www.gestioncultural.org/ficheros/
1_1316768545_JJuan.pdf
Tresserras Juan, J. (2014). El turismo naranja, el color del turismo cultural y creativo. *en
Revista de Economía Creativa. Santiago Creativo*, 1, 51–52. Programa CORFO del Ministerio
de Economía de Chile, Santiago.

7 Cultural and creative entrepreneurs

Elisabetta Lazzaro[1]

In an era of change, increased complexity and big challenges accompanied by a contraction of public support to the cultural and creative sector, the figure of the cultural and creative entrepreneur becomes particularly relevant in the arts, culture and creative industries.[2] Furthermore, as we discuss in this chapter, cultural and creative entrepreneurs bear idiosyncrasies that can be of significant interest not only for other more general entrepreneurs but also for their overall impact on the wider economy and society.

Creative entrepreneurs are a particular type of entrepreneur. Like general entrepreneurs, creative entrepreneurs start a new business, initiative or experimentation with the aim of innovation and venture creation. Cultural and creative entrepreneurs, however, differ in a number of aspects. These include the degree of their for-profit orientation, attitudes toward uncertainty and risk, work conditions and regulation, entrepreneurial attitude, skills, type of innovation, networking, financing and business models, firm creation, growth patterns and resilience, performance assessment and overall societal impact.

Remarkably, profit making is a less inherent or less compulsory aim of creative entrepreneurs, relaxing to some extent the same definition of entrepreneurship. At least two factors would explain that. First, artists and creatives are supposed to be compensated by forms of satisfaction that are alternative or at least complementary (especially for professional creatives, that is those who make a living out of their creative work) to monetary compensation (see e.g. Frey, 2000). Second, especially arts and cultural organisations have been historically non-profit oriented and more supported by or dependent on public subsidies. However, due to the fact that public resources are less available and competition to obtain them is increasing, the cultural and creative sector needs to find new forms of financial sustainability. Notice also that newborn micro-sized start-ups in the more commercially-oriented creative industries (e.g. audiovisual, gaming and design) are similar to those of other creative entrepreneurs, but are different from large and mature organisations in the same creative industries, which are characterised by a high concentration of capital and industrial organisation of production and work.

Creative entrepreneurs are quite exposed to risk and, at the same time, they present a particularly high attitude toward risk (see e.g. Klamer, 2011). This may

be related to the forms of cultural and creative innovation, which are usually less codified than the innovation of products, services, processes and organisations in more traditional sectors. Creativity bears higher levels of uncertainty that cannot be resolved by planning alone. Possible other explanations rely on some structural idiosyncrasies of the labour market of the cultural and creative sector, such as precariousness, discontinuity and instability in job and career paths and duration, jobs fragmentation and bundling, geographical and gender concentration, flexibility, productivity, rates of unemployment, regulation, reputation, talent and specialisation (see e.g. Ellmeier, 2003). Noticeably, while at least some of these idiosyncrasies may be considered as drawbacks in traditional economics, specific exposure habits, and hence coping with them, can make creative entrepreneurs particularly resilient when facing high levels of change and complexity, as well as periods of crisis. This would be also supported by some empirical evidence of the relatively higher rate of survival and lower newborn mortality of creative entrepreneurs (see e.g. Fontainha, Lazzaro and Mossinkoff, 2016).

Creative entrepreneurship does not always correspond to a firm's legal status. Especially in the case of individual artists, it can rather imply work conditions and work attitudes such as being the worker on the project, creator of her own employment, multi-talented team leader and inventor of new structures and organisations. In this case we rather refer to an atypical form of work, somewhere in between an employee and an independent worker (see e.g. SMartBe, 2011). More generally, this corresponds to the entrepreneurial attitude of artists and creatives, a skill that is increasingly relevant for their success. Such a modus operandi can be learned by doing, although it is being integrated into curricula at higher education, as well as lower, vocational and continuous education levels (see e.g. HKU, 2010).

Creative entrepreneurs, more than other entrepreneurs, crucially rely and build on networks to start and develop their ventures (see e.g. Konrad, 2013). Networks are essential to recognise, access, exploit and develop ideas, opportunities, skilled labour, financial resources, as well as market (clients, suppliers and competitors) and business knowledge, partners and outsourcing. Specifically, creativity and innovation are not only internal processes, but can also be stimulated by audiences and markets, competitors, research and collaboration. Networks are important for coping with the micro size of firms – typical of the majority of organisations in the cultural and creative sector (see e.g. Eurostat, 2016) – and hence with limited resources, since these are usually the project of their own founders (start-ups rather than spin-offs) and with their own and their family's financial resources. Networking can reduce asymmetric information (another typical feature of the cultural and creative sector) and increase trust and reputation in many stakeholders' relations.

From a financing perspective, information asymmetries originate from absent or limited collateral, rather intangible assets and difficulty in measuring their innovation value. Hence networks can compensate for these asymmetries by providing increased credibility and trust by venture capital and banks, as well as

by the public sector, especially at early stages of creative ventures. More sophisticated private financing instruments, such as venture capital, business angels and equity, are more concentrated in more commercial creative industries. On the other hand, more recent instruments, such as crowd-funding and crowd-financing, are enriching financing opportunities for the rest of the cultural and creative sector, and are sometimes integrated into public-partnership schemes.[3]

Business models represent the principal tool through which entrepreneurs combine, plan and manage external and internal resources and ideas and assess their output and performance (see e.g. McKelvey and Heidelmann-Lassen, 2013). In this rather technical respect, compared to general entrepreneurs, a considerable number of artists and creatives still remain virtual entrepreneurs. Uncertainty and complexity cannot be completely be solved by rational planning. In this regard, design thinking can be a useful instrument for keeping a balance between intuition, experience (when available) and rationality, and exploring, co-creating and contributing to a more systemic approach. When implementing business plans, creative entrepreneurs need to balance creativity with a market perspective in organisation and management.

Noticeably, from an economic and business perspective, growth (and even internationalisation) has been considered the typical purpose of business models. However, especially in the case of creative entrepreneurs, and for the considerations made above for networks, it is worth considering the different aspects and consequences of growth, including of newborn start-ups (to allow the overcoming of this particular delicate life phase), of further mature phases of cultural and creative firms, and of the economy and society in which they operate. In particular, networks and their advantages can redimension a quite traditional firm's objective of scaling up, especially toward more mature phases of creative firms and when entry and exit barriers are low.

Creative firms' growth and, more generally, performance can be assessed through qualitative and quantitative indicators, which are more or less straightforward to use, depending on data availability and measurability. Even if statistically available, traditional economic indicators can be limited in capturing the full impact of cultural and creative entrepreneurs and other professionals and organisations in the same sector. For instance, innovation, so important in the cultural and creative sector as in the whole society, is barely captured by patents and intellectual property rights, which are more suitable for measuring innovation in high-tech sectors. On the other hand, economic impact studies are based on firms' and economic variables, such as sales, employees, funds, turnover, profitability, new-firms generation and geographical density (for clusters), or more complex indicators based on those variables. However, on a technical plan, many of these studies struggle with sufficient accuracy of the dimensions included, and the availability and compatibility of statistics (see e.g. Lazzaro and Lowies, 2014). On a more conceptual plan, a mere economic vision crucially limits the capturing of the full value that cultural and creative firms and organisations generate (or co-generate at the inter-sectoral level) in the wider economy and society, in terms of overall growth, innovation,

societal development and wellbeing, among others. Concepts such as spillovers (see e.g. Tom Fleming Consultancy, 2015) and, more recently, crossovers (Lazzaro, 2016) are being used to better equip creative professionals as well as policy-makers in generating, organising, acknowledging and fostering more comprehensive effects in and through the cultural and creative sector, including creative entrepreneurship.

Therefore, cultural and creative entrepreneurship has at least two orders of implications and related challenges beyond its own sphere, namely with respect to more general entrepreneurship and to public policy. A better understanding of cultural and creative entrepreneurship is helpful for general entrepreneurs, because creative entrepreneurs can constitute rather "extreme" cases of challenges for entrepreneurship, as well as zones of experimentation. For instance, as discussed above, creative entrepreneurs may show higher levels of resilience. Such resilience can also take on a more financial connotation, where other forms of remuneration (e.g. higher job satisfaction) compensate below-average monetary remuneration. Concepts such as clusters and stakeholders, typically related to creative entrepreneurs and the creative sector (see e.g. Bagwell, 2008), are closely related to that of a network. Clusters' advantages greatly coincide with those of networks. Clusters allow more flexibility and adaptation. They can facilitate spillovers and crossovers at intra- and inter-sectoral levels. Related open issues include how to monetise spillovers and crossovers, effectively manage and nurture these networks, contain associated coordination costs and make partnering modalities more effective. On the other hand, public policy aims at fostering the conditions (e.g. through incubators) for these more systemic effects to happen. How to effectively do so and measure the outcomes is still an open challenge. Other challenges include how to stimulate only positive spillovers (namely crossovers) and avoid negative ones, and to avoid wasteful overlapping – as opposed to complementarity – of public and private interventions.

Notes

1 Prof. Dr., HKU University of the Arts Utrecht, Department of Creative Economy.
2 Following, among others, UNESCO (2005) and, in particular, European Statistical System Network on Culture (ESSnet-Culture) (2012), we refer to the cultural and creative sector as including the arts, culture and creative industries.
3 See for instance Brandt-Grau et al. (2015) for the case of cultural heritage, and Martinez-Canas, Ruiz-Palomino and Pozo-Rubio (2012) for the music industry.

References

Bagwell, S. (2008). Creative clusters and city growth. *Creative Industries Journal*, 1(1), 31–46.
Brandt-Grau, A., Busquin, P., Clausse, G., Gustafsson, C., Kolar, J., Lazzaro, E., Mallouchou-Tufano, F., Smith, B., Spek, T., and Thurley, S. (2015). *Getting cultural heritage to work for Europe – report of the Horizon 2020 Expert Group on cultural heritage*. Brussels: European Commission.
Ellmeier, A. (2003). Cultural entrepreneurialism: On the changing relationship between the arts, culture and employment. *International Journal of Cultural Policy*, 9(1), 3–16.

European Statistical System Network on Culture (ESSnet-Culture) (2012). *Final report*. Luxembourg: European Union.

Eurostat (2016). *Cultural statistics*. Brussels: European Union.

Fontainha, E., Lazzaro, E., and Mossinkoff, M. (2016). Do cultural and creative entrepreneurs sail against the tide? *Mimeo*.

Frey, B. S. (2000). *Not just for the money: An economic theory of motivation*. Cheltenham, UK, and Northampton, MA: Edward Elgar.

HKU University of the Arts Utrecht (2010). *The entrepreneurial dimension of the cultural and creative industries*. Brussels: European Union.

Klamer, A. (2011) Cultural entrepreneurship. *The Review of Austrian Economics*, 24(2), 141–156.

Konrad, E. D. (2013). Cultural entrepreneurship: The impact of social networking on success. *Creativity and Innovation Management*, 22(3), 307–319.

Lazzaro, E. (2016). *Creative Economy*. Inaugural Lecture, HKU University of the Arts Utrecht, Utrecht.

Lazzaro, E., and Lowies, J.-J. (2014). *Le poids économique des Industries culturelles et créatives en Wallonie et à Bruxelles*. Namur: Institut wallon de l'évaluation, de la prospective et de la statistique (IWEPS).

Martinez-Canas, R., Ruiz-Palomino, P., and Pozo-Rubio, R. del (2012). Crowdfunding and social networks in the music industry: Implications for entrepreneurship. *The International Business & Economics Research Journal*, 11(13), 1471–1476.

McKelvey, M., and Heidelmann-Lassen, A. (2013). *Managing knowledge intensive entrepreneurship*. Cheltenham, UK, and Northampton, MA: Edward Elgar.

SMartBe (2011). *L'artiste un entrepreneur?* Brussels: Les Impressions Nouvelles.

Tom Fleming Creative Consultancy (2015). *Cultural and creative spillovers in Europe: Report on a preliminary evidence review*. London: Author.

UNESCO (2005). *Convention on the protection and promotion of diversity of cultural expressions*. Paris: Author.

8 It's all in the books

How libraries play a key role in
fostering creative practice and
entrepreneurship

Emmanuelle Marion

When we talk about cultural and artistic entrepreneurship, we seldom think about libraries. And yet, they have globally become key platforms for the development and dissemination of cultural and artistic practice and entrepreneurship. Typical 'third places', libraries had to re-invent themselves in the late nineties when faced with the advent of digitalization. They now hold center stage at every level of creative practice.

The third space: a natural synergy between library and creativity

Creative entrepreneurship is closely linked with notions of place. Many creative entrepreneurs deal with product and therefore need fit-for-purpose spaces, and many creative endeavours are closely linked to local specificities. The quest for adequate spaces has been a long-standing one, and is still ongoing, especially in countries where urban developments are rigidly pre-defined: housing, commercial units, office space, etc.

It is therefore not surprising that Ray Oldenburg's concept of 'third place'[1] got such purchase in creative circles. As post-eighties capitalism spread out, creatives had in Oldenburg's posit a legitimate basis to develop the flexible, cross-discipline spaces they needed. After a decade of trialling and pioneering, the noughties saw the hatching of more established Hubs, Labs and Third Spaces.

Another key element of that creative revival was the realisation that creative activities are intrinsically linked with a social element, a social capital as defined by Robert Putnam in his book *Bowling Alone*.[2] In this context, social capital refers to the "wide variety of quite specific benefits that flow from the trust, reciprocity, information, and cooperation associated with social networks",[3] of which creative hubs is one. Creative entrepreneurship was gaining legitimacy and culture was becoming widely acknowledged as the fourth pillar of sustainability.

Interestingly, what is still little written about is the role that libraries were going to take in this coming age of creative entrepreneurship. If Oldenburg

does not mention libraries, Putnam takes the Chicago State Library as a key Third Space, a vector for change.

> The perception of the library – all kinds of library – as 'place' is an historic, enduring, and resilient one. Popular libraries have come to accord with Oldenburg's concept of the 'third place' – a place distinct from the other two main 'sites' of human existence, namely work and home. They have strengthened their traditional role as 'hangout' institution, alongside other such neutral and levelling institutions as the coffee shop, bookstore, and community center; and this has been reflected in a flood of exciting new designs. Spectacular new libraries have helped rejuvenate the downtown areas of major cities, from Seattle and Vancouver in North America, to Amsterdam and Vienna in Europe, and Shanghai in China.[4]

Less than a decade after Oldenburg's publication, faced with the advent of digitalization, libraries had to re-invent themselves – become creative entrepreneurs in their own right: shifting paradigms and embracing the Third Space as their new *raison d'être*. Although borne out of distinct needs, creative entrepreneurs and libraries were about to cross paths and to become one of the most successful cultural synergies globally.

> Those hybrid spaces can be defined as living spaces; they offer new approaches to culture, test new formulas (ground-breaking programming, pooling of cultural infrastructures and/or services . . .), and go beyond the perimeter traditionally imparted to the library, they morph into community-based cultural centres.[5]

One of the prime concerns of libraries has become "first and foremost to bring the user to culture thanks to varied, attractive and novel ways".[6]

Creating new platforms for creativity: from practice to entrepreneurship

So how are those novel ways impacting creative entrepreneurship? First, by providing new tools to foster creativity and entrepreneurship; second by providing for a whole new network of showcasing platforms. Idea Stores, Discovery Centres, DOK (Library Concept Center), Belevnisbibliotheek (experience library), this new generation of libraries has shown clairvoyance and leadership in developing some ground-breaking concepts to foster creativity in individuals, as much as taking creative entrepreneurship to the next stage, thanks to artists and creatives-led workshops, fab labs, makerspaces and other incubators.

> To date, much attention has been paid to the makerspaces as an integral part of creative activity in public libraries. To describe them simply, makerspaces

are community centres with tools and materials that allow for creative practice of a variety of purposes to occur. Examples of creative practices in maker spaces include those concerned with arts and crafts, building, computing, engineering, carpentry and design.[7]

If Fab Labs and Makerspaces are means to foster everyone's creativity, it is only the basis of the creative pyramid developed by libraries. Callouts for creative practitioners to ensure quality and creativity of programming – both at workshop and performance levels – is common practice. If writers led the way with creative workshops, it naturally expanded towards illustration and graphic design; the book-object inspired recycling workshops, starting a long series of hacking prototypes that opened the door to coding and other bottom-of-the-pyramid tech hacks. Work had to be exhibited for appraisal, developing in parallel best practice in community art and showcasing best practice in contemporary art.

Meanwhile, the performed word opened the door to performances in general. While some very successful contemporary dance programmes were run in French libraries, in countries like Ireland, where the spoken word is tightly woven with music, the step to showcasing musicians was an easy one. Yes, but not enough. Indeed, with the deepening of the engagement with other art forms, librarians started identifying the missing needs of the artists and creative entrepreneurs themselves.

Some libraries like Vancouver and Dublin decided to opt for the creation of recording studios and techie outlets, while others (like the Tablelands regional libraries in Australia), reached the ultimate step, the implementation of very successful creative start-up programmes.

Finally, pioneering libraries are now developing the 'Fourth Space', setting trends in the digital and technological realms. Libraries create "experimental learning opportunities for the community in a public library environment. This involves a creative technology approach that will provide not only games and

Table 8.1 Examples of best practice

Name	Idea Stores London (UK)	Their ethos
Created	2002 in Bow Street	Learning and skills – increasing opportunities for learners to progress and achieve their creativity and unlock their potential
Particularity	4 franchises opened: Idea Store Chrisp Street (2004) Idea Store Whitechapel (2005) Idea Store Canary Wharf (2006) Idea Store Watney Market (2013)	Co-locate cultural, leisure and other council services where this will increase efficiency, effectiveness and value for money
Website:	www.ideastore.co.uk/	

Name	Dublin City Library (Ireland)	Their ethos
To Be Opened	2020	It will inspire and excite, welcome and include with collections, connections, places, services and programmes for learners, readers, researchers, children and families, all citizens. It will be a place to learn, create and participate.
Particularity	Will house – a Digital Library – a Music Hub – an Innovation Hub – a Storyhouse	
Website:	http://parnellsquare.ie/about-the-project/city-library-services/	

Name	Dokk 1, Aarhus (Denmark)	Their ethos
Created	2015	Which societal problem does your library answer? To solve which problem was it built? Dokk1 is a meeting place, a cultural centre, a learning space.
Particularity	A holistic, sustainable project, the most pioneering to date. Interactive installations such as CultureWok	
Website:	https://dokk1.dk/english	

Name	Vancouver Public Library (Canada)	Their ethos
Created	1995-2013	New, re-energized and expanded community spaces – including dynamic collaboration zones and high-tech creation spaces. A bold new way of delivering service. Dramatically enhanced opportunities to connect, learn, collaborate, create and contribute – all in places where no one has to pay a fee to enter, sit down, or join.
Particularity	Hosts – Creation Stations – Digitization Stations – Recording Studios	
Website:	www.vpl.ca/	

Name	Libraries of Tablelands (Australia)	Their ethos
Created	New structures from 1988	A program specifically tailored for independent artists and creative entrepreneurs. The program will deliver a series of innovative seminars by successful entrepreneurs and will provide participants with information, essential skills and access to new, online multimedia and print learning materials
Particularity	Creative Start-ups Incubator	
Website:	www.slq.qld.gov.au/visit-us/find-a-public-library/services/tablelands	

(Continued)

Table 8.1 (Continued)

Name	Dun Laoghaire Library (Ireland)	Their ethos
Created	2014	The establishment of the LexiconLab and the appointment of the first creative technology curator has ensured access to equipment for people of all ages. Families engage with age-appropriate technologies and interactive learning tools. The lab provides learning opportunities for 3D design and printing technology.
Particularity	Hosts: – Performance and screening space – Contemporary art gallery – Makers workshops – Digital & Tech Lab	
Website:	http://libraries.dlrcoco.ie/	

Name	Culturethèque (France)	Their ethos
Created	2013	To reinforce dialogue with world cultures, to foster dialogue and accompany partnerships throughout the world.
Particularity	Free digital portal to a large number of digital libraries and online resources, including 1D, the only ethical online platform to showcase and reward independent musicians.	
Website:	www.culturetheque.com/	

Name	BiblioRemix (France)	Their ethos
Created	2013	It is a tool for participative experimentation, invention and creation, based around library services. In a constantly evolving social, cultural and technological environment, how can we invent tomorrow's public library, its realm, its outreach mechanisms, its modalities of action, its offerings?
Particularity	A travelling 'space' moving from library to library, as well as freely duplicable under creative commons principles.	
Website:	https://biblioremix.wordpress.com/	

rapid prototyping but also personalised tech programmes for teens and the wider community."[8] Other libraries pioneer innovative digital resources centres, with for example the library service of the Institut français (the French cultural network abroad) having developed Culturethèque, a digital portal to many online libraries including 1D, the first ethical online platform to showcase and reward independent musicians. "Those organizations, primarily built on the needs of their users, do foster within their walls an actual process of cultural democratisation, process that is vetted by their outstandingly high numbers of visitors."[9]

Notes

1 Oldenburg, R. (1999). *The great good place*. New York: Marlow and Co.; Oldenburg, R. (2001). *Celebrating the third place: Inspiring stories about the 'great good places' at the heart of our communities*. New York: Marlow and Co.
2 Putnam, Robert D. (2001). *Bowling alone: The collapse and revival of American community*. New York: Touchstone Books by Simon & Schuster.
3 Website for *Bowling alone: The collapse and revival of American community*, by R. D. Putnam. Available from: http://bowlingalone.com/
4 *Library Trends*, 60(1), 2011 ("Library design: From past to present," edited by A. Black and N. Dahlkild), 1–10. © 2011 The Board of Trustees, University of Illinois.
5 Servet, M. (2010). Les bibliothèques troisième lieu. *Bulletin des bibliothèques de France (BBF)*, 4, 57–63.
6 Ibid.
7 The Impact of Libraries as Creative Spaces, State Library of Queensland, Queensland Government, 2016
8 Dún Laoghaire-Rathdown Library. (2016). Development plan: 2016–2020, p. 12. Available from: http://libraries.dlrcoco.ie/sites/default/files/files/using-your-library/Library%20Development%20Plan%20English%20version%20Final.pdf
9 Servet (2010).

Resources

Bib Doc. Cultiver un esprit d'ouverture dans les bibliothèques de lecture publique, pourquoi, comment? www.bibdoc.fr/index.php/session-2014.html
Bib Doc. La bibliothèque augmentée: regards croisés sur la co-construction des saviors www.bibdoc.fr/index.php/session-2015.html5
Biblio Remix. CDI Remix: Et si on ré-inventait le CDI ensemble? https://biblioremix.wordpress.com/
Bibliothèques Sans Frontières/Libraries Without Borders. Ideas Box Section. www.bibliosansfrontieres.org/fr/activites/
Dún Laoghaire-RathDown Library. Development plan 2016–2020. http://libraries.dlrcoco.ie/sites/default/files/files/using-your-library/Library%20Development%20Plan%20English%20version%20Final.pdf
École Nationale Supérieure des Sciences de l'Information et des Bibliothèques. Fab Lab en bibliothèque: Un nouveau pas vers la refondation du rapport à l'usager? http://bbf.enssib.fr/matieres-a-penser/fab-lab-en-bibliotheque_66269
École Nationale Supérieure des Sciences de l'Information et des Bibliothèques. La bibliothèque: pourquoi un (troisième) lieu à l'heure de la dématérialisation? www.enssib.fr/recherche/enssiblab/les-billets-denssiblab/bibliotheque-3eme-lieu-amandine-jacquet-abf
École Nationale Supérieure des Sciences de l'Information et des Bibliothèques. Les bibliothèques troisième lieu: Une nouvelle génération d'établissements culturels. http://bbf.enssib.fr/consulter/bbf-2010-04-0057-001
École Nationale Supérieure des Sciences de l'Information et des Bibliothèques. Les idea Stores: Une nouvelle approche de la bibliothèque et de l'accès à la connaissance. http://bbf.enssib.fr/consulter/bbf-2008-01-0069-013
École Nationale Supérieure des Sciences de l'Information et des Bibliothèques. L'innovation en bibliothèque ou comment dépasser la reproductibilité. www.enssib.fr/content/linnovation-en-bibliotheque-ou-comment-depasser-la-reproductibilite
Fab Lab London. www.fablablondon.org/
Idea Store. Idea Store Strategy Document 2009. www.ideastore.co.uk/assets/documents/IdeaStoreStrategyAppx1CAB290709(1).pdf

Illinois Digital Environment for Access to Learning and Scolarship. Library Trends 2011. www.ideals.illinois.edu/bitstream/handle/2142/31859/60.1.black01.pdf?sequence=2

Idea Store. A Library and Lifelong Learning Development Strategy for Tower Hamlets. www.ideastore.co.uk/assets/documents/misc/A_Library_and_Lifelong_Learning_Development_Strategy_for_Tower_Hamlets(1).pdf

Lab Fab France. Charte des Fablabs. http://www.labfab.fr/charte-fablab/

La Coursive Boutaric. les Rencontres de l'entrepreneuriat culturel et créatif 2016. www.la-coursive.fr/rencontres-pros

Languedoc-Roussillon Livre et Lectures. Rencontres du 3ème lieu : des bibliothèques qui bougent en Europe. www.lr2l.fr/rencontres-du-3eme-lieu-des-bibliotheques-qui-bougent-en-europe.html

Library Buildings & Equipment. What comes after the "Third Place"? Visionary libraries – spaces and users. www.ifla.org/library-buildings-and-equipment/conferences-seminars

Model Programme for Public Libraries Denmark. Thematic Cases. http://modelprogrammer.slks.dk/en/cases/thematic-cases/

Public Libraries Connect. The Impact of Libraries as Creative Spaces. http://plconnect.slq.qld.gov.au/__data/assets/pdf_file/0003/339717/SLQ-Creative-Spaces-Low-Res.pdf

Utne Reader. Make the Public Library Your Creative Space: Turn the public library into your creative space by making use of their resources. www.utne.com/community/public-library-creative-space-ze0z1406zcalt?pageid=1#PageContent1

9 Smart libraries make smart communities make smart cities

Liz McGettigan

What a time of opportunity for libraries and librarians! We can seize the opportunity to underpin the "Smart City" agenda, but to do this we must find our voice!

It is no mean feat to try to explore the major challenges facing libraries today.

- How do we influence policyholders and paymasters on our impact and potential?
- How do we replicate the public's trust in us in a digital world?
- How do we compete with Google?

In the digital age, libraries are transforming and maximising community connections and expertise alongside new technologies to promote citizenship, new world skills, entrepreneurship and business development.

We must think about citizens and library users in a new way, as mobile and digitally accessible, yet unique and focused on receiving the service that they want whenever they want it. Technology affords citizens and librarians the opportunity to build a new relationship.

Clearly, change is mandatory, but survival is optional.

The library and cultural services are no exceptions to the fact that when consumers are exposed to fantastic customer experiences or faster ways to do something online, they are quick to apply their newly-raised expectations to every other brand or industry. We're changing so fast as human beings, in the ways we communicate, learn and interact. We're getting more demanding in an expectation economy that is customer-led and data-driven; disruption and innovation have ceased to be "nice to have" or "some other person's role".

I remember when the library's business model was based on the fact that books were scarce and information was hard to find. The public library's role was then to equalise access to the knowledge and skills required for Joe Public to learn, thrive and succeed, and the only means to do that was through books.

Fast forward to now, and that currency moved from books to equalising access to the internet and online information. UK Libraries put in The People's Network, providing internet access and learning across the UK. (Incidentally – this

was the first and only UK ICT project brought in on time and within budget, and all staff were trained to ECDL level.)

Fast forward again and now the job is creating "experiences", equalising access and skills around the new and fast-developing technologies from 3D printing, robotics, coding and circuit making to self-publishing and augmented reality. It's about creating virtual reality experiences that enable ordinary people to see and experience the Taj Mahal or Moscow's works of art from a library in Glasgow or anywhere else.

Learning has changed. Social media means that we can all now contribute to and learn from each other very quickly. Expectations of our physical spaces and digital services have changed too. However, many people still have stereotypical images of us and what we do, and that must change. As we find our voice we need to change our attitude and get comfortable with words that can make some librarians uncomfortable – e.g. business, income, customers, advertising, promotion, and ROI. Accepting these terms and embracing them can revolutionize the culture and expand the reach of your library.

We are very poor at promotion and marketing – library services almost always offer much more than people understand. We need to voice what we do! We know the role is about merging physical and digital excellence, technology and learning but also the creation of innovative employment, social enterprise and regeneration spaces. Spaces for opportunity to thrive, opportunities for people to shape and influence their community, to co-design and co-produce. Not only are libraries places where we can start learning about new technologies, but they are also spaces where creativity, collaboration, and play can thrive.

These services, while beyond traditional function, have now become an integral part of many libraries and yet have developed without any additional finance and staffing resources. A reasonable option for meeting such needs both comprehensively and efficiently must now be reconsidered in the digital world, and there is therefore the need for an exciting new view of the library service. Rather than focus on asset management and cost savings, we should instead focus on identifying the "must do" services and those services that are currently provided but which should be dropped or become chargeable. We should also focus on innovative asset development and alternatives and on income generation. We need to rethink our funding – philanthropy, appropriate sponsorship, crowdsourcing?

Future libraries will need to incorporate new designs, philosophies, technologies, spaces, and practices to provide the services people want. Many public libraries have responded well, but many will find it too challenging to shape their future and redesign their relevant "next" library – the 21st-century people's library. Many libraries have learned from this (although many haven't!) and now we know that the library of the future is a very exciting and visually stimulating place; it uses display and interactive technology to expose content and resources that we were once completely unaware of (Figure 9.1).

In the future, library customers will be able to self-issue items within the library using the Library App. Where a Library Service has no security in place,

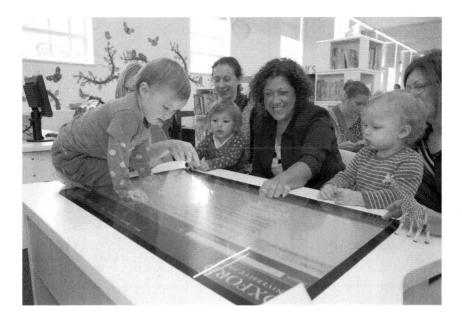

Figure 9.1 Interactive table

library customers will be able to scan the library barcode to issue the item to themselves.

An entrepreneurial approach to developing new paid-for products, services and spaces will improve audiences and impact on trends in library usage, appealing to new audiences.

The digital library experience of the future lets you do it all from your mobile at home, on the bus, or on the train 24/7. It lets you pay bills and fines or buy that old map facsimile you fancied. It will let you rent a library space or meeting room and actively encourages income generation.

If you can't afford an expensive education at a college or university, then only in the library of the future – the Streetcorner University for the common person – will you learn about and experience 3D printing, coding, augmented reality and virtual reality. Who else will nurture your community's creativity and innovation?

Collections in bays of books are brought to life by giant displays at the end of the bays – so read the hardback or paperback, download the e-book or buy the book.

It's a place much loved by all ages because they can do so much there. They can read, add content, publish that amazing novel to the national digital platform or actually get involved and teach a creative writing class there. Kids are making, reading, learning code or having a homework club class.

It also looks so coooooooool!

Figure 9.2 The SOLUS mobile Cre8 Digital Space

The library of the future is your meeting place, your learning space, your 24/7 trusted and assured information resource (Figure 9.2).

Library services across the world must come to grips with new technologies. The big facilitator in all of this will be "the platform". We must own a new, trusted global platform; indeed, we should have had this 10 years ago! To get there, it will require the development of technological and social platforms, the existence of a central core of workers and skilled individuals connected to that platform who can provide services to library customers worldwide.

The library of the future contributes to and enables your access to a national digital platform with access to a wonderful world of unique content and resources once kept quiet and hidden. The cultural experience of the future functions as beautifully as an Apple store, makes recommendations like Amazon, speaks in hashtags, loves Tumblr and is ready for its selfie.

Figure 9.2 (Continued)

The library of the future knows exactly where you are and maybe even what you want. Tiny Bluetooth beacons positioned strategically around the library and outside send a push notification to your phone urging a visit to the author event it thinks you'll like or to the book by the author you enjoyed.

The library experience of the future sees you enjoying your glass of wine, beer or lovely meal in the rooftop restaurant.

The library of the future will be one of the very few free, public spaces that you and your community can nurture, design, build around and own. The library of the future will be one of the very few free, public spaces where you and your community become Smart citizens and Smart communities.

Conclusion

Smart libraries build smart communities and smart cities! Enterprising activity and income generation could support the diversification and evolution of

services far beyond the current definition of library services. We now have a huge opportunity as the internet proliferates to provide cost-effective, rich and trustworthy digital solutions for our library services. It is a very special opportunity, because we value privacy and refuse to exploit users' private data. Now is the time replicate the "physical" access, value and trust we have in libraries in excellence in the digital world. If libraries are to evolve rapidly enough to meet that challenge, they will have to make radical changes to their digital offerings, changes that will at the same time revitalise physical visits and non-users' perceptions of relevance. In addition to developing many of these innovative models, there are potential efficiencies of scale by delivering and extending regionally and perhaps nationally.

If libraries are to thrive in this new world they must play an active role in shaping their future and redesigning the relevant, experience-based "next" Library – the 21st-century people library. Public libraries in the 21st century must become learning and digital hubs – one-stop destinations to test drive and learn about the latest technology, equalising access and skills around the new and fast-developing technologies from coding, circuit making and self-publishing to augmented reality. They should be experiential, entrepreneurial, experimental spaces where access to technology enhances opportunities to learn, work and create.

The public library has a voice! A loud one!

10 The economic (and other) benefits of losing

James E. Doyle

The founder of the Olympics, Baron Pierre de Coubertin, said, "The most important thing – is not winning but taking part." In practice most people seem to think otherwise, to win is everything, even to come second is for many to leave with nothing. Of course in life this is false and in the cultural field it is double false, from dance to dialectics, from gastronomy to Glastonbury, in culture it's the taking part that matters perhaps more than the success. Culture is, and always has been about the experience, but that's not to say it can't be competitive and there are losers. So what's it like to lose in the competitive world of culture? What is to be gained from failure? In terms of economic benefit the European Capital of Culture (ECoC) is one of the most financially rewarding competitions for any city to win. "The total operating expenditure reported by all European Capitals of Culture is €737 million and the total capital expenditure €1.4 billion, making total expenditure over €2 billion."[1]

Which begs the question, what's it like to lose? What's it like not even to be shortlisted? What's it like to come last? Dublin had exactly this experience in 2016. After three years of preparation, it came in last place in the competition, fourth in a pack of four runners, knocked out in the first round of the European Capital of Culture bid 2020, a tough reality check for Ireland's biggest and capital city. You might easily think that Dublin had nothing to do but walk away, but we will now look at how embedding the bid for the European Capital of Culture in the overall plans and strategies for the city of Dublin and some long-term thinking led Dublin to reap significant economic and other benefits, regardless of the loss. This example will hopefully show you how your solid preparations and planning for all areas of the cultural economy can ensure that you will have a level of success regardless of the outcomes. It will show you how the cultural sector leaves winners when it creates losers and how Dublin's failure resulted in Dublin's success.

As the coordinator for the start-up of Dublin's bid for the European Capital of Culture 2020, I was lucky enough to be in on the ground floor, although I chose not to be part of the bid team. Prior to this I has had been part of the core team that brought Dublin to a place where it could consider bidding for the European Capital of Culture 2020. How we got there is the single most important factor in showing you how you can ensure your own long-term

success. The story began in 2012 with the publication of the Dublin City Coun-cil's Arts Plan for 2014–2018. The Arts Plan is the work plan for the Arts Office, a section of and guided by the Culture, Recreation and Economic Services, Dublin City Council, and based in the Lab; a bespoke arts centre in Dublin 1. This plan was a new departure in the development of strategic and sustainable cultural planning for the city. For the first time the city noted broader cultural actions within its Arts Plan and laid out a vision, in broad strokes, as the basis for actions, rather than detailing the actions themselves. It is this vision that has since taken the project far beyond its initial ambitions. However, we are getting slightly ahead of the timeline, and it's important to look at the context under which this work took place. Dublin's unique position as Ireland's capital city and the largest local authority in Ireland is complex. Dublin experienced the economic highs of the Celtic Tiger and the lows of the global downturn. How-ever, its central role in the Irish economy made it slightly more resilient to these effects and the first to feel the benefits of the recovery. Ireland's GDP is ranked as the highest in the Euro area (in 2015). Major social change has also taken place, typified by Ireland becoming the first country to approve same-sex mar-riage by popular vote. Dublin also has a unique position as home for many of the national governmental departments, national and international businesses, and most of the national cultural institutions, servicing sports, language, the arts and communities. Dublin's central socio-economic position enabled the Dub-lin City Council and the Arts Office to play a significant role in the creation of regional and national policies for sustainable cultural development. At the time of writing this potential had yet to be fully realised; however, in recent days the CEO of the Dublin City Council has contacted all the cities still bidding for ECoC 2020 and is offering a strategic partnership with Dublin for their bid and co-programming if selected. Galway City Council has approached Dublin to form a strategic cultural partnership whether or not it is successful in securing the designation, and in addition the Dublin City Arts Officer has been asked by the Department of Arts at the national level to chair the collaborative strat-egy of the competing cities. This is clear evidence that the role of Dublin City Council's Cultural Department as a capital city encompassing local national and international actions is expanding as a direct result of strategic planning. Dublin City Council has an overarching Development Plan for the city. This contains all the city council's agreed objectives, priorities and policies for the coming years. The plan was adopted by Dublin City Council at a Special Council meet-ing on 23rd September 2016. The process for the creation of the plan includes internal departmental and public consultation with citizens, communities and organisations. The plan also complies with national and regional strategies and includes the high-level goals of the Economic and Community Plan. The draft Development Plan states that it is an objective of Dublin City Council "to facilitate the growth and continued development of cultural life in the city by supporting the implementation of Dublin City Council's Cultural Strategy". Local cultural policies are formulated in a number of ways: as actions aris-ing from legislation; from the request of the elected representatives of the city

council; as a response to a strategic goal of the city council's development plan; on instruction from the Culture, Recreation and Economic Services; or from a section within a city council department, which is recommending a specific course of action. Examples include policies on cultural heritage and conservation, promoting the designation of Dublin as a UNESCO City of Literature, supporting the national cultural institutions, and facilitating the provision of fit-for-purpose, sustainable cultural infrastructure. In terms of cultural policy the weakness was in the lack of interconnectivity to other areas and policies of the Development Plan; specifically, more could be done to connect culture to the sections on the economy, development and regeneration, land use and zoning amongst others. Much of the plan is focused on infrastructure, which in some ways dilutes the impact and potential of a more sustainable approach to city planning. For example, roughly 65% of the section on Culture and Heritage is heritage based and forms the entire first 10 pages of this section. While of significant benefit to developers and planners, this weighting is disproportionate in terms of the potential of a fully integrated cultural plan for the city. It is anticipated that the incorporation of new recommendations in the plan, such as the greater consideration of the issue of sustainability in cultural provision for new developments, will ensure that Dublin City Council is more able to more fully address these issues. The city council has a Corporate Plan with objectives, priorities and actions which informs the Culture, Recreation and Economic Services Business Plan and subsequently the Arts Plan. Each of these plans has business unit actions, milestones, KPI measurements including outcomes and dependencies, such as resources and partnerships, and progress measurements; the usual statistics; and a risk register for all actions. The KPIs are classified as "definitive" and are usually specific actions arising, programmes delivered, and percentage of programmes completed. The results obtained have been detailed in earlier sections.

Given this context we need now to look at where the plan came from. The Arts Plan was authored by City Arts Officer Ray Yeates and co-signed by Executive Manager Brendan Kenny. It was written to replace the previous Arts Plan with the aim that "the Arts Plan will articulate the values, strategy and actions of Dublin City Council in developing, promoting and maintaining the arts as a fundamental part of city life". The need to increase ownership of the Arts Plan by a wider community of citizens was highlighted early on as the largest gap between the plan and the citizens. In 2012 Green Hat, a community-based consultancy, was contracted to undertake a widespread consultation process with key stakeholders and the general public. Around 60,000 people were engaged through this process and given the opportunity to contribute. Consultees came from across the arts, culture, community, voluntary, education, local authority, sports and other sectors. The outcome of the consultation was an independent report acknowledging the richness and diversity of arts and cultural activities currently experienced in Dublin and the highlighting of future priorities for the Arts Plan. The connection to wider cultural planning was clear from the outset (2012), and the Arts Office stated that it had

"commissioned the consultation to inform the development of a new Arts Plan which in turn will feed into the Cultural Strategy for the City". In terms of coherence, the priorities and process used for Arts Plan were transferred in the preparations for the Cultural Strategy, also authored by Ray Yeates. In addition, the Cultural Strategy is referenced in the Development Plan. The Arts Office also provided contributions and facilitated the wider arts sector in contributing to the plan. In this way the Arts Plan informed the Cultural Strategy, and both the Arts Plan and the Cultural Strategy are informing the Development Plan. A specific example of these actions can be mapped out by noting that one of the priorities arising from the 2012 consultation was "local delivery and infra-structure", which appears again in the Arts Plan under the priority "Developing the Arts in Local Areas", in the Cultural Strategy as "Establish a sub-committee within each City Council Area to develop a cultural infrastructure programme" and finally in the Draft Development Plan as "It is the policy of Dublin City Council to ensure that all Local Area Plans and other spatial plans incorporate relevant priorities and actions of Dublin City Council's Cultural Strategy."

From the beginning the Arts Plan has paralleled the intent and priorities of Agenda 21 for Culture. In particular the accord between UCGL and UNE-SCO was complimented in 2015, when Dublin City Council (DCC) adopted the UNESCO definition of culture. Namely in its Cultural Strategy arising from the Arts Plan, the city council affirmed that culture is "The set of distinc-tive spiritual, material, intellectual and emotional features of society or a social group, that encompasses, not only art and literature, but lifestyles, ways of living together, value systems, traditions and beliefs."[2] In the same document, DCC also adopted the UNESCO Cultural Rights of the Child Charter and with particular reference to this strategy, Article 31. These significant milestones had their genesis in the Arts Plan which stated in 2014 that it "acknowledged the change driven by major technological advances, by demographic shift and by new forms of social participation and cultural expression" and that "The City Arts Office believes that everyone has a right to access the arts, physically and intellectually, throughout their life." While both the Arts Plan and the Cultural Strategy have noted the importance of heritage, creativity, the environment, equality and social inclusion, the two strongest themes are heritage, which takes a significant position inside the Development Plan for the city, and education, which is one of the strongest stands of work to come out of the Arts Plan. The priority for education and learning is seen as interconnected with rights from which stem both knowledge and access to information. DCC understand these tenets as core to the implementation of the policies and actions of Agenda 21 for Culture. The Arts Plan at its outset stated that

> in recognition of our belief that everyone has a right to access and engage with the arts throughout their life, and as illustration of our arts develop-ment function, the City Arts Office will devise an overarching education and learning policy statement that presents all actions of the City Arts Office as having an educational/learning orientation.[3]

It is further anticipated that this recognition will soon be ratified by the adoption of a new Education and Learning Policy for the city.

The main aim in creating the Arts Plan was to increase ownership and in so doing, to more closely connect the work of the Arts Office to a wider public. The wide-ranging consultation process was key to this aim, and what was heard during this process enabled the city to define the role, future goals, priorities and actions of the Arts Office and the Cultural Strategy. This process has enabled the city to maintain and highlight the interconnected relationship between the citizen, the arts and culture.

The main goals/priorities of the Arts Plan were:

- To ensure quality arts experiences extend to all city areas;
- Maintain, develop and grow short-, medium- and long-term partnerships, provided that they add value, grow new resources and are opportunities for learning and shared experience;
- Ensure all actions of the Arts Office have within them opportunities for education and learning;
- Support artists in the delivery of quality arts experience that contribute to Dublin's cultural life and its reputation as a modern vibrant city rich in art and heritage;
- To significantly increase resources to fulfil the vision of the Arts Plan in line with priorities for the next three years; and
- Ensure the Arts Office advocates for the essential value of the Arts at every opportunity in the City of Dublin.

Main actions carried out to date and results:

- The legacy of Dublin's failure to be shortlisted for ECoC 2020 led to a new Cultural Strategy and four million euros in new funding allocation for culture.
- The Public Art Programme, Policies and Strategies for Managing Public Art, Policy for Decommissioning of Public Art, Commemorative Naming of Infrastructure and the Provision of Monuments, Memorials and Plaques policy – Policy Adopted.
- Equitable Payment of Artists Policy – Policy Adopted.
- Arts, Education and Learning Policy Statement – Draft Policy Issued.
- Support for cultural quarters projects – rejuvenating Parnell Square, Temple Bar, Dublin 1 and Monto in pursuit of cultural participation and renewal – Projects underway.
- The Masters in Art and Research Collaboration (ARC), Institute of Art, and Design and Technology (IADT) – Ongoing.
- The Vacant Spaces Scheme – Toolkit and website published, scheme in review.
- Free Local Arts Festival Training Sessions+ Toolkit – Annual training available.

- Provision Drama in Schools Toolkit – Published.
- Review Arts Grants funding (€500k+) with a focus on increasing allocation of funding to neighbourhoods projects – Review completed, grants services to be fully digitalised by 2017.
- Review of Artist Residential Studios leading to the creation of three new spaces focused on financially sustainable models with significant increased capacity – Completed.
- External Reviews: The Lab Arts Gallery – arts venue, visual art gallery space and resource centre for the city's arts practitioners; the Arts Office services; Dublin Chinese New Year Festival, re-launched with a new board 2015 – Others in process.
- Music Town – a new annual festival, celebrating all of Dublin's music, comprising over 50 musical events for all ages and all tastes – Festival launched 2015.
- Project 20/20 – an arts in education project, an action-research project focusing on visual literacy – Programme ongoing.
- Review and development of festivals including The International Literary Festival Dublin, Opera in the Open, Dublin Culture Night and the Chinese New Year Festival Dublin.

Phases of the arts plan

The Arts Plan is now moving through the third year of execution, although in real terms the concept work was undertaken as far back as 2012. Performance and control are now the core phases in operation, and project closure is three years away. It is important to note that the Arts Plan was built for growth and flexibility, and in that context many changes are taking and will take place. For example, the legacy of the bid for ECoC 2020 is significant and, as with the possibility of a European Funding Unit, not yet fully realised. Some areas, such as partnerships, have grown significantly and others, such as the Bealtaine Arts Festival for older people and the Opera in the Open, are subject to close review. In this way, the Arts Plan does not conform to a traditional phased project, it was and is a launch pad, redefining its goals and executing new initiatives as the plan begins to pollinate the city.

Obstacles

Many of the obstacles that the plan encountered were anticipated, including the need to increase resources and train new personnel, particularly in the recruitment of staff for Dublin 2020, the failure to be shortlisted for ECoC 2020, the demands of a decade of commemorations including the National 2016 Commemorations, increased delivery with smaller budgets and the parallel need to increase resources, and brokering changes with revenue organisations through the grants process review. Some were less so, such as working towards the plan while at the same time undertaking independent reviews of LAB gallery and the

Arts Office, maintaining autonomy and sharing concept and responsibility in new partnerships, the changing context of a resurgent economy and the critical loss of artist studios in the city, preparing the resources required for new city-wide projects including the Cultural Audits and the strategic repositioning of the Arts Office, delivering the service during a time of rapid innovation and a need to digitalise service. Other obstacles that require more management and negotiation include disengaging with projects which have a history in the city but do not fit into the Arts Plan or are ineffective in terms of resource allocation and outcome.

Results

The growth of all types of partnerships in the Arts Plan running in tandem with new policy actions display a unity in planning and policy that is continuing to grow. The direct and indirect effects of the plan on the Cultural Strategy and the City Development Plan have changed the way that the arts and culture are understood across the city by artist, professional and citizen. As noted above, the Arts Plan has achieved more than was set out in 2014. As important will be a growing a focus on sustainable cultural development, sharing of knowledge and a greater focus on European programmes, all of which will enable the city to strengthen the local implementation of Agenda 21 for Culture.

Collaboration

The Arts Plan, its collaboration between the city council and the citizens, and the consultation process would be the core mechanism for the creation of the plan. Collaborations also focus on delivery and include

- Linking the national cultural institutions with area offices and local cultural organisations, including the National Concert Hall, National Gallery, National Library, National Museum of Ireland, Irish Museum of Modern Art and Chester Beatty Library;
- Strategic relationships with the Department of Arts Heritage and Culture, Failte Ireland (tourism) Board and Docklands SDZ;
- "Young Dublin" – Young Artists and Young Arts Audiences – Partnership with Axis Arts Centre, the National Association for Youth Drama (NAYD) and City of Dublin Youth Services Board;
- "Dublin 1" – Partnership with cultural institutions in the Dublin 1 area.

All projects are in stage 1 – first to second year. The Arts Office is primarily the originator and broker in these partnerships, with roles for others including specific fields: heritage, tourism, language, curation, production and programming. The main difficulties are brokering the partnership, maintaining an open agenda, maintaining shared ownership of concept and defining responsibility for programme and programme delivery.

While the Arts Plan was not developed in direct collaboration with other levels of government, a range of local government acts and guidelines identify the responsibilities that local authorities have in serving the public. Article 3 of The Irish Arts Act, 2003, requires that a local authority stimulates public interest and promotes knowledge, appreciation and good practice in the arts. Also, the Arts Plan is informed by the priorities of the Arts Council and the Department of Arts, Heritage and the Gaeltacht. An example of this is the promotion of the Irish language, including the statutory requirement for reproduction of the plan in the Irish language and an emphasis towards projects that have connectivity to both the Irish language and Irish traditional culture.

As noted above, public participation in the consultation process for the Arts Plan was a primary motivator in its creation, and the findings of the independent report from Green Hat are in many cases directly transferred into the Arts Plan. In this way, the citizens are designers and beneficiaries. However, it should be noted that limited resources and competing priorities did affect the final plan, and the city council had to look to where its resources could be most effective. The clarity that arose from this was extremely helpful in that there was a general expectation that the Arts Office should, through the plan, display leadership, taking up a more strategic position in the city. This led directly to the adoption of a set of roles for the Arts Office: advisor, curator and producer, partner, asset developer and manager, evaluator, broker and advocate, and in this sense the Arts Office was also a clear beneficiary. The Arts Plan was designed to be reactive to context and flexible enough to adapt and review its progress. The Arts Office, and by inference the Arts Plan, is currently being evaluated by a panel of external experts. In tandem with this, the Arts Office is conducting quarterly reviews of the plan, evaluating progress and, as part of the implementation of the plan, an annual conference will be undertaken with all stakeholders. A re-engagement with the public, along the lines of the original consultation process, has not been tabled at present but could prove beneficial.

What changed for the city?

The Arts Plan changed the way the Arts Office engages with its other sister departments: several interdepartmental partnerships have arisen with the Area Offices, Libraries, Planning, Events, Tourism and Sports and the Intercultural Unit, which previously engaged with the Agenda 21 process. The benefits are increased sharing of resources, parallel planning and the increased recognition of culture as an effective tool for public engagement and sustainable practice. These changes in relationships are in large part based on the exchange and sharing of knowledge, resources and networking aimed at increasing opportunities and enhancing projects for mutual benefit.

There is an increase in partnerships and sharing of working practice with external organisations such as Failte Ireland (tourism), Dublin Docklands Development, the National Cultural Institutions and the Department of Arts, Heritage and the Gaeltacht. Cultural institutions and organisations across the

region are working together and developing projects targeted at increased participation. In addition, Dublin City Council has become a lead agent in these partnerships and networks. While many of these relationships are relatively new, the sharing of resources, knowledge and expertise has been a key feature with the full impact on the city yet to be seen.

The impact on cultural rights and access to culture is more subtle, but potentially deeper; the adoption of the UNESCO definition of culture is a significant change to the traditional interpretation of the word. It engages across all departments in the city council, and therefore with a much wider citizenry. Also, the adoption of the UNESCO Cultural Rights of the Child Charter speaks to a wider platform concerning cultural rights for all. In essence, the question posed here will be: Can a child who has cultural rights maintain them as an adult?

Transversal impacts

The economic impacts of the plan are less definitive. The legacy of the bid for the ECoC 2020, arising from the plan, was its greater social impact because of increased engagement with more people. It developed capacity and increased funding with an additional one million euros set aside for cultural actions in each of the next four years. In addition, the Cultural Strategy provides for 100,000 euros for each of the five electoral areas for national cultural institutions partnering with local neighbourhood organisations. One such example is the work of the Chester Beatty Library with a Muslim community in the south of the city. In addition, a pilot unit is to be set up with the goal of increasing participation in and funding for European projects. The city council is also looking to the work titled *Cultural and Creative Spillovers* published by Tom Fleming's creative consultancy and funded by the Arts Councils of England and Ireland. The recommendations from this research will go some way to informing the research that Dublin City Council intends to commission in the same area and will be able to provide more definitive data on the transversal effects of the Arts Plan and the Cultural Strategy.

The Arts Plan and through it the bid for the European Capital of Culture was effective because

- It was based on a wide-ranging consultation process;
- It sets out the strategic vision, clarified roles and defined priorities;
- The strategic positioning of the plan allowed it to act as a launch pad for wider and deeper programmes and policies;
- It recognised the potential of the city to act as a lead agency for the arts and culture.

The plan makes it clear that sustaining cultural growth and diversity is at the heart of its goals for the city: "The City Arts Office develops relationships locally, nationally and internationally with a view to providing greater opportunities

for artists and the public, securing additional partners and resources, and thereby sustaining cultural growth and diversity of experience." The plan and the bid can be seen in a simplified way as the continuity of the city council's obligations under the Arts Act 2003, and as such the emergence of another plan will continue to be a responsibility of the city council. The commitment to the legacy of the bid for ECoC 2020, the creation of the Cultural Strategy and the additions to the Development Plan, alongside the four-year rolling plan of investment in culture and the development of a European Funding Unit, make it clear that at least for the next four years, an unequivocal commitment to the goals outlined in the plan have been made.

The Arts Plan led to the Dublin bid for the European Capital of Culture 2020 (which is noted on page 32 of the Arts Plan). The plan, the bid process and the new Cultural Strategy fundamentally changed the direction of all of Dublin City Council's cultural planning. It deepened our understanding of culture, placing an emphasis on participation and a drive towards sustainable practice. The Arts Plan led directly to:

- Strategic partnerships, including the first of its kind in Ireland with Business to Arts, which led to the Docklands Development Fund;
- An additional one million euros per year for sustainable cultural projects;
- A set of European pilot projects, including the new EU Funding Unit with a remit to generate five new EU applications over its first year;
- A schedule for a series of independent city-wide cultural audits with the goal of directing the provision of new cultural infrastructure for the entire city;
- The rewriting of the Cultural Strategy for all areas of the city with a clear focus of needs and income generation;
- New planning recommendations for cultural infrastructure for the city, including the requirement for private and public developers to consult experts in cultural provision for all new planning;
- The adoption of the UNESCO definition of culture and the UNESCO Cultural Rights of the Child;
- The formation of a city-wide policy for arts, education and learning.

In this way we can see clearly not only the detailed experience, growth and befts of the "taking part" but also the successes in failure that show how even when you lose, you can win.

Note: All the documents listed, including the Arts Plan; Cultural Strategy; Development Plan; the bid for the European Capital of Culture; The Public Art Programme; Equitable Payment of Artists Policy; Arts, Education and Learning Policy Statement; Support for Cultural quarters projects; The Masters in Art and Research Collaboration (ARC); Institute of Art; and Design and Technology (IADT); Former Vacant Spaces Scheme; Local Arts Festival Training Sessions; and other tool kits and documents can be found online on the City Council Arts Office website at www.dublincityartsoffice.ie/.

Notes

1 The Palmer Report on the Capitals of Culture from 1995–2004. Available from: https://ec.europa.eu/programmes/creative-europe/document-library/capitals-culture-palmer-report_en
2 UNESCO. (1989). Convention on the rights of the child, Article 4, page 3. Available from: www.unesco.org/education/pdf/CHILD_E.PDF
3 Dublin City Council. (2014). The City Arts Plan: 2014–2018, p. 27. Available from: www.dublincityartsoffice.ie/content/files/ArtsPlan.pdf

Part II

Inclusive design, culture and innovation

11 Breathing information

The online media and the demands for innovation

Miroslav Keveždi

If information is the oxygen of democracy, then our societies seem to have serious respiratory problems. For years the media systems have been stepping into a thin air zone. According to the Pew Research Center, the drastic decrease in newspaper circulation in the U.S. is apparent – in 2015, daily circulation declined by 7% in comparison to 2014 – the greatest decline since 2010.[1] According to the same source, the workforce in U.S. newspaper newsrooms is 20,000 positions fewer than 20 years prior (39% less). The number of daily papers in the U.S. is decreasing as well.[2] Public trust in journalism has never been lower – according to a 2014 nationwide poll conducted by Gallup, only 40% of Americans expressed confidence in the ability of the mass media – newspapers, television, and radio – to report the news "fully, accurately, and fairly."[3] National newspaper sales worldwide are also decreasing.[4] The media are under economic, political, and professional pressure.[5] Working conditions for journalists overall are deteriorating, and they are even worse in newly democratic countries.[6] Whereas currently there is a trend toward media consolidation, increased media concentration was known much earlier.[7] Quality decline was also noticeable before.[8] These and similar developments demonstrate that the media scene around the world is in a crisis.[9] On the other hand, there is an effort throughout the world to find a solution to the new situation and the threatening trends.[10] The focus is also on the Internet, which is seen as a great opportunity, but also a great threat.[11] Some individuals are overly optimistic, while others show a note of pessimism about this. A megatrend is destructive, thus finding solutions is equivalent to learning swimming during a tsunami. The question arises: is online journalism something which rescues us and to which we should cling to stay afloat, or is it a trick, a trendy tool which makes it even more difficult to remain in the media flow?

Getting information from the Internet has been a phenomenon for several decades now, but it is simultaneously a completely new phenomenon due to the technical development of platforms on which the online media and media products appear.[12] Negroponte wrote back in 1996,

> The economic models of media today are based almost exclusively on "pushing" the information and entertainment out into the public.

Tomorrow's will have as much or more to do with "pulling," where you and I reach into the network and check out something the way we do in a library or video rental store today. This can happen by asking explicitly or implicitly by asking an agent on your behalf.[13]

There is a noticeable imbalance – how can we pull something before someone else pushed something? The metaphor of breathing is usable here: we pull the fresh air of information every day from the Internet, but serious media producers who are pushing that air into our souls are every day in a weaker position. Publishers are losing audiences and advertisers to the Internet and are unsuccessful in making a profit from that same Internet, as many case studies show.[14] Andrew Currah stated,

Although they now have access to an audience of millions, publishers of local and regional news are finding that the web does not pay. The principal challenge is two-fold: consumers now expect news content to be free, whilst advertisers expect much lower rates around the news due to the transient and fragmented character of web traffic.[15]

Mitchelstein and Boczkowski pointed to studies showing that the advertising model does not guarantee substantive profits. One reason for this conclusion is the relatively low level of expenditure on online ads in comparison to other media. The top 50 advertisers spent only 3.8% of their budgets on online ads in 2007.[16] Same as media consumers, advertisers are also not willing to pay for news services online – digital advertising accounted for 2% of the spending on newspapers in 2005, rising only to 4% in 2009.[17] It seems that we are really considering information as we are considering the air – omnipresent, natural, and substantially free.

To have the media today is similar to having a private library. The problem is readers who take the content but are not willing to join and pay fees, and there is no one to cover the costs.[18] This problem is not uncommon, if you know the history of the creation of the Internet and the principles that are embedded in its functioning. Castells stated that Internet was developed in a secure environment, provided by public resources and mission-oriented research, but an environment that did not stifle freedom of thinking and innovation.[19] Values of individual freedom, of independent thinking, and of sharing and cooperation with their peers were in the core of Internet creation.[20] Castells pointed out that business could not afford to take the long detour that would be needed to spur profitable applications from such an audacious scheme.[21] Media performances today seem to be the symptom of the end of patience in media business. The patience of the media business is nearing its end today. Media performance is a symptom.

In this situation – who is looking for the innovation? According to Castells, technological systems are socially produced. Social production is culturally informed. The Internet is no exception. The culture of the producers of the Internet shaped the medium.[22] The Internet culture is characterized by a

four-layer structure: the techno-meritocratic culture, the hacker culture, the virtual communitarian culture, and the entrepreneurial culture – together they contribute to an ideology of freedom that is widespread in the Internet world.[23] Media systems primarily belong to the entrepreneurial culture. Together with the Bill Gates, they are repeating his question from the "An Open Letter to Hobbyists":[24] Who can afford to do professional work for nothing?[25]

Doing professional work for nothing was usually characteristic of the techno-meritocratic culture rooted in academia and science. This is a culture of belief in the inherent good of scientific and technological development as a key component in the progress of humankind.[26] It is interesting that their position in the media is analogous to that which is expected of the media – they are expected to willingly share their knowledge for free (i.e. with the press, with their audience), except in rare cases. Experts are somehow naturally expected to give statements without compensation. Based on the same principal, it is unrealistic for journalists to write articles without being paid. Castells recognizes hackers[27] as largely identified with the UNIX technical culture, and without care about commercial services (the hackers wanted better tools and more Internet).[28] The third culture is virtual communitarian. These communities work based on two major, common cultural features: "The first one is the value of horizontal, free communication. The practice of virtual communities epitomizes the practice of global free speech, in an era dominated by media conglomerates and censoring government bureaucracies".[29] The second shared value emerging from virtual communities is what Castells labels as self-directed networking – the capacity for anyone to find his or her own destination on the Net, and, if not found, to create and post his or her own information, thus inducing a network. A close example of this value fulfilled is an active Facebook account. Facebook is "free and always will be". On the other hand, the Internet is full of texts about "price of free" paid in collected data.[30]

Although the requirements for innovation came from culture, it is business entrepreneurs who brought the innovation to the world. The key point is that they made money out of ideas, while the lack of new ideas led to money losses for established corporations. So, entrepreneurial innovation rather than capital was the driving force of the Internet economy.[31] Media entrepreneurs are interested in selling media content. As such, they belong more to the traditional offline entrepreneurship. In their business ecosystem, plentiful ideas were oriented to the needs of the less entrepreneurial cultures – how to develop a platform for free sharing of media content – texts, images, sound, video. The crucial question for business entrepreneurs is, "What kind of content can I monetize?"[32]

Ideas with a business attitude are the ones that create the sharing of media content for a fee. On the other hand, the Internet enabled the sharing of digital copies of contents. Copies can be shared indefinitely, which potentially also increases the supply – making its price approach zero. In order to raise the price again, it is necessary to limit the offer. In order to limit it, it is necessary to know the quantity and distribution of content. In order to realize the former,

a system of statistics, monitoring – and surveillance – needs to be established. Measures that would penalize the perceived activities of content consumption, which had been shared without compensation, would make information rarer, and therefore a chargeable and more expensive commodity. On the other hand, this would be contrary to the basic principles of free cultural sharing to which we are accustomed on the Internet – it would be as if charging for the air we breathe.

The situation in which the media cannot feed on the revenues from readers seems to have changed some traditional roles. The media is used to hunting readers with content, and in the past, readers were willing to pay for that content. A fair attitude meant that readers paid for content that interested them. The emergence of the Internet has made readers become the hunters of information, much like fish that feed on bait but never get caught. Over time, traditional media-oriented business systems, as well as new online media, are becoming thinner.

It is expected that more and more information will be produced by amateur journalists. In this regard, the question is whether poor quality information can also be the oxygen of democracy? Back in 1984, when describing cyberspace William Gibson used the metaphor of a metropolis.[33] Our media machines appear as public and private actors of urban transport. Both are on the move within cyberspace, broadcasting information. Instead of machines that produce the oxygen of democracy, they now resemble cars that emit exhaust fumes and make our environment unsuitable. Very few people are prepared to pay for informational content – just as they are not prepared to pay for oxygen. The essential question is whether hobbyists are ready to produce quality information.

Notes

1 Pew Research Center. (2016, June), *State of the news media 2016*, p. 4.
2 *Editor & Publisher's* DataBook lists 126 fewer U.S. daily papers in 2014 than in 2004.
3 Sarver Coombs, D., Collister, S., and Marino, J. (2016). *Debates for the digital age – the good, the bad, and the ugly of our online world* (pp. 206–222). Santa Barbara, CA: Praeger. See also: www.gallup.com/poll/185927/americans-trust-media-remains-historical-low.aspx
4 Jackson, J. (2015, April 10). National daily newspaper sales fall by half a million in a year. *The Guardian*, Friday. Available from: www.theguardian.com/media/2015/apr/10/national-daily-newspapers-lose-more-than-half-a-million-readers-in-past-year
5 For example: in 2008, advertising expenditure in Spain decreased 11% and went down again 20% in 2009. See: Artero, J. P., and Sánchez-Tabernero, A. (2015). Media and telecommunications concentration in Spain (1984–2012). *European Journal of Communication*, 30(3), 319–336; Anderson, J. P., and Egglestone, P. (2012, October). The development of effective quality measures relevant to the future practice of BBC news journaiism online. *Journalism*, 13(7), 923–941; Akin, A. (2016, November). Conditions of sense making and news making in Turkey after the failed coup attempt: Sisyphus labor on two fronts. *Journalism*, 1–15.
6 Yesil, B. (2016). *Media in New Turkey: The Origins of an Authoritarian Neoliberal State*. Champaign: University of Illinois Press; Mihailović, S. [ur.] (2015). *Od novinara do nadničara. Prekarni rad i život*. Beograd: Dan graf – Fondacija za otvoreno društvo – Centar za razvoj sindikalizma.

7 See: Baker, C. E. (2006). *Media concentration and democracy: Why ownership matters* (1st ed.). Cambridge: Cambridge University Press; Doyle, G. (2002). *Media ownership: Concentration, convergence and public policy* (1st ed.). Thousand Oaks, CA: SAGE Publications; Doyle, G. (2002). *Media ownership: The economics and politics of convergence and concentration in the UK and European media* (1st ed.). Thousand Oaks, CA: SAGE Publications.

8 "The short television life of the early high-quality but low-rated documentaries soon ended, and the evening news broadcasts began to stress more crime, scandal, and celebrities, all of which tended to crowd out foreign and public affairs news." In Hachten, W. (2005). *The troubles of journalism; a critical look* (3rd ed., p. 72). Mahwah, NJ: Lawrence Erlbaum Associates, Publishers.

9 Reljić, S. (2013). *Kriza medija i mediji krize.* Beograd: Službeni glasnik; Reljić, S. (2011). *Odumiranje slobodnih medija.* Beograd: Službeni glasnik.

10 Cagé, J. (2016). *Saving the media – capitalism, crowdfunding, and democracy.* Cambridge, MA: Harvard University Press; Kaže, Ž. (2016). *Spasavanje medija – kapitalizam, participativno finansiranje i demokratija.* Novi Sad: Akademska knjiga.

11 McChesney, W. R. (2013). *Digital disconnect: How capitalism is turning the Internet against democracy* (1st ed.). The New Press; Robert, M. V. (2015). *Digitalna isključenost – kako kapitalizam okreće internet protiv demokratije* (pp. 235–248). Beograd: Fakultet za medije i komunikacije – Univerzitet Singidunum, str.

12 Hulin, A., and Stone, M. (2013). *Vodič za samoregulaciju online medija.* Beč: Ured predstavnice OSCE-a za slobodu medija.

13 Negroponte, N. (1996). *Being digital* (1st ed., p. 170). New York: Vintage.

14 van Kerkhoven, M. C. (2016). *Lost in transition: Media innovations in the Netherlands.* Available from https://pure.uva.nl/ws/files/2799699/175078_Proefschrift_Lost_In_Transition_Marco_van_Kerkhoven_20160527.pdf

15 Currah, A. (2009, September). *Navigating the crisis in local and regional news: A critical review of solutions,* Working Paper. The Reuters Institute for the Study of Journalism.

16 Mitchelstein, E., and Boczkowski, J. P. (2009). Between tradition and change: A review of recent research on online news production. *Journalism,* 10(5), 565.

17 Simon, J. P. (ed.). (2012). *Statistical, ecosystems and competitiveness analysis of the media and content industries: A quantitative overview* (No. JRC69435). Institute for Prospective and Technological Studies, Joint Research Centre, p. 10.

18 At the same time, users pay a relatively significant cost to the provider for Internet access.

19 Castells, M. (2001). *The Internet galaxy: Reflections on the Internet, business, and society.* Oxford: Oxford University Press, p. 23.

20 Ibid., pp. 24–25.

21 Ibid., p. 23.

22 Ibid., p. 36.

23 Ibid., p. 37.

24 Gates, B. (1976). An open letter to hobbyists. Available from: www.microsoft.com/about/companyinformation/timeline/timeline/docs/di_hobbyists.doc

25 Gates had the same problem in 1976 as do today's media houses. He was developing BASIC: "The feedback we have gotten from the hundreds of people who say they are using BASIC has all been positive. Two surprising things are apparent, however: (1) Most of these "users" never bought BASIC (less than 10% of all Altair owners have bought BASIC), and (2) The amount of royalties we have received from sales to hobbyists makes the time spent on Altair BASIC worth less than $2 an hour."

26 Castells, M. (2001). *The Internet galaxy: Reflections on the Internet, business, and society.* Oxford: Oxford University Press, p. 39.

27 Some hackers recognize themselves in the "cyberpunk" characters of science fiction literature. They build their social autonomy on the Internet, fighting to preserve their freedom against the intrusion of the powers that be, including corporate media takeover of their Internet service providers. See: Castells, M. (2001). *The Internet galaxy: Reflections on the Internet, business, and society.* Oxford: Oxford University Press, p. 51.

28 Castells, M. (2001). *The Internet galaxy: Reflections on the Internet, business, and society.* Oxford: Oxford University Press, p. 44.

29 Ibid., p. 55.

30 Hachman, M. (2015). The price of free: How Apple, Facebook, Microsoft and Google sell you to advertisers. *PC World*, October 1. Available from: www.pcworld.com/article/2986988/privacy/the-price-of-free-how-apple-facebook-microsoft-and-google-sell-you-to-advertisers.html

31 Castells, M. (2001). *The Internet galaxy: Reflections on the Internet, business, and society.* Oxford: Oxford University Press, p. 56.

32 YouTube. (2017). What kind of content can I monetize? Available from: https://support.google.com/youtube/answer/2490020?hl=en

33 "Cyberspace. . . . A graphic representation of data abstracted from the banks of every computer in the human system. Unthinkable complexity. Lines of light ranged in the nonspace of the mind, clusters and constellations of data. Like city lights, receding . . . " In: Gibson, W. (2004). *Neuromancer* (20th anniversary ed.). New York: Ace Hardcover, p. 32.

12 Innovation in media

The rise of the machine

David Smith

Weaving my way to work one sunny July morn carefully navigating the gaps between Pokémon Go players, branded solar bins and digital billboards, it was like playing my own real-world video game, "Avoid the incomings". It felt like a seminal moment where a tangible shift had just occurred, the singularity as Ray Kurzweil referred to, the crossover of man and machine was upon us. Months earlier Deepmind, an AI system acquired by Google in 2014, announced a major milestone. A computer program, for the first time, had comprehensively beaten European champion Fan Hui at GO, a highly strategic and intuitive ancient game that had until this point remained beyond the grasp of AI experts.

This rise of the machine and the impact of this more intelligent and more integrated force in our lives is deeply significant. Furthermore, the continuing crossover of our physical reality and technology is as alarming as it is awesome.

Stimulus

From an advertising point of view, with both outdoor and online combined, we are now bombarded with an average of 5,000 advertising messages a day, a monumental level of incomings. Digital billboards can now scan you and based on your age/sex/location will deliver content accordingly. Online your known profile directly leads to the content in your feed. We are surrounded by unseen algorithms bubbling below the surface working out how best to interact with us. Maths, the one true universal language, is the mover and shaker of our times and we literally make up the numbers.

What's fascinating is the online ecosystem that has emerged where we are not just consumers of stimulus but also the creators of it. It is no longer one-way traffic but an interconnectedness of all elements. Anyone with a phone is a potential filmmaker, photographer, on-the-fly journalist, food critic, philosopher, gaming guru. Our individual creative output drives the very platforms on which we are the product. To consider the scale of all this is quite exhausting.

Content and form

In terms of the progression of media, the new forms it is taking are integrated into the whole. From an outdoor point of view, digital billboards are all portrait.

It is a statement that 'This is not a TV'. It is something far more dynamic and at its core is a nod to the most digested media format on the planet . . . your mobile phone.

Instagram has begun creating portrait content as their preferred format. It's a significant shift from the traditional landscape orientation born from the original but increasingly outdated monarchy of screens . . . the television. The king is dead, long live the king.

With 5,000 incomings per day the question for media providers is how do you effectively cut through the noise?

This is a positive insofar as it requires media owners, entertainment providers, brands and publishers to work harder in order to deliver real value for the consumer. This results in far more holistic and integrated forms of media as essentially it is now a relationship between consumption and the experiential value of that consumption, i.e. did the value derived from consuming the media outweigh the underlying commercial reality of the transaction.

My own business, Micromedia, developed out of a flyer/poster music promotion background. We now specialise in digital screen networks where it has become increasingly unacceptable for us to just offer one-dimensional rotating billboard advertising. It simply isn't good enough. We are now content creators and providers, our daily news is delivered by Waterford Whispers, music recommends by Nialler9, on-screen art exhibitions by cutting-edge digital artists. It is a content-rich outdoor media platform, so if you choose to engage with it, you enjoy the incomings and don't feel you're being advertised to. We are by default curators of the outdoor stimulus if we choose to look at it that way. Do we then choose to leave a positive or a negative indent?

So not only has the format of my industry been completely re-invented but the entire model to suit.

This is directly mirrored online where it is increasingly ineffective to simply advertise overtly. The emergence over the years and now dominance of online content creation companies highlights this shift. The focus is now on delivering compelling content in the form of snapshot stories or animations for you to digest in 90 seconds or less without even realising you're in fact watching an ad. Ninety seconds, a possibly worrying metric on our decreasing attention spans.

"It's not making people like stuff, it's making stuff people like." Heather Thornton from the Dublin-based advertising company Along Came a Spider (http://alongcameaspider.ie/) sums it up in one line.

Again, we see the relationship here between consumption of the media versus the value of the experience. This is a model that drives authentic engagement. Why? Because ultimately it delivers value for the consumer of the media that outweighs the commerciality underlying its *raison d'être* in the first place. Getting this balance right though is a fine line.

On the opposite end of the spectrum from holistic integration is 'disruption', an industry buzzword of 2016. The award-winning Orchard Thieves campaign

saw the announcement of this new product on the market by mischievously stealing other brands' ads. The mirroring of disruption on a meta level is interesting, where major industries are being disrupted by the new kids on the block a la Uber and Airbnb, to name two.

"Techover" of the physical

As technology continues to permeate our physical environments, so too does our dependence on it solidify. The always on and always listening ASR (automatic speech recognition) devices like Amazon Echo and Google Home are really the first AI to start getting into people's homes. The intelligence of these devices is awesome with their ability to learn, control your IOT (Internet of Things) environment and even act as your personal assistant.

Augmented reality and virtual reality are really beginning to come of age, and this year will see the leveraging of both for entertainment and advertising purposes. From a media perspective, the crossover of tech with the physical landscape remains the holy grail. The potential to set new benchmarks in terms of entertainment and media will push towards what could actually be a paradigm shift. Be warned, though, by the tale of Pokémon Go – the fastest rising and falling game of all time. It racked up over 500 million downloads in three months and by month 4 lost 79% of its users. What it highlights, however, is the appetite, willingness and readiness to bridge this divide.

The economics

We have never lived in a more commercial reality than in the one we now reside. Within this reality is a very thorough ecosystem based on two-way traffic. For entertainment and high-quality content to exist, they need to generate revenue. Artists need you to buy their albums and go to their gigs, film companies need bums on cinema seats, online publishers need eyes for their advertisers. It is a universal synthesis of sorts.

On a meta level the economics is worrying, as the emergence of Netflix, Spotify and the like arguably shortchanges the artists and creators. What's more concerning is the bulk of industry revenues are slowly shifting, and potentially entirely, the way of Facebook and Google, which is shrinking the ecosystem. Variety is the spice of life after all and as it's a finite pool of money – the sacrifice of the ecosystem could be detrimental. Indie publishers and independent media operators are integral parts of this.

On a micro level the anti-movement is most visible in the rise of ad blocking. Two hundred million people used ad blocking software last year. That figure is expected to rise to 400 million by 2019. Life is undoubtedly less noisy with less incomings but on the other hand you simply cannot expect that quality of media and entertainment without them. It's a microcosm to the macrocosm. The darkness versus the light.

Conclusion

So what is the significance of these innovations to us?

What is the impact of 5,000 increasingly effective incomings a day and can this stimulus actually shape our reality?

Most certainly it can but only if you allow it to.

Back in the time of the ancients, when the main stimuli that existed were the sun, moon and stars, they, as a result, had a deep connection to the earth and an understanding of the universe far more profound than ours. After all this was their major incoming, their stimulus.

The intelligence of the machine will only increase and permeate further into our lives. Whether the rising of this intelligence leads to the dumbing down of our species is ultimately your choice. Consume mindlessly and be consumed fully.

If you reframe our situation you can see it as an opportunity to level up. Don't run from it, don't hide from it but accept it and engage with it. We now share our daily lives with it, depend on it for social interactions, information, business and entertainment. Through discernment and discrimination become the curator of your own existence. Don't allow stimulus to be one-way traffic but create a two-way relationship by consciously and mindfully engaging with it. That is integrated living.

As Victor Frankl put it, between stimulus and response is space and in that space lies our ultimate freedom.

Welcome to the future. It's surprisingly roomy out here.

13 Value innovation in the "new" age of experiential consumption

The millennial force

Jörn H. Bühring

There are any number of market drivers that affect consumption in society, important market drivers such as globalization, innovation and technology. From a business perspective, these market drivers have greatly impacted the development of economies of scale, as seen in manufacturing and even within the service economy. As a result, industries often place their primary focus on innovation linked to the efficiency and improvements of the overall delivery performance. While these strategies produce undeniable benefits, the economic achievements most often translate into the erosion of value of many goods and services to the point where they are becoming increasingly commoditized.

Conversely, societal changes are progressively influenced by rising affluence and expanding possibilities, not least affording consumers global access to an almost unlimited choice of products and services. Among the market drivers increasingly affecting consumption are social factors that have direct influence over consumers' decision-making and consumption behaviors. Unsurprisingly, in this era of unparalleled material abundance, a new generation of affluent and lifestyle-oriented consumers suggests that the pursuit of pure material satisfaction is fading. Indeed, it is here that no other consumer cohort receives as much attention as the Millennials: a demographic generation born between 1980 and 1999. Millennial consumer cohorts are in search of additional experiential value and points of differentiation when comparing products and services providers. Indeed, such is this societal force that we are witnessing a transformation from the mere accumulation of material goods toward purposeful and enduring satisfaction obtained from the consumption of experiences.

This phenomenon is most evident in the growing interest from managerial and popular media, gradually examining the importance of the Millennial consumer experience. This far-reaching acknowledgment thus underpins the need for a deeper understanding of generational consumer perspectives, and the value of the customer experience purposely designed into the processes of innovation.

Looking back in recent history, our understanding of knowledge pertaining to human experiences, as seen in the context of consumption, has been the subject of diverse managerial and scholarly exploration. In fact, our knowledge has expanded significantly over the last two decades, with the focus expanding from

the characteristics of the service offering, to the relationship between service providers and their customers. Consequently, further emphasis is placed on the constructs of experiences and the relationship between physical environments, human interactions and the value that customers perceive they derive from their consumption experience. In fact, the organization-centric approach to studying the customer experience is no longer adequate, as the role of the customer is increasingly becoming that of an active participant and, therefore, the customer perspective is critical when designing successful customer experiences.

Nowadays, the term 'experience' emerges in fields as diverse as design, architecture, gaming, human-computer interaction, education, retail, marketing, healthcare, tourism and leisure, where the common focus centers around the role of the customer. As diverse as the field in which the term is used today, American futurist and sociologist Alvin Toffler (1928–2016) famously proffered in his book *Future Shock* (1970) that experiences would be sold on their own merits, and that whole experiential industries would someday center their offerings on the experience itself. In this bestseller book, Toffler went on to predict that consumers would be collecting experiences as passionately as they once collected things.

Today, some of the fastest growing economic sectors are related to the consumption of experiences, and the importance placed on the customer experience holds no truer than for those catering to the wants and desires of the Millennial generation. Tourism, for example, is one such economic sector widely regarded as standing at the forefront of staging experiences. Broadly described as 'traveling for pleasure', tourism has its prime business centered on products, services and the value that consumers attribute to the (tourist) experience. In fact, rising affluence and individual wealth among the Millennial consumer population is seen as a catalyst for experiential travel through the engagement in leisure- and travel-related activities. Millennial consumers are traveling more often than any other generation has before; they are motivated by acquiring life experiences and personal encounters that can be shared with others. Moreover, these active and frequent travels are becoming more concerned with intangible factors like how they are made to feel and the emotions generated through the multisensory consumption experience.

Indeed, their quest for unique and extraordinary destination experiences is observed by profound travel behavioral changes in how these Web- and tech-savvy travelers engage with destinations, attractions and local hospitality that inspire the emotions and produce unforgettable experiences. Responding to these growing consumer interests, it comes as no surprise that hospitality and tourism service providers are increasingly seeking innovative value propositions that can satisfy the pursuit of novel and enjoyable experiences. It is here that the focus on product and service innovations is beginning to shift toward value creations in the form of experiential innovations. Not only do producers of experiences hope to attract this Millennial generation; following Toffler's earlier predictions, the motivation rests firmly in the expectation that this approach to value innovation generates new forms of competitive advantages and economic

value (currency) derived through designing and delivering unique and memorable experiences.

Increasingly, affluent Millennial consumers are further influenced by the advancement in technology. Over the last decade, competition between providers of tourism-related products and services has further intensified as a result of growing access to the Internet. For example, such access to vast amounts of information allows consumers to review consumer-generated feedback and compare prices, offers and the experiential value between competing service providers within a chosen destination. Whilst technology and innovation are well-documented drivers of economic growth, non-technical innovations, like those that are critical to the development of value across industries focused primarily on experiences involving the individual user, are less visible.

In this new age of experiential desire, how do these producers then create value through experiences? Here it is argued that product and service innovations require a broader approach, thus fueling customer-centric value innovation through the emerging practice of experience design. Experience design is best defined as an approach to creating an emotional connection with customers through careful planning of tangible and intangible events that are functional, purposeful, engaging, compelling and memorable. To achieve an emotional connection outcome, however, the importance of various experience aspects, an understanding of human consumption and behavioral dimensions, the constructs of experiences and the factors that make an experience memorable, are all critical considerations when designing consumption-related experiences. Accordingly, experience designers aim to evoke meaning with less of an attachment to objects. Instead, they focus on the relationship, the context in which experiences are consumed, as well as the situation, the environment, passive-to-active levels of engagement, and the intended goal (e.g. economic value) for which a particular consumer experience proposition is being designed. This understanding forms the beginnings of a platform, and indeed a language on which value-generating consumption experiences can be designed.

Particularly relevant to the tourism sector are numerous examples of consumer experiences offered through entertainment and leisure activities. Within the experience economy literature, commonly cited examples like a day at Disneyland, a Broadway show, or a thrill helicopter ride over Las Vegas and the Grand Canyon are often referred to when describing (and visualizing) experience encounters that attract consumers in search of extraordinary experiences. While these are valid and proven examples of entertaining experiences, innovators of experiential value targeting the Millennial population, however, must go beyond passively entertaining their customers. In fact, entertainment is now tied to a plethora of activities in physical and virtual contexts, where the consumer has become very actively engaged in the creation of value. Consequently, experience designers aim for maximum experiential value innovations informed by consumer psychographics (personality, values, attitudes, interests and lifestyles), thus appropriately balance active and passive levels of user engagement that become value generators of experiences.

Returning to Toffler's version of *Future Shock*, he stressed how producers who design intangible benefits into their value propositions would learn that consumers are quite willing to pay a premium for what they would perceive as the associated value during the consumption. Indeed, Toffler saw economists as having great difficulty in imagining a society in which the consumers' material needs were being satisfied, implying that their attitudes were stuck in the past, where technological advances were a non-revolutionary extension of the known.

To be successful in engaging with the Millennial consumer force will require producers of experiences to consider the long-term benefits of taking an innovative approach to designing and delivering highly desired and valued consumption experiences. This too implies that they need to involve other stakeholders and experience designers, and include the consumer in the process of learning about opportunities to design, stage and co-create enjoyable and lasting experiences. Consequently, in this age of experiential consumption, experience producers should develop an experience value innovation language that takes into consideration brand, property, location, multidisciplinary teams, culture and evolving consumer-business networks (social, technological) and the full spectrum of customer relationship touch points.

14 Developing an eco-system of support for the creative sector

Louise Allen[1]

While it is true that much has changed over the past decade, Europe's recognition of the creative sector as an economic driver has led to the development of infrastructure in major cities. The rise of communities of practice is breaking down silos between sectors and disciplines, opening up the potential for integration and collaboration. Europe recognises the critical importance of small and medium enterprises (SMEs) to rural and national economies.[2] Research conducted in 2015 by the World Economic Forum has found that revenue from creative industries exceeds those of telecommunications services.[3] The impact of the creative industries globally cannot be understated. However, as the economic contribution of the sector is not yet matched by investment, cultural organisations responsible for developing and delivering programmes on a national basis are often challenged. The task of educating and changing the mind-set of existing support mechanisms whether in education, enterprise or government can seem daunting on many levels. In order to embed culture and creativity in the fabric of society, developing an eco-system of support for creatives and those working in cultural sectors is essential. What I present in the following text is the approach I took to develop an eco-system to provide mutually beneficial supports in education, enterprise and international contexts.

I joined the Design & Crafts Council of Ireland (DCCoI) in 2008.[4] As a Curator of Education, one of my responsibilities was the development of an education programme for primary teachers and children. I initiated a programme called 'CRAFTed'. It focused on communicating the skills of the craftsperson entering a classroom environment, the integrity of the making process, the experience of the child and the value to the teacher. To begin with, the programme was delivered in six schools to around 180 students. Budget was limited to €50,000, but there was a demand to develop a national programme. The only way to achieve this was through partnership. In Ireland, we have an Association of Teacher Education Centres Ireland (ATECI) which is mandated to provide skills development to teachers; the local centre in Kilkenny was my first port of call. At that meeting with the then director, I outlined my vision for a locally delivered programme with national reach in partnership with the ATECI.

It was important from the outset that the benefits for education centres, teachers and children and the added value that a partnership with DCCoI would bring be clearly outlined. In essence, we needed to provide solutions for a problem that education centres had. From a DCCoI perspective, we wanted to influence and enhance delivery of the visual arts curriculum, raising awareness of craft and design at the primary level. For education centres, 'visual arts' were not a high priority – the government's focus was on STEM subjects (science, technology, engineering and maths) – so we aligned our offer to match, demonstrating how craft and design skills support integrated learning methodologies within the classroom, with an emphasis on underpinning numeracy and literacy skills. I presented our approach, highlighting the broader context and application of craft and design practice to a meeting of directors of education centres. At this initial meeting, my focus was on developing relationships with four key centres, whose directors were respected and connected at government levels. The rollout of the national programme happened over a period of years, starting in 2009 with four education centres agreeing to co-fund the participation of four to six schools annually.

To facilitate expansion of the scheme, some fundamentals needed to be put in place. The Design and Crafts Council developed an education panel of craftspeople and designers who received training on teaching skills and working in school environments. We developed a child protection policy, and all those on our education panel were required to have child protection training and clearance. Over time we developed a resource called 'Learn Craft Design' (www.learncraftdesign.com).[5] The resource provides profiles of our entire education panel, which numbers over 60[6] and provides learning resources for teachers. In partnership with the education centres, we initiated Continuing Professional Development for teachers. In advance of each programme we hold information evenings for schools interested in applying to participate. To fund the expansion we introduced a fee of €200 for schools and agreed upon a payment structure for craftspeople and designers. As word of the programme grew, schools from across Ireland began to request that it run in their education centres. By 2014, CRAFTed was running in 15 education centres (ATECI), with 71 school projects, 62 craftspeople, 12 teacher facilitators and 2,130 students.[7] The development of the national programme was achieved through our partnership with ATECI without a core budget increase from DCCoI.

In 2012, I became Head of Innovation and Development programmes. In Ireland, we have an established infrastructure of Local Enterprise Offices[8] (LEOs). They provide supports to SMEs. Our parent organisation, Enterprise Ireland, provides funding to both the DCCoI and LEO network. Historically, DCCoI has a good level of interaction with LEOs; however, their engagement with the craft and design sector was mixed, because certain LEOs provided significant supports and others hardly engaged at all.

What the DCCoI and the network lacked was a co-ordinated approach to developing creative enterprise. DCCoI's relationship with the LEO network needed to be defined and formalised. From a DCCoI perspective, the network

was crucial to our ability to provide business supports nationally. Work undertaken to develop the market[9] for craft and design enterprise was having significant impact. Sales from our annual trade event, 'showcase – Ireland's Creative Expo' (www.showcaseireland.com), were increasing, as were those in national and international markets. However, there were fundamental challenges; the rate of development of new products was slow, engagement in market research limited, the quality of product design, merchandising and branding needed to improve and issues of scale had to be addressed in order to meet a growing demand for high-quality, well-designed hand-crafted products. On the business side, development of business plans and export strategies was also an issue. In 2012, I presented a plan to the CEOs of the LEO network. It outlined a joint approach where DCCoI would develop infrastructure and programmes to enhance the design and product development capability of the sector while LEOs would provide targeted and bespoke business supports. This led to the establishment of a working group and to the signing of a memorandum of understanding between the DCCoI and LEO network.

Following the agreement, the Innovation and Enterprise team at DCCoI developed an enterprise website (ccoienterprise.ie) with business information specific to our client needs. We developed a design-mentoring panel with expertise across product and industrial design, interaction design, branding, merchandising and public relations. This platform can be accessed by SMEs and LEOs and is a central tool for DCCoI in the development and delivery of programmes. Mentors are selected based on the range and quality of expertise and geographic location. In parallel, we restructured our support programmes to ensure there was a pipeline for SME development.

Entry level programmes include 'Enterprise and Innovation workshops' and 'FUSE development clinics'. Both are run over one or two days. The model for FUSE is currently being adopted and delivered in Finland. The clinics are high-energy events that combine a mix of presentations by industry leaders with a range of expertise in different business and design-related areas and one-to-one mentoring sessions with each client. They enable DCCoI to quickly assess the exact type of support required at a particular stage of business. Craft and Design enterprises progress from these types of interventions to more intensive programmes such as 'Building craft and design enterprise' and 'smarter export' programmes. All of these initiatives are co-funded by LEOs and delivered regionally through the network of enterprise offices across Ireland. This partnership has significantly extended DCCoI's resources and reach, enabling us to support over 800 businesses annually.

In 2015, the Design and Crafts Council received an additional €5 million from government to deliver Irish Design 2015 (ID2015), a year-long programme exploring, promoting and celebrating Irish design through signature events on the island of Ireland as well as in prestigious partner venues in international capitals of design and commerce. I was co-opted from my role in Innovation to design, drive and deliver the international programme. Over the course of the year, over 150 events and exhibitions were delivered internationally. Underlying

all activities were two core objectives: to develop the global market and to position Irish design on the international stage.

Collaborative engagement was paramount to success, and the ability to leverage existing networks on an international scale essential. One of the most significant programmes, 'Connections', was developed in partnership with the Trade and Promotions division of the Department of Foreign Affairs and Trade (DFAT). In autumn 2014, I held my first meeting at the department. I asked about their international cultural and trade activities and the type of materials used when hosting events abroad. I was shown a series of pull-up banners with imagery and quotes from famous Irish writers – Joyce, Yeats, Wilde. I knew immediately that there had to a better way to develop a touring exhibition that would promote the quality of Irish design to international audiences.

Working closely with a design team, Studio AAD, we developed a capsule and a photographic exhibition that collectively features the work of over 50 designers and design companies. The exhibition is contained in a set of sturdy flight cases that open to reveal a range of exhibits showcasing the wealth of Irish design talent across all disciplines. There are two themed versions of the capsule, 'Life and Culture' and 'society and Progress'. Throughout 2015 and during 2016, four exhibition sets toured to over 34 embassies across the globe simultaneously. The capsule is supplemented by a website (connections.irish-design2015.ie) that tracks the locations of each exhibition and a photographic exhibition that features selected images of over 100 Irish designers. The files for photographs were distributed by DFAT and images are selected and printed locally by Embassies to suit the type of event and venue. Embassies and Consulates linked exhibitions to local events promoting the quality of Irish design to international audiences and facilitating the development of new relationships with local industry representatives, key buyers and influencers, and international media. The capsules were an effective method of generating high-level interest in Irish design and realised the ambition to extend the reach of Irish design to every corner of the globe.

Building relationships and working in partnership is the key to the development and evolution of dynamic and engaged eco-systems of support. While this would seem obvious, in Ireland and in the many countries I have visited there is often a distinct lack of cross-sector and interagency co-operation. On the ground this is changing; as societies we are moving towards unparalleled levels of co-creation, sharing and interaction; at organisational and government levels the shift is significantly slower. At all levels there is an increasing recognition of the power of creativity and lateral thinking. None of the projects that I have outlined would have been possible without the ability to see and create synergistic alignment between what appear at first to be radically different organisations. Culture, creativity and design have a vital role to play as a catalyst for systemic change across all cultures and all societies. More organisations and the individuals within them need to seek out opportunities in unexpected places and have the ability to recognise how working together can meet the often very differing and distinct needs of each other.

Notes

1 Head of Innovation and Development Programmes, Design & Crafts Council of Ireland.
2 Tuffs, R. (2015, October). *The Parliament Magazine.* www.theparliamentmagazine.eu/articles/opinion/smes-key-eu-economic-success
3 Santiago, J., (2015). *Digital content specialist, public engagement,* World Economic Forum. www.weforum.org/agenda/2015/12/creative-industries-worth-world-economy/
4 The Design & Crafts Council of Ireland (DCCoI) is a national organisation responsible for fostering the sector's growth and commercial strength, communicating its unique identity and stimulating quality design, innovation and competitiveness. DCCoI is funded by the Department of Jobs, Enterprise and Innovation via Enterprise Ireland. www.dccoi.ie
5 For the website development, we secured additional funding.
6 www.learncraftdesign.com/learn/craft-edu-panel
7 CRAFTed Learning Skills for Life, Primary Schools Programme Evaluation, Design & Crafts Council of Ireland, 2014
8 Formally known as County Enterprise Boards (CEBs).
9 The market development team at DCCoI undertook significant work to build the market for craft and design.

15 Are cultural sites leisure businesses?

Jean-Michel Tobelem[1]

The boundaries between cultural sites and the world of leisure-time activities has for some time given the appearance of blurring, with the increasing use of managerial techniques by cultural sites, their rapprochement with the sphere of tourism, and their development of earned income. Using a multidimensional approach (from interviews to an international review of the literature as well as case studies), our methodology seeks to pinpoint the interaction between cultural sites and the leisure market. From a theoretical point of view, this research proposes a consideration of the notion of "Major Facility of Cultural Leisure" as a further development of the previously introduced concept of "Market-responsive Cultural Organization". In this chapter, we argue that if cultural institutions must show their management capabilities, their success should nevertheless not allow it to be forgotten that their missions, based on the general interest, are not for profit and consequently will continue to call upon the intervention of public authorities and/or donors.

Introduction

Over the past several decades, cultural sites[2] have increasingly been applying managerial techniques such as strategy, marketing, cost control, quality management, branding, and performance evaluation. Furthermore, due to their rapprochement with the world of tourism and the development of earned income (ticket sales, retail, restaurants, etc.), numerous observers consider that the boundary between cultural sites and the world of leisure-time activities (represented notably by theme parks) is exhibiting a tendency to blur. As a result, there would scarcely seem a significant difference between a "classic" museum and a venue oriented towards mass consumption and family-based leisure activities, even more so when the latter is based on certain scientific foundations (e.g. Vulcania in Auvergne or the Cité de l'Espace in Toulouse).

This chapter explores the relationship between entertainment and culture, with a view towards highlighting the specificities of the cultural sector and assessing its consequences for management. The analysis is threefold. First, beyond generalities on the relationships between leisure and culture and those on the links between popular culture and high culture, this research approaches

the question of cultural entertainment through concrete case studies. Furthermore, it poses the question of the potentials of financing the cultural sector by resources generated from tourism, while taking inspiration from approaches used by the entertainment sector. Finally, from a theoretical point of view, this chapter proposes a consideration of the notion of "Major Facilities of Cultural Leisure" (MFCL, or GELC/"*Grands équipements de loisirs culturels*").

Previous observations lead to the proposed plan: after a presentation of the methodology in the first part and a review of the literature (the theoretical background) in the second part, the third part analyses the condition of rapprochement between cultural sites and the sector of entertainment; the fourth part defines the concept of "Major Facility of Cultural Leisure"; the final part suggests implications of the interactions between leisure and culture for the management of public and private not-for-profit cultural sites.

Methodology

In terms of method, our research is based partially upon an (ad hoc) qualitative study, centered on the management dimensions of public cultural sites, carried out with 28 professionals interviewed on several major themes: place and role of management, new modes of governance, relationships with the environment, changing role of museums, impact of economic and tourism issues, professionalization and training. The aim was to study a diversity of examples according to the relevant criteria in relation to the object of research: size of the institution, size of budget and staff, type of funding and status, presence or lack of an administrator, location in an urban, suburban, or rural setting, type of collections, etc. The interviews were partially directive, based on an interview guide and recorded. They were analyzed case by case then globally. This chapter tries to clarify the relationship between culture and entertainment in complement with a review of the literature and case studies.

Our research is based, on the other hand, on the realization of case studies dealing with cultural sites present in the market of family leisure-time activities, which brings them close to the theme park industry. These case studies deal with six sites with different types of legal status and various content (historical, scientific/technical, ethnographic), in France and abroad: namely, the Alsace Ecomuseum (Ungersheim), the National Museum of the Automobile (Mulhouse), Océanopolis (Brest), the National Maritime Center/Nausicaa (Boulogne-sur-Mer), and the citadel of Besançon, as well as Te Papa Tongarewa (New Zealand). In addition, we analyze three leisure facilities based on science and research: the Cité de l'Espace in Toulouse (dealing with aeronautics and space exploration), Vulcania (Puy-de-Dôme, on volcanoes), as well as the cultural park of Tjapukai (Australia).

This list is of course limited, and other examples could have been borrowed from North America as well, as the phenomenon appears on a worldwide scale. For instance, in the case of the United States: Experience Music Project/Science Fiction Museum (Seattle), National Museum of Baseball (Cooperstown),

National Museum of Civilisations (Gatineau), Biodome (Montreal), etc. Through its multidimensional approach and the flexibility permitted between different perspectives (going from in-depth interviews with the relevant actors to an international review of the literature as well as case studies from direct observations), this methodology thereby seeks to pinpoint as closely as possible the complex interaction between cultural sites and the leisure market. This remains an exploratory chapter that is intended to pave the way for a treatment that will exploit the data more in depth (interviews, case studies, statistics, etc.).

Theoretical background

While it may be an old claim (in light of the Frankfurt School theory and of – among others – Hannah Arendt, Guy Debord and Jean Baudrillard), the phenomenon of leisure time is leaving today an increasingly distinct imprint on the sphere of culture in general, and in particular on that of cultural sites. According to sociologists, we are witnessing a sort of dilution of culture into the world of entertainment: Leisure and culture should not be confused, at the risk of a deadly confusion. For others still, and on the contrary, there is the beneficial sign of a rapprochement between "high culture" and popular culture, or even between "high culture" and "low culture", which is a landmark of post-modernity. Is it therefore possible to speak of an opposition between an "elitist" approach to culture (reserved for a minority of connoisseurs, art lovers and other specialists) and a more "democratic" approach to culture – which is thereby made more accessible to a larger audience, little familiar with works of art and the intellect, by means borrowed from the entertainment industry? Or is it simply a matter of envisioning cultural goods as consumer goods like any other in the creative industries? In this sense, cultural goods would not justify a 'cultural exception' and should thus be considered (and treated) like any other product related to cultural consumption and the mass tourism industry.

Another consideration is that cultural sites constitute leisure businesses belonging essentially to the realm of tourism and entertainment. It is true that the new environment in which cultural sites are evolving is characterized by a stagnation or a reduction in public funds, increasing professionalization of their management, and unprecedented modes of governance (with the seeking of increased autonomy and flexibility of operations), as well as by a growing interpenetration between culture and the rest of society. Cultural sites are furthermore confronted with new expectations concerning the economic impact of their activities, increased pressure of the competition, the development of public-private partnerships, and the desire for more participation in the process of local development.

"Hybridization" between the management of not-for-profit and for-profit organizations represents one of the primary characteristics in the contemporary evolution of the new public management (covering also the cultural sector). If the previously mentioned evolutions suggest a growing integration of cultural sites into market mechanisms (attendance, collections, digitalization, education, donations ...), must they be likened to private companies? In order to acknowledge their particularities – cultural sites are organizations; these organizations

are part of the field of culture, their functioning is more and more dependent on the market – we have proposed the concept of "Market-responsive Cultural Organizations" (MCO) (*"organisations culturelles de marché"*, or OCM; Tobelem, 2010). It thus appears necessary – for epistemological and not axiological reasons – to establish a distinction between private, for-profit companies and cultural facilities led to develop their own sources of revenue, to collaborate with the business sector, and to master management techniques.

Cultural entertainment: between culture and leisure?

The importance of the leisure market

The total market of leisure sites in Europe is estimated at some 300 million visits (55% of Europeans 15 years old or older and 67% of those between 15 and 44 years old have visited a leisure site). In Europe, the number of visitors to theme parks is about 100 million (the French market comprising almost 300 sites, of which many are small and seasonal). In France, one out of three members of the population makes at least one visit per year to a park. The clientele is primarily French, family and local, with the exception of Disneyland. Disneyland Paris is the leading European tourist destination, with more than 13 million visitors annually, of which 45% are French, followed by Universal Mediterranea close to Barcelona (more than 3 million visitors) and Euro Park, in the German Black Forest, with 3.1 million visitors (including 600,000 French).[3] In France, new facilities continue to open (Parc du Végétal in Angers, MuseoParc Alesia in Burgundy, etc.), or are being planned, while there are already around 30 theme parks and heritage sites directed by public-private partnerships (*sociétés d'économie mixte*, or SEM), such as Futuroscope (Poitiers), Nausicaa (Boulogne-sur-Mer), Océanopolis (Brest), the Cité de la mer (Cherbourg), the Cité de l'espace (Toulouse), and the cave of Lascaux replica.

Interest in these facilities on the part of government representatives seems to remain stable, because the impact of these blockbuster projects are considered "structural" (given expected long-term effects on their environment), and are viewed favorably, despite failures (the Ship Museum in Douarnenez, and Cap'Découverte in Carmaux) or lower than envisioned level of visitation (Parc de la Préhistoire in Tarascon-sur-Ariège, Parc du Végétal, and Vulcania, among many others). The French National Audit Office (*Cour des comptes*) stresses that the increase in demand for tourist offerings with a dimension of culture or of leisure has been very rapid, the number of visitors to theme parks having passed from 1 million in 1987 to 34 million in 2002:

> Projects of a great variety have multiplied, combining culture and entertainment in various proportions. Local authorities have been active in the implementation of these projects, often with the help of the state. But the financial balance of these facilities relies primarily on income stemming from public attendance, which has become unpredictable in a market that is very competitive.
>
> (Cour des comptes, 2007)



Table 15.1 The criteria of distinction between leisure and culture

Type of Facility	Cultural Facility	Leisure Facility
Dominant Characteristic	Conservation/education/creation	Consumption
Mission	Scientific, artistic, educational	Commercial, financial
Goal	Cultural and social development	Profitability and economic development
Financing	Subsidies + income + gifts	Market (income) + subsidies (PPP)
Market	Visitors/audience/users	Clients/consumers
Organization	Public institutions and nonprofit institutions (associations, foundations...)	Private companies and public-private partnerships
Public Involvement	Strong	Limited to none
Sector	Non-market	Market
Determining Principle	Supply	Demand
Grants and Patronage	Yes	No
Role of marketing	Weak to variable	Strong
Commercialization	Limited	Significant

George F. MacDonald and Stephen Alsford add that

> museums cannot compete with theme parks on their own game, namely that of recreation, but they can upgrade them by making use of their techniques and by offering a product bringing value that theme parks cannot present to the public.
>
> (MacDonald and Alsford, 1989: 72)

Michael A. Ames warns still that

> the greatest danger posed by West Edmonton Mall and Epcot to museums and galleries stems not from their competition, but rather from the manner in which they dazzle us and lead us to believe that we must compete with them, diverting our attention from our true mission.
>
> (Ames, 1998: 44)

Therefore, it is fitting to respect the differences in approaches between these two sectors: "The two worlds have made contact, and a zone of intersection has become apparent...A new model for museums is emerging, but will retain differences of perception and approach to theme parks" (MacDonald and Alsford, 1995: 145).

Cultural facilities draw a part of their inspiration for management from the theme park industry (quality management, customer care, marketing planning,

crowd control, branding, CRM/customer relationship management), notably in North America:

> More and more museums are making contact with Disney for help with the development of activities or exhibitions likely not only to attract new visitors, but also to charm the "regulars," while at the same time preserving the essential values of the institution. Museums that have undertaken such collaborations claim that, if they hold firmly the commands on the fields of education, the "house tour" could be rather original and attractive, for the personnel of the museum as well as, in the end, for the public.
>
> (Tramposch, 1998: 32)

Conversely, a few theme parks emphasize their "educational" role. In this regard, Ann Mintz points out that theme parks have taken lessons from museums notably in the areas of presentation and educational activities, and that moreover they integrate an educational dimension in various programs or attractions:

> The newer attractions are explicitly educational. The newest combine hands-on interactivity with dramatic rides and high-end simulators ... Disney has made a strategic decision to increase its emphasis on education ... Theme parks are clearly learning from museums – about hands-on experience, combining education and entertainment, even providing services to educators.
>
> (Mintz, 1994: 34–35)

In this way, Disneyland Paris and Parc Astérix have designed "educational booklets" intended for teachers who accompany their students during visits to these parks.

The concept of major facilities of cultural leisure

Entrepreneurial policies in museums

On 20 hectares between Strasbourg and Mulhouse, close to the borders of Switzerland and Germany, the Alsace Ecomuseum (écomusée d'Alsace, opened in 1984) comprises a group of old farms, houses (some 70 original half-timbered buildings transferred after disassembly) and rural buildings, as well as several restaurants, a bakery, a boutique, a tavern, a sawmill, a barrel maker, an ironworks, a cabinetmaker's studio, a potter, an old school, a bookseller, an exhibition space, a museum of folk art and a hotel. However, according to Marc Grodwohl, its former director,

> these acts of conservation of vernacular architecture have been done apart from any institutional contest. The old adage, "help yourself, and heaven

might help you," has been proven from the first days of the association, which had no financial means of carrying out these works other than the allocation of the saved buildings for new functions, sources of some new income.

(Grodwohl, 2002)

Significant projects were hardly advancing because of the

alleged impossibility of amassing the necessary public financing. However, at this point we reached the level at which volunteering – one of the major components in the success of the Ecomuseum – cannot be any more effective than a private investment that has no hope of return.

(Grodwohl, 1996: 28)

The open-air museum has generated a number of educational programs, beginning in kindergarten. It also proposes numerous activities that encourage the public to visit repeatedly. What can we say:

Museum or theme park? Although the Ecomuseum of Alsace is, as its name indicates, a museum founded on a collection of furnishings and buildings, it is not without analogy to leisure-time parks, or even theme parks. Most of the proposed activities take place in open air, their program permitting a visit of a full day or otherwise. It is thus a local park, as well as a "*lieu de mémoire*" for the local population.[5]

At the same time, "after fifteen years of growth and strength, with attendance of around 400,000 visitors annually, the Ecomuseum of Alsace has been suffering from faltering attendance, beginning in 1998" (Grodwohl, 2005: 193).

Today, local authorities have brought about the departure of the director, taken control of the Ecomuseum, and expressed their wish to turn the direction over to a private company that ran the Bioscope, albeit with difficulty, until it went bankrupt. Situated not far from the Ecomuseum of Alsace, the Bioscope, which opened in 2006, was a theme park dedicated to health, nature and the environment. Its cost of 31 million Euros was financed by the region of Alsace, the *département*[6] and the "concessioner" (the Compagnie des Alpes) as part of a 30-year contract. It was the symbol of an unprecedented example of a joint venture between local authorities and a private group. The group (formerly Grévin & Cie) became entrusted in 2001, in the legal context of a delegation of public service, with the conception, realization and management of the park, which was seeking to link entertainment and education about the environment. It was hoping to tap into new flux of tourists thanks to its synergy with the "Biovalley" of the upper Rhine, where major international pharmaceutical groups are concentrated (bringing together about 25,000 employees). The site aimed to have 800,000 visitors within several years, with an increase in new attractions: the results obtained (less than 65,000 visitors

the first year of opening instead of the 200,000 anticipated) were hardly in line with projected attendance, which led to its closure (creating in the meantime a difficult situation for the Ecomuseum, in terms of revenues and level of attendance).

On the concept of Major Facilities of Cultural Leisure

In light of the foregoing analyses, we propose the term "Major Facilities of Cultural Leisure" to refer to the major projects which have arisen these last years and until today (e.g. the recent opening of the Cité du Vin in Bordeaux), at the meeting point between theme parks and more traditional museum-like organizations. Moreover, we consider that there does not exist a true solution of continuity between museums, interpretation centers, zoos, botanical gardens, science centers and theme parks. How does one think, for example, of the Cité des sciences et de l'industrie, as well as the Parc de la Villette in Paris (the center of scientific, technical, and industrial culture, the museum of music, the concert hall and the *Grande Halle*, which offers both exhibitions and shows), the museum of Civilisations of Ottawa (Canada) or the City of Arts and Sciences of Valencia (Spain)?[7] In the case of the Cité de l'Espace (Air and Space Center) in Toulouse, "the objective remains very clearly that of promoting the science and technology of outer space, to interest and motivate young people in scientific field of study." At the same time, however, the city has decided to

> make its offer evolve towards more entertainment in order to durably widen the spectrum of its clientele. For this, it has chosen to position itself clearly as a park of leisure and education, and to inscribe resolutely its activity in the market of family leisure.
>
> (Reilhac, 2005: 206–207)

As for the Futuroscope (near the city of Poitiers), it claims to occupy "a place of its own between the entertainment aspect of theme parks and the pedagogical function of museums and science centers".[8]

It seems that every major French region is equipped with – or plans to become equipped with – a Major Facility of Cultural Leisure, which confirms the hypothesis of an increasing hybridization between private structures and public structures in the cultural tourism and leisure sector, in that these projects are frequently the fruit of public/private financing and respond to a will toward economic development of the territory in question. In effect,

> given the significance of the investments and the public vocation of the parks, there cannot be creation of those facilities without the participation of public funds. The local governments are thus called to put forth money with little or no return on the investment but with much return on local image and development, by creating structural facilities aiming to generate

supplementary flows of tourism which will feed the economy of their region.

(Website of the French Secretary of State of Tourism)

This analysis leads us to state that the Major Facilities of Cultural Leisure can be defined by three distinctive primary characteristics. First, they are created *ex nihilo*, from a local will toward territorial or regional development based on "structural" facilities aiming to create additional flows of tourists. Second, they aim for attendance of several hundreds of thousands of visitors per year. Third, their theme lies at the boundary between scholarship and entertainment, leisure and culture, scientific content and family-oriented activities, more old-style museums and theme parks. Table 15.2 proposes a distinction between cultural sites capable of being considered as "traditional" and facilities that approach our theoretical definition of MFCL.

By way of illustration, the following institutions can be mentioned as Major Facilities of Cultural Leisure: the Futuroscope (Vienna),[9] the Coupole Delfaut (Pas-de-Calais), the Mémorial de la Paix (Caen), Nausicaa (Boulogne-sur-Mer), Océanopolis (Brest), Vulcania (Puy-de-Dôme), Parc du Végétal (Angers), the Cité de l'Espace (Toulouse) and the Cité du Vin (Bordeaux).

Table 15.2 Major Facilities of Cultural Leisure (MFCL)

Criteria	"Traditional" Cultural Site	Major Facility of Cultural Leisure
Direction	Scientific/cultural profile	Development/Outreach/Education profile
Collection	Central to the mission	One component of the mission
Personnel	Public sector employees	Public and/or private sector employees
Income level	Weak	High
Partnerships	Underdeveloped	Multiple
Communication	Modest	Strong
Quality of service	Not measured	High
Assessment-evaluation	Infrequent	Systematic
Autonomy (Decision-making)	Reduced	Pronounced
Management style	Administrative	Entrepreneurial
Status	Public	Public-private partnership and other private statutes
Importance of special events	Minimal	Developed
Attractiveness for tourists	Variable	Strong
Impact on the local territory	Limited	Significant

Implications for the management of cultural sites

In relation with our definition of MFCL (creation *ex nihilo* from a local will toward development, high attendance expectations and a positioning between culture and entertainment), the results of the research cover three areas: first, lessons related to the management of cultural sites; second, lessons concerning the success of major projects; finally, lessons on the specificity of the world of culture regarding the leisure sector.

Attractiveness, management, and promotion of cultural sites

Cultural sites – particularly those aligned with the dynamics of tourism – can become actors or partners in territorial development policies by sensitizing decision makers to the significant issues affecting the region's potential, by supporting local projects, and by helping to valorize them. From a normative point of view, the management of the sites should respond to the following principles: the consideration of managerial issues by the leadership and by a staff having a proved expertise in strategy, marketing and quality control; the collaboration with the stakeholders (both public and private) that are actively involved in tourism and local development policies; the provision of significant resources for promotion and branding.

To achieve this, the training issue seems decisive, with the consideration of management imperatives and contributions of management to the success of their mission. Without this, curators and educators risk ceding managerial control to private entities and/or directorships. The challenge thus raised, however, seems complex: to lead, strategically, tactically and operationally, an educational, scholarly and cultural organization immersed in the world of consumption and of major events, all of which tends to negate its particular attributes. In this context, how should one avoid losing the *raison d'être* of the organization; how is it possible to maintain integrity, and remain faithful to professional ethics, while at the same time adapting to a changing environment?

Expectations, often unmet, concerning economic impact

According to the Cour des comptes, beyond the remarks applying to each of the cases (Pont du Gard, Futuroscope and Cap'Découverte in Carmaux), "the evaluation of attendance must be particularly prudent. The number of visitors is not growing indefinitely, especially in a sector that has become very competitive, and where consumer behavior changes relatively fast." (Cour des comptes, 2007). Three aspects should therefore be taken into consideration: first, it is necessary to define the market positioning of facility (it is pointless to aim for a wide family audience if the content is far from accessible to everyone). Second, the choice of the optimal size of the site is crucial. If too small, it will not attain the critical mass sufficient to attract enough visitors; if too large, it will not reach the desired economic equilibrium. Finally, it is useful to reevaluate

during the course of the project realistic levels of provisional attendance, since the preliminary studies often lack reliability.

The success of major projects of this sort necessitates taking into account a certain number of relatively well-known factors. If one can arrive rapidly at a high threshold of attendance, thanks to the efficiency of promotion efforts and of the professionalism of marketing officers, the issue is one of maintaining attendance levels for a longer period. This calls for regularly renewing the offering by changing activities (events, exhibitions, etc.) or by reinvesting in the scenography (which is often, however, costly). In this highly competitive context, one should avoid being cut off from one's environment, which demands a series of partnerships, alliances, cooperation with professionals in various fields (the arts, education, tourism, local development). Moreover, given the fact that the local clientele provides the base of the attendance, inflated entrance fees – like those in the theme park industry where the attractiveness and the duration of the visit are generally greater – could be devastating, particularly when accompanied with indifference or negative word of mouth from the locals.

The necessity of clarifying fixed objectives

The emergence of mixed-purpose facilities, seeking a family-oriented tourism clientele through scholarly discourse and educational tools, requires a proper balance between public service and entrepreneurial procedures, an appropriate level of investment in future offers, and a realistic appreciation of its economic impact in the concerned territory. Finding a good combination of scholarship and entertainment is no easy task. The consideration of numerous facilities of this type shows that the balance is particularly difficult to find, frequently bringing about the disappointment of public decision makers. Let's mention some of them: the Parc de la Préhistoire in Tarascon-sur-Ariège, the Parcours des Impressionnistes in Auvers-sur-Oise, the Automobile Museum in Mulhouse, Cap'Découverte in the Tarn region, the Bioscope in Alsace, or Vulcania in Auvergne. The indispensable step of clarification necessitates knowing where to place the emphasis: On encouraging the patronage of the widest possible audience? On deliberately presenting the institution as a tourist facility with a "structural" ambition for the region? On achieving a form of economic profitability (although this is often illusory in the cultural sector)?[10] Not to mention that the granting of public subsidies can also give rise to suspicion by the European Union of anti-competitive practices.[11]

Within the cultural sector, it is appropriate to keep in mind in any case that it is the scientific, artistic and/or educational mission that must take precedence in the last account, for it constitutes the justification for public investment. Thus, the use of techniques issuing from the world of leisure or the borrowing of expertise from the business sector must be considered strictly as a means of servicing the projects of the organization. Inversely, in the world of leisure, entertainment constitutes an end in itself, not something condemnable, but arising from a process that is different because it is must obey the imperatives

of profitability. Finally, the convergence between the worlds of culture, tourism, leisure and entertainment assuredly demands the accrued professionalism of managers of cultural sites, who must come to a perfect mastery of management tools in order to overcome the veritable constraints of good governance, rigorous use of public funds, and optimization of available human resources.

Conclusion

This chapter has attempted to come to an understanding of the reciprocal influences between culture and leisure. It shows that, despite an inarguable narrowing of the gap between cultural sites and the leisure and entertainment sectors, notable differences persist. Failure to recognize them, in our opinion, could pose a risk to the scholarly and educational mission of cultural institutions. That remains even true when they play a positive role in the development of a region's potential attractiveness for tourists, or when they serve as a symbol of a city's rebirth. This research could be followed by further research trying to identify specific strategies adapted to cultural institutions that target a wide, family-based audience seeking a "clever" kind of entertainment; and by research seeking to define business models put in place in order to attain them. The stakes are high, for if the cultural institutions must demonstrate their management capabilities and be accountable for their actions to their board or to local authorities, their financial success (which paradoxically could justify the withdrawal of their financers) should nevertheless not allow it to be forgotten that their mission of general interest (preservation, conservation, and study of collections, educational activities, publications and research, etc.) is not profitable and consequently will continue to call upon the intervention of public authorities and/or donors (individuals, foundations, corporations), according to their respective institutional system and legal framework.

Notes

1 Director of Option Culture (Studies and Research Institute) and associate professor at Paris 1 Panthéon-Sorbonne University

2 Understood as museums, monuments, science centers, archaeological sites, art centers, memorial sites, and interpretation centers.

3 French Ministry of Tourism.

4 "Some museum professionals get it. They understand what theme parks do very well: excellence in visitor services, multisensory experiences involving simulated environments, and state-of-the-art technologies" (Volkert, J. [1998, March–April]. Of mice and men. *Museum News*, 25–26).

5 "Un été à l'écomusée", op. cit, p. 16.

6 France is subdivided into some 100 political "*départements*" governed by elected "*Conseils départementaux*".

7 This city of arts and sciences, designed by celebrated architect Santiago Calatrava, comprises notably a museum of science, a planetarium, an IMAX cinema, a laserium, an oceanographic park, a sculpture garden, and a "palace of the arts", designed to host shows of theatre, dance and opera.

8 Hummel, D. (2005, September). Futuroscope. La stratégie du 10, 20, 60. *Cahier Espaces*, 199.
9 Despite the characteristic through which it strongly resembles theme parks.
10 "The financial balance of theme parks, taken between the client-consumer orientation that calls primarily for the entertaining, and for the orientation toward the general interest, which leads toward exploitation, will forever remain a difficult exercise" (Geneteau, J-M. [2005, September]. La Sem, un outil adapté à la gestion des parcs à thème. *Cahier Espaces*, 86, 5).
11 Boughilas, Z. (2005). La légalité des aides publiques au regard du droit européen. L'exemple du Bioscope. *Cahier Espaces*, 86, 8.

References

Ames, M. M. (1988, Spring). Oser être différent: une alternative. *Muse.*

Cannon-Brookes, P. (1991). Museums, theme parks and heritage experiences. *Museum Management and Curatorship*, 10, 351–358.

Cour des comptes. (2007). Trois aménagements à vocation culturelle et de loisirs. *Rapport annuel pour l'année 2006*. Paris: La Documentation française.

Grodwohl, M. (1996, November–December). Les musées de société en crise, le temps de la déception et de l'inquiétude. *Espaces*, 142, 26–29.

Grodwohl, M. (2002, November 6–8). *Écomusées et musées de société, pour quoi faire?* Fédération des écomusées et des musées de société, Besançon.

Grodwohl, M. (2005, September). De la nécessité de réinventer les parcs à thème. L'exemple de l'écomusée d'Alsace. *Cahier Espaces*, 86.

MacDonald, G. F., and Alsford, S. (1989). *Un musée pour le village global, Musée Canadien des Civilisations*. Hull: Musée Canadien des Civilisations.

MacDonald, G. F., and Alsford, S. (1995). Museums and theme parks: Worlds in collision? *Museum Management and Curatorship*, 14(2), 129–147.

Mintz, A. (1994, November–December). That's edutainment! *Museum News.*

Reilhac, B. (2005, September). La Cité de l'espace à Toulouse. Du centre de culture scientifique au parc ludo-éducatif. *Cahier Espaces*, 86, 4.

Tobelem, J.-M. (2010 [2005]). *Le nouvel âge des musées: Les institutions culturelles au défi de la gestion*. Paris: Armand Colin.

Tramposch, W. J. (1998). Te Papa: une invite à la redéfinition. *Museum International*, 199, 50(3), UNESCO.

Wireman, P. (1997). *Partnerships for prosperity: Museums and economic development.* Washington, DC: American Association of Museums.

16 Coping with ICT adoption

A difficult route for heritage in Southern Europe

Anne Gombault, Claire Grellier, Aurélien Decamps and Oihab Allal-Chérif

Introduction

Heritage and tourism organizations have had to cope with two important changes: first, the move to an experience and entertainment economy (Pine and Gilmore, 1999; Wolf, 1999) and second, the digital revolution and the resulting participatory culture (Jenkins, 2006). Tourism was quick to seize the opportunities to be gained from the spread of the Internet. This was a chance to simplify the connection between partners, a strategic asset for a sector dominated by packaged offers. Information and communication technology (ICT) also made it possible to do away with intermediaries and facilitate the relationship with customers, who were themselves empowered by the advent of Web 2.0 (Buhalis, 2004). Tourism became by far the first sector to use ICT as a major source of innovation, especially in the e-commerce field (Buhalis and Law, 2008).

Heritage organizations do not face the same strategic issues as tourism does and are less threatened by competition and the pressure to "innovate or die". The heritage sector is learning the hard way how to assimilate digital technology (Parry, 2013), especially in Southern Europe where most heritage organizations are isolated and consider these technologies as a threat that may alter, put at risk or even destroy inestimable works and artifacts (Vicente, Camarero and Garrido, 2012; Rizza, 2014). Difficulties encountered during implementation inhibit the decision to adopt ICT, and hence by implication, knowledge, experience and digital innovation are lacking in the field (Gonzalez, Llopis and Gasco, 2015). This chapter studies ICT adoption by heritage organizations in South-Western Europe and contributes to an understanding of practices and organizational factors of learning, the role of activities, status, size and context.

The research methodology is based on a multi-case study approach, examining thirty various heritage organizations in France, Spain and Portugal (see Table 16.2 in the chapter Appendix). The research findings reveal a general conservative behavior in the field (with nevertheless a willingness on the part of some organizations to adopt ICT in order to cope with financial difficulties due to a decrease in public subsidies). A familiarity with technology on the part of management or in relation to the activity of the heritage organization is a determinant factor here.

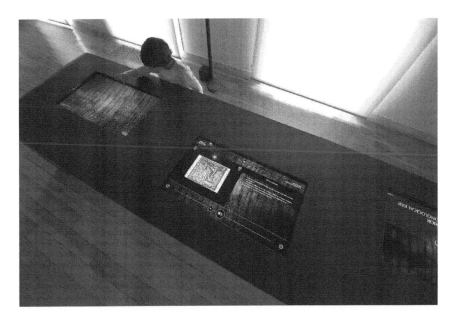

Figure 16.1 Interactive table, Museum Nacional Machado de Castro, Coimbra

After this introduction, the first section describes digital adoption from the Southern Europe perspective and presents the multi-case study methodology used in this research. The second section presents the empirical findings from analyzing the ICT adoption behavior of heritage organizations studied in the sample and factors that matter, before concluding with recommendations of strategies for heritage organizations and suggestions for the research agenda.

Going digital: the Southern Europe perspective

In times of rapid change, competition between organizations is fierce and the ability to adapt and innovate is becoming a strategic resource. Since the 1980s, the heritage sector has focused on audiences along with leisure alternatives, and they have needed to innovate to keep up with their competitors. In particular, they have adopted digital innovation through various organizational factors. In South-Western Europe, heritage organizations are mainly conservative.

Organizational factors of digital adoption in the heritage field

During the last decades, ICT has been increasingly implemented by heritage organizations (Parry, 2007, 2013) as a marker of innovation to help in their curating mission, their audiences mission and their management mission.

Table 16.1 Digital tools implemented in heritage organizations per mission

Heritage organization missions	Use of digital tools
Curating mission	Archives, scientific research, maintenance and preservation of artifacts, etc. (MacDonald, 2006; Stanco, Battiato and Gallo, 2011; Borowiecki and Navarrete, 2015)
Audiences mission	Online access to collections and databases, virtual exhibitions, multimedia content, interactive and participative tools such as crowdsourcing, dedicated play spaces, social media, online shopping, Internet of things and 3D making technologies (Bertacchini and Morando, 2013; Solima, 2014; Pulh and Mencarelli, 2015)
Management mission	Corporate communication (Wallace, 2006; De Man and Oliveira, 2016), internal communication, management tools, etc.

The adoption of technologies follows a lifecycle that can be accelerated or slowed down by different parameters. In particular, the decision to adopt ICT depends on several organizational factors (Orlikowski, 2000).

Heritage organizations have adopted ICT at various rates. Their learning depends on several characteristics (Parry, 2007; Peacock, 2008): nature of collections, cultural policies of the countries, type of governance, funding, size, staff commitment and networking.

Science and technology museums which are very committed to the IT revolution are more involved in digital innovation than art and history museums, which tend to be more reluctant.

In terms of cultural policies, Vicente and Lopez (2011) notice a digital divide, i.e. a structural geographical difference in the use of digital technologies. Museums in English-speaking countries, specifically Canada, the United States, Britain and Australia, were the first movers in digitalization. This transition is more recent in continental Europe with its strong tradition of interventionist policy, bureaucratic structures and an old vision of culture, especially in Latin countries such as France, Spain and Italy (Vicente, Camarero and Garrido, 2012). Public heritage organizations are more stagnant and conservative. Private organizations, however, are more independent and willing to move closer to companies in order to find sponsors and benefit from their innovative approaches. Privately owned organizations in particular, such as tourism companies, are connected with potential markets and position audience growth as the main objective of its action.

The impact of funding on digital innovation in the heritage field can be considerable (Peacock, 2008). On the one hand, heritage that receives private

funding will focus on welcoming the public by investing in scenography, digital display and communication tools. On the other hand, heritage financed by public funding will be more concerned about innovation in preservation, such as the digitalization of collections (Gombault, Allal-Chérif and Décamps, 2016).

The size of the organization is not as important a factor as its status in terms of attitude to ICT adoption. Large institutions, such as national museums, have greater skills, money, technological know-how and learning processes, whereas some small private structures are more flexible and dynamic. In general, small organizations create more innovation, but the value of these innovations becomes greater as the size of the organization increases (Hall and Williams, 2008). In the heritage field, there are few small organizations with the profile of a dynamic entrepreneurial company, and as a consequence digital innovation tends to be better established in large organizations.

ICT adoption is grounded in networks and communities of practice, both inside and outside the heritage community (Bakhshi and Throsby, 2012; Parry, 2013; Allal-Chérif, Gombault and Décamps, 2017). It is eased by a "diaspora" of highly committed people, untypical digital heritage practitioners (Marty, Rayward and Twidale, 2003). Most of them are "digital migrants", but some young staff are "digital natives" (Prensky, 2001) playing an important role in the adoption of ICT. According to their own professional identity, these actors cooperate through different discursive and practical spaces: curatorial, mediation, technological and academic. They believe that digital innovations present new opportunities to heritage organizations without destroying the sensitive experience approach. This revolution is an opportunity to reconsider the heritage identity and examine its tendency to transform organizations, visiting experiences and preservation work (Peacock, 2008).

Digital adoption in Southern Europe

Considering the organizational factors of ICT adoption as developed above, the use of digital technologies in continental Europe is still often seen as peripheral to the museum's traditional mission of knowledge dissemination (Vicente, Camarero and Garrido, 2012). It has not yet become a full strategy, or even part of an integrated work process and structure (Holdgaard and Ekelund Simonsen, 2011).

Based on the technology adoption life cycle model constructed by Moore (2014), an earlier article (Gombault, Allal-Chérif and Décamps, 2016) analyzed three categories of ICT adoption model for heritage organizations: conservative, pragmatist and visionary. In a context of slow digital heritage learning in Southern Europe (Vicente, Camarero and Garrido, 2012; Rizza, 2014), most heritage organizations have a conservative attitude. They limit their digital contribution to a basic website, not regularly updated, and a Facebook page. Other heritage organizations are more pragmatist and initiate creative approaches to optimize the use of digital tools by choosing the cheapest and easiest way to

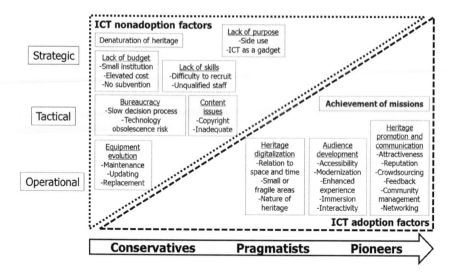

Figure 16.2 Factors motivating and hindering ICT adoption in heritage organizations
Source: Gombault, Allal-Chérif and Décamps (2016)

take charge, such as social media. A few pioneers have invested in more elaborate technologies such as augmented reality, digital games and geolocation apps (see Figure 16.1).

A multi-case study across three European regions

This research was undertaken in the framework of the SUDOE Interreg program, financed by ERDF (European Regional Development Fund) from 2011 to 2014. This program was created to support transnational projects in Southern Europe. The main project, Transcreativa, was to position the cultural and creative industries in the SUDOE space as good practice to encourage economic development and social cohesion. Nine partners were involved in the project, including universities, digital agencies and cities from three regions: Aquitaine (France), Euskadi (Basque Country, Spain) and Centro (Portugal).

The purpose of this piece of research was to understand digital practices of heritage organizations in these three regions and especially the organizational factors impacting the adoption of ICT (Figure 16.2). These regions were selected because of the diversity and richness of their heritage, which constitutes for them a strategic asset for attractiveness and economic and social development. A sample of thirty heritage organizations was selected based on two principal criteria: the best organization in terms of digital practices, and diversity in terms of reputation (local to international notoriety), attendance (from 10,000 to 1.5 million visitors per year), geographic area (rural or urban),

type of heritage (natural, cultural, tangible or intangible) and status (private, public or mixed) (see Table 16.1).

Data collection was triangulated for each case by way of documentary (1) direct observation, (2) participant observation and (3) semi-structured interviews of staff members. Direct observation was carried out as an Internet user explored the online tools proposed by the heritage organization: website, blogs, social networks such as Facebook, Instagram, Twitter, YouTube and TripAdvisor. Participant observation was based on an onsite user involved in a mystery visit using all the digital tools available: application, digital display, audio guides, QR code, digital games, virtual reality, etc. and reporting on the experience via notes and photos. Available documentation produced by the heritage organization itself or related discussions were analyzed, including posters, brochures, programs, websites, published articles and conference communications. Several employees were interviewed in the research framework, mainly top management and the person in charge of the digital implementation: managers from marketing, communication, community management and curatorial departments. Thematic content analysis of data was conducted for each case, and cases were then compared and classified according to their level of ICT adoption.

Findings: factors of conservatism and ways to learn

From conservatism to visionary behavior

The majority of heritage organizations in South-Western Europe have a conservative attitude towards technology (Gombault, Allal-Chérif and Décamps, 2016). These organizations consider ICT as a tool to make themselves more visible, to give out the right information and to attract more visitors. Yet technology is only an accessory and is not strategic for these organizations (Holdgaard and Ekelund Simonsen, 2011). It is essential for them to have material artifacts, and they are reluctant for digital tools to dominate during the visit. These conservative organizations are resistant to change and to risk taking, and they also suffer from a lack of human and economic resources. For example, at the Phare de Cordouan historical monument in France, ICT is "not part of the organization culture" and they have no one in charge of it: "my colleague is dealing with it among a thousand other things".

Pragmatist heritage organizations use mainstream technologies such as a website, social media and interactive applications. They have no digital strategy, but they have seized the opportunity presented to them (company sponsorship, employee projects, partnership with universities, etc.). The perfect example of pragmatism is the Museum of Grão Vasco in Viseu (Portugal), a museum with no budget to invest in ICT, so it uses company sponsorship and a qualified employee to install digital tablets in the museum. Because of its lack of autonomy on the official website, which is controlled by the city, the staff use social networks, especially Facebook, to communicate news of the museum.

Monastero Di Batalha, a pragmatist heritage organization: progress using all possible means

Monastero di Batalha is the third historical monument in terms of visitor numbers in Portugal. With no specific skills or means, it seizes all available opportunities to develop ICT in its organization and can be considered as pragmatist. As it is a national monument, the administration of the monastery is controlled by Lisbon, so the director has no power over the budget and hiring. The organization suffers from this lack of autonomy, which could help them become digital. Its latest technological innovation, the implementation of audio guides, took five years to become operational and was obsolete on its first day in use. A huge investment was made by the state and the region to create a digital wall. This was installed in the monastery; it worked for three months then broke down, with no plans in place to repair it (no one in the monastery team was qualified and they had no control over the budget to employ someone). To raise its profile and perform its preservation tasks, the monastery relies on partnerships. The organization has connections with universities for preservation – it employs students from the Polytechnic University in internships; it welcomes cultural organizations who perform arts shows sponsored by local companies; it authorizes free 3D digitalization of part of the monastery which is not visible to visitors in order to make it accessible; and it is ready to welcome Google to digitalize the entire monastery.

Some niche heritage organizations can be considered as visionary concerning ICT adoption; digital is a strategic asset for them. According to the Guggenheim Museum, digital is "the center of our audience policy". For them, heritage has to follow the societal evolution by integrating technology into its organization in order to be ready for the future. The Semana Grande, a Donostia festival, assumes that "nobody can question that that future lies in network and digital". ICT has plenty of possible heritage applications, including the ability to re-create history and a lost heritage. Digital is a strategic asset.

Heritage type counts in ICT adoption

The study brought to light organizational factors which are determinant in the ICT adoption life cycle (Parry, 2007, 2013; Peacock, 2008; Vicente, Camarero and Garrido, 2012). One of the most important factors is the type of heritage: the closer the organization activity is to technology, the deeper it will be involved in ICT adoption. Scientific museums are identified as pioneers among

cases studied in this research, whereas natural heritage, historic monuments and historic museums are the most conservative.

For scientific museums, technology is part of their activity and skills, and obviously this type of museum will use it to give the public broader access. In Spain, for example, the Eureka Science Museum of Donostia positioned many highly evolved interactive and digital tools during the visit, such as a virtual reality simulator. It is also an opportunity for preservation and research: the Science Museum in Coimbra in Portugal uses the Internet for open innovation and public participation to help them process research data.

Technology is also a concern for immaterial heritage, which can be promoted and shared thanks to Internet. Gastronomy is used widely by people on social networks, and the Basque Culinary Center of Donostia provides evidence of this phenomenon: "cooking is something very visual, everyone goes out to dinner, takes a photo of their dish and shares it on Instagram or Twitter".

Natural and historic heritage, on the other hand, are more concerned about preservation than public access and are afraid of the denaturing power of digital tools; heritage has to retain its essence. Furthermore, technology is not part of their fundamental skills. For example, the village of Saint-Emilion or the Dune du Pilat in France, both classified as heritage sites, have no digital tools visible on site.

Aldeias do Xisto: balance between authenticity and digital

Aldeias do Xisto ("Schist Villages") are authentic villages situated in the central region of Portugal, appreciated for nature tourism; the 19 municipalities welcomed 500,000 visitors to their paths in 2013. Tourism activity in the villages is under the control of a territorial development agency composed of public and private actors. Each of the 200 members has to participate by making a monthly contribution. This project was started in 2002 and is a great success, making it possible to revitalize the region and renovate its heritage. Aldeias do Xisto do not favor digital technology in the villages; there is no digital display or Wi-Fi available so as not to alter the nature experience: "We offer an intimacy between people who come, those who stay and live here with nature, with the environment's specific characteristics, there is only one way to experience it, with one's eyes and mouth." Yet digital technology is actively used to promote the destination online and to encourage visitors' comments on social media in order to create a virtual community around the Schist Villages. Digital is "essential" to create or maintain a relationship with previous and future visitors.

Freedom is good for digital heritage

Heritage activity is important to determine the ICT adoption of an organization, but a natural site or a historic monument is not automatically classified as conservative. Status, size, origin of funding and capacity for autonomy can all contribute to considering an organization as pragmatist, or even visionary (Vicente, Camarero and Garrido, 2012).

A decision-making capacity in employment, budget and strategy give the organization the freedom and the necessary efficiency to evolve with technological advances. The Tourism Office of Saint-Emilion is independent and is run as a private company. It is an excellent example in terms of destination promotion; it welcomes one million visitors a year, manages a wide range of guided tours (online booking available) and trains a network of wine estates in providing a welcome for tourists. The organization uses ICT to facilitate the relationship with all its partners: visitors, tourism office members and institutional stakeholders.

More importantly, the search for private sponsors undertaken by private organizations and public organizations in danger gives them the opportunity to be connected with companies, to be involved in a network and to benefit from knowledge transfer. The Contemporary Art Museum of Vitoria in Spain, Artium, financed by a mix of public and private funding, is aware of the necessity to become digital. For the museum, digital is not only a tool, it is becoming heritage itself. The museum uses it actively to preserve heritage by digitalization and also to create a relationship with its customers: "we are trying to maintain discussion and to listen to their comments on social networks such as Twitter and Facebook". The augmented reality project created for Parc de Thot, a prehistoric park in Dordogne, France, managed by Semitour, was possible because of the involvement of digital companies from the region.

The size of the organization plays its role in ICT adoption, mostly because the implementation of digital tools costs a lot in terms of money, time and human resources. Small organizations, hindered by their lack of means, prefer to put their funds directly into preservation and essential equipment for welcoming the public. The smallest organization studied was the least involved in ICT adoption.

Catedral Santa Maria of Vitoria: priority to preservation

The cathedral was constructed in 1181 in Vitoria (Spain) and is now managed by a foundation directed by three public entities: the province of Alaba, the city of Vitoria and the Church. Investment by the foundation is concentrated on the renovation of the cathedral, which began 22 years ago. The majority of religious monuments have not adopted ICT; major cathedrals have their own websites, but this is generally the only technological tool used. In 2014, the cathedral had a website with a virtual visit, but there was no social network activity and no digital tool during the visit. At Vitoria, the renovation of the cathedral gives an

understanding of the value of technology. In fact, 3D digitalization was used to create a representation of the original building and in this way improve the quality of the renovation. The plan is to set up a digital display at the end of the construction work.

Go digital and get younger

When they adopt ICT, one of the aims of heritage organizations is to attract a younger public (Stuedahl and Lowe, 2014). Many museums face an aging audience and take strategic actions to deal with this issue. For example, the Musée d'Aquitaine in Bordeaux (France) installed digital tablets for young people (13–18 years old) in the museum because "it is attractive and it encourages teenagers to come by creating a more dynamic visit". For Cap Sciences (Bordeaux, France), ICT adoption stimulates knowledge appropriation by young people from 15 to 25 years old. According to the Museo de la Bellas Artes of Bilbao, if they do not use social media to communicate with the younger generation, digital natives (Prensky, 2001), "there is a collapse in communication". However, museum digitalization is not well accepted by people aged over 60, who are not receptive to these new tools (observed in Museo San Telmo in Donostia).

In order to set up digital tools, heritage organizations need skilled employees. The majority of their employees are "digital migrants" (Prensky, 2001). They are not part of the digital generation; some are willing to learn but others are reluctant to use technology and do not want to be involved in ICT adoption. As a consequence, these organizations need to employ young people, to establish partnerships with universities and to welcome students in internships. Heritage organizations find it difficult to follow these recommendations because they do not have enough resources to employ someone dedicated specifically to digital or to train their employees, and sometimes they depend on the decisions made by their hierarchy. These were our observations in several organizations studied, such as Museu Nacional Machado de Castro in Coimbra and Monastero di Batalha. The Cathédrale Saint-André of Bordeaux website was created by a student free of charge at the request of the archbishop. The cathedral welcomes many visitors each year, and this was an opportunity to communicate with a wider audience. The collaboration was profitable for the cathedral but without a long-term partnership, it is not sufficient, as now the website is not updated.

Don't remain isolated, network

Heritage is not a homogeneous group; it includes private and public organizations, institutions and not-for-profit associations, scientific and artistic bodies, etc. In addition, heritage is sometimes isolated from tourism stakeholders. This diversity does not encourage the creation of a community organized into a network with exchange of their practices and knowledge. Fortunately,

heritage organizations which are independent in their decision-making and headed by a committed and digital-sensitive director are pioneers in the field and by their actions they create a dynamic in the region (Bakhshi and Throsby, 2012; Parry, 2013; Allal-Chérif, Gombault and Décamps, 2017). During the survey, it was observed that two dynamics could overturn these barriers: the strong involvement of territories or cities helped by tourism organizations and the impetus from a visionary organization. Collaboration is encouraged to achieve a common goal: the promotion of a destination to attract more visitors.

In the Basque Country, for example, the influence of Bilbao's cultural policy and the reputation of the Guggenheim Museum is key, and it is identified as a model by other heritage actors.

In the Aquitaine region, the MOPA (Mission for Tourism Offices in Aquitaine), a pioneer in terms of e-tourism in France, created training for a new profession in 2010: Digital Territory Organizer. This was a starting point to educate public tourism actors in digital technology and to create a community of practices for digital actors. The connection between the MOPA, digital companies and visionary heritage organizations such as Cap Sciences and Pôle Internationale de la Préhistoire encourages the diffusion of digital practices. According to the Musée d'Aquitaine in Bordeaux, "it is because local actors are developing digital that we, as a museum, can progress in this field".

Cap Sciences: a pioneer for Aquitaine

Cap Sciences is a private center for the sciences. In 2014, it was the most visited cultural destination in Bordeaux, with 500,000 visitors per year. Its activities consist of exhibitions, research and development in the scientific and cultural domains. It is visionary in the digital field and is considered as "a center which creates social, cultural and economic value" for the region. Its role extends beyond the usual mission of a traditional museum, as it is active in knowledge transfer and regional development.

The center proposes virtual exhibitions and participatory activities on its website and is very active on social networks. The physical exhibitions offer numerous digital tools, and thanks to a personal C-You card, the visitor can interact with and contribute to the exhibition. The director considers that digital technology gives another relationship with time and space because it is able to follow the visitor before, during and after the visit. Cap Sciences is very connected with its environment, it works with institutions, companies and other heritage organizations. It has been quoted as an example by other actors, such as the Pôle Internationale de la Préhistoire (International Prehistory Center).

The influence of cultural policies on digital adoption

Heritage organizations evolve in a specific context shaped by other actors' behavior and public policies. France benefits from a long-term interventionist policy to support heritage and culture, as does Portugal. However, Spain promotes autonomy and private initiative. These policies have an impact on the behavior of heritage organizations towards technology. As mentioned previously, the search for private funding and autonomy in decision-making boost the adoption of ICT by heritage organizations while public funding, on the contrary, favors conservatism (Vicente, Camarero and Garrido, 2012, Allal-Chérif, Gombault, and Décamps, 2017).

Consequently, Spanish heritage organizations are more involved in digital technology than are French and Portuguese organizations. They are aware of the strategic advantage brought by ICT and are very much implicated in the use of social media for promotion and communication. This trend is particularly visible in the Basque Country, where the economic contribution of the digital sector seems fairly significant. In another part of this study, using micro-level data on firms' activity and the UNCTAD classification of the CCI sector (cultural and creative industries), the research project produced a map of CCI economic output (operating revenue and net income) at the regional level (Aquitaine, Basque Country and Portugal Centro). It showed that the New Media sector carries considerable weight in terms of economic output in the Basque Country. This sector is representative of an important integration of digital technologies and seems to have resisted the effects of the economic crisis well. This regional context may be a factor in accelerating the integration of ICTs in heritage organizations, because they can easily benefit from this expertise in their close location.

Portugal is suffering from the economic crisis, and consequently, subsidies for heritage and culture are decreasing and organizations are in danger. Many heritage organizations in the country are remaining conservative and trying to fulfill their main missions, but with difficulty. Some try to adopt ICT tools because they think that it can help them to be more visible, to attract new visitors and increase their profits. They are tinkering with unpaid work, partnerships, sponsorships, students in internships, etc. According to the director of the Grão Vasco Museum, "I think that we are beginning to put digital in museums, at the moment the problem is money". This observation is confirmed by mapping of economic output of the CCI sector: heritage organizations have suffered a great deal from the economic crisis in terms of operating revenue and net income. While the New Media sector has remained at a higher level compared to other CCI sectors, the economic crisis has generated a significant decrease. This deprived regional context in terms of CCI and digital economic output may partly explain why heritage organizations adopt a conservative behavior towards the integration of ICTs.

In general, French cultural organizations have long benefited from public subsidies and have concentrated on their missions of preservation and

education. However, a two-fold change in public policies has begun which could transform the behavior of heritage organizations towards innovation: there has been a decline in public subsidies for culture and an increase in public investment in digital. In Aquitaine, especially, the region supports a large number of projects to develop ICT in the economy. As a result, some organizations seize the opportunity to receive subsidies for digitalization. For example, the Library of Pau opened in 2011 with numerous digital displays and a project for an online library: Pireneas. Each year, the library receives the necessary budget for its upkeep and the digitalization of new documents. Once again, the regional context of CCI economic dynamism may reinforce this interpretation: heritage and the new media organizations' economic output have resisted the effects of the economic crisis, allowing investment for digitalization by heritage organizations.

To conclude, the Basque country's organizations are probably the ones most involved in digital technologies and those of Portugal Centro the least because of the tradition of public funding and the current economic problems. Aquitaine was conservative, but investment by the region in digital will probably encourage heritage organizations to gradually adopt ICT.

Conclusion

This study contributes to an understanding of ICT adoption by South-Western European organizations. Their behavior is mainly conservative, with some differences depending on the nature of their collections and their status, size and regions of implementation. Many organizations are still stuck fast in their outdated attitudes, isolated, with no digital skills, lacking in funding and reluctant to turn to technology. Nevertheless, even if digital technology is not perceived as strategic at the moment, more and more organizations are willing to use it to improve their image and attract more visitors. The dynamism of private organizations, the commitment of some pioneer organizations, the support from public policies for digital projects and the energy developed by digital networks are a powerful driving force for ICT adoption by heritage organizations.

Conservative and pragmatist organizations have to keep going, to consider all types of financial support (public or private), to work towards a better way of welcoming visitors and above all to exchange their knowledge and practices in an open innovative system with a community of digital, heritage, cultural and tourism organizations. Compared with other sectors of the economy, especially in continental Europe, ICT adoption in heritage organizations, even in those that are pioneers, is still merely incidental. Organizations must go further and become more involved in innovation. The relationship with visitors has to become central. Many companies interact with their customers in order to create innovation with them and to involve them in the production offer. Public authorities have to encourage networking by digital, heritage and tourism organizations and promote financial support for digital heritage, and they also have the duty to educate heritage employees in the use of digital tools.

The next step in this research could be to compare these results with other Southern European countries and also with Northern European countries. Digital is evolving fast, and major change in the regions can bring about an evolution in the results. In Aquitaine, for example, the opening of a digital center in Bordeaux with a department dedicated to e-tourism and the arrival of an international center for cave art in Lascaux that is filled with technology could be game changers in digital learning in the region. As has already been done for French art museums (Allal-Chérif, Gombault, and Décamps, 2017), another step in this research could be to study the best practices to design true communities of practice involving mutual commitment, resource repertoire and practice-based networks so that heritage organizations can learn collectively, transferring and co-creating knowledge and innovation (Hildreth and Kimble, 2004).

Appendix

Table 16.2 Sample of heritage organizations

Heritage Organization	Attendance 2014	Country	Heritage Type	Status
Dune du Pilat, Bassin d'Arcachon	International and National stars: 500,000 to 1,500,00 visitors/year	France	Natural heritage	Public-Private
Juridiction of Saint-Emilion Tourism Office, UNESCO label		France	Material and immaterial heritage	Private
Fêtes de Bayonne		France	Immaterial heritage	Public
Guggenheim Museum, Bilbao		Spain	Arts museum	Private
Semana Grande, Donostia		Spain	Immaterial heritage	Public
Semitour, Perigord Lascaux Cave, UNESCO Label		France	Prehistoric site	Public-Private
Aldeias do Xisto, Centro Region		Portugal	Natural, material and immaterial heritage	Public-Private
Monastero Di Batalha	Regional stars: 100,000 to 500,000 visitors/year	Portugal	Historical monument, Religious site	Public
Cathédrale Saint-André, Bordeaux		France	Historical monument, Religious site	Public
Catedral Santa Maria, Vitoria		Spain	Historical monument, Religious site	Public
Museo San Telmo, Donostia		Spain	Arts and Civilization Museum	Public

Heritage Organization	Attendance 2014	Country	Heritage Type	Status
Museo de las Bellas Artes, Bilbao		Spain	Arts museum	Public
Musée d'Aquitaine, Bordeaux		France	Arts museum	Public
Cap Sciences, Bordeaux		France	Science museum	Private
Eureka, Donostia		Spain	Science museum	Public-Private
Museo Machado Di Castro, Coimbra		Portugal	Arts and Civilization Museum	Public
Museo Balanciaga, Getaria		Spain	Fashion museum	Public-Private
Pôle International de la Préhistoire, Les Eyzies		France	History museum	Public
Museo Do Pao, Seia		Portugal	Food museum	Private
Artium, Vitoria	Local stars: 10,000 to 100,000 visitors/year	Spain	Arts museum	Public-Private
Museu Grao Vasco, Viseu		Portugal	Arts and Civilization museum	Public
Museo Maritimo de Ilhabo		Portugal	Maritime museum	Public
Pireneas, Pau		France	Digital Library	Public
Museu a Ciencia, Coimbra		Portugal	Science museum	Public
Phare de Cordouan	Local stars: 10,000 to 100,000 visitors/year	France	Historical monument	Public
Basque Culinary Center, Donostia		Spain	Food heritage center	Public-Private
Filmoteca vasca, Donostia		Spain	Immaterial heritage, digital platform	Public-Private
Museo Gorrotxategi de la confitería, Tolosa		Spain	Food museum	Private
Museo de imagen em movimiento, Leiria		Portugal	Science museum	Public
Son d'aquí, Bilière		France	Immaterial heritage, Digital platform	Public-Private

References

Allal-Chérif, O., Gombault, A., and Décamps, A. (2017, June 28–30). French art museums going digital: From a vicious to a virtuous cycle. *7th Global Innovation and Knowledge Academy Conference (GIKA 2017)*, Lisbon, Portugal.

Bakhshi, H., and Throsby, D. (2012). New technologies in cultural institutions: Theory, evidence and policy implications. *International Journal of Cultural Policy*, 18(2), 205–222.

Bertacchini, E., and Morando, F. (2013). The future of museums in the digital age: New models for access to and use of digital collections. *International Journal of Arts Management*, 15(2), 60–72.

Borowiecki, K. J., and Navarrete, T. (2015). *Digitization of heritage collections as indicator of innovation*. University of Southern Denmark, Discussion Papers on Business and Economics No. 14/2015.

Buhalis, D. (2004). eAirlines: Strategic and tactical use of ICTs in the airline industry. *Information & Management*, 41(7), 805–825.

Buhalis, D., and Law, R. (2008). Progress in information technology and tourism management: 20 years on and 10 years after the Internet – the state of eTourism research. *Tourism Management*, 29(4), 609–623.

De Man, A., and Oliveira, C. (2016) A stakeholder perspective on heritage branding and digital communication. In V. Katsoni and A. Stratigea (eds.), *Tourism and culture in the age of innovation*. Springer Proceedings in Business and Economics. Cham: Springer.

Gombault, A., Allal-Chérif, O., and Décamps, A. (2016). ICT adoption in heritage organizations: Crossing the chasm. *Journal of Business Research*, 69(11), 5135–5140.

Gonzalez, R., Llopis, J., and Gasco, J. (2015). Social networks in cultural industries. *Journal of Business Research*, 68(4), 823–828.

Hall, M., and Williams, A. (2008). *Tourism and innovation*. London: Routledge.

Hildreth, P. M., and Kimble, C. (eds.). (2004). *Knowledge networks: Innovation through communities of practice*. London: IGI Global.

Holdgaard, N., and Ekelund Simonsen, C. (2011). Attitudes towards and conceptions of digital technologies and media in Danish museums. *MedieKultur: Journal of Media and Communication Research*, 27(50), 100–118.

Jenkins, H. (2006). *Convergence culture: Where old and new media collide*. New York: New York University Press.

MacDonald, L. W. (2006). *Digital heritage: Appling digital imaging to cultural heritage*. Oxford: Butterworth-Heinemann.

Marty, P. F., Rayward, W. B., and Twidale, M. B. (2003). Museum informatics. *Annual Review of Information Science and Technology*, 37(1), 259–294.

Moore, G. A. (2014). *Crossing the chasm* (3rd ed.). New York: HarperCollins.

Orlikowski, W. J. (2000). Using technology and constituting structures: A practice lens for studying technology in organizations. *Organization Science*, 11(4), 404–428.

Parry, R. (2007). *Recoding the museum*. London: Routledge.

Parry, R. (2013). *Museums in a digital age*. New York: Routledge.

Peacock, D. (2008). Making ways for change: Museums, disruptive technologies and organizational change. *Museum Management and Curatorship*, 23(4), 333–351.

Pine, B., and Gilmore, J. H. (1999). *The experience economy: Work is theatre & every business a stage*. Cambridge, MA: Harvard Business Press.

Prensky, M. (2001). Digital natives, digital immigrants part 1. *On the Horizon*, 9(5), 1–6.

Pulh, M., and Mencarelli, R. (2015). Web 2.0: Is the museum-visitor relationship being redefined? *International Journal of Arts Management*, 18(1), 43–51.

Rizza, M. (2014). La numérisation du dossier d'œuvre. *Culture et Musées*, 22, 25–45.

Solima, L. (2014). Digital resources and approaches adopter by user-centred museums: The growing impact of the Internet and social media. In L. Aiello (ed.), *Handbook of research on management of cultural products: e-Relationship and accessibility perspectives* (pp. 181–100). Hershey, PA: Business Science Reference, IGI Global.

Stanco, F., Battiato, S., and Gallo, G. (2011). *Digital imaging for cultural heritage preservation: Analysis, restoration, and reconstruction of ancient artworks*. Boca Raton, FL: CRC Press.

Stuedahl, D., and Lowe, S. (2014). Social media as resource for involving young people in museum innovation: A cultural studies approach to co-design. *International Journal of Socio-technology and Knowledge Development (IJSKD)*, 6(3), 60–80.

Vicente, E., Camarero, C., and Garrido, M. J. (2012). Insights into innovation in European museums: The impact of cultural policy and museum characteristics. *Public Management Review*, 14(5), 649–679.

Vicente, M. R., and Lopez, A. J. (2011). Assessing the regional digital divide across the European Union-27. *Telecommunication Policy*, 35(3), 220–237.

Wallace, M. A. (2006). *Museum branding: How to create and maintain image, loyalty, and support*. Walnut Creek, CA: AltaMira Press.

Wolf, M. J. (1999). *The entertainment economy: How mega-media forces are transforming our lives*. New York: Times Books.

17 Innovation and design thinking

Socially engaged design thinking and the D/E/A paradigm

James E. Doyle

Introduction

This chapter draws together many proven ideas and processes that will aid you in developing innovative processes as applied through the design thinking model. However, and I hope this doesn't disappoint you too soon; the goal here is to raise more questions for the reader than answers. The inspiration for this chapter was in part the Designing Dublin project, whose goal, amongst others is "Engaging citizens in conversation and participation using Dublin as a living laboratory."[1] While the project achieved many successful outcomes, it seemed at times superficial and too inwardly focused, which may account for one of its early tag lines: "Learning to lean". In retrospect, the project was undertaken during a time of acute austerity in Ireland, and many of the team, myself included, were perhaps looking for the project to provide economic and social solutions that were way beyond the capacity of the project. The project may have appeared to lack a greater goal, while it did say that it would engage citizens in conversation and participation, it didn't offer them anything beyond that. In this chapter, we will explore the "beyond" or the added value; a greater purpose beyond, but not to the exclusion of, the solely economic. In the following chapters, we will explore what that purpose might look like, with a focus on socio-cultural benefit, sustainability and responsible practice, pathways to innovative practice for economic benefit and social good. For the purposes of brevity and clarity, this chapter will use the term "design thinking" as a shorthand for and interchangeable with innovative thinking.

A short background to design thinking

Innovative/design thinking isn't anything radically new. It has its genesis in theories expounded by the pragmatist philosopher Charles Sanders Peirce (1839–1914), but some would say its trajectory dates back to the earliest of cooperative solution-based designs, and hence could logically be traced back to primitivism and tribal cooperation. This chapter begins by advancing an interpretation for "Socially Engaged Design Thinking" and the "D/E/A (Design/ Economics/Anthropology) paradigm". These suggested that it might provide

us with something new, when actually it transcends the "something new"; it is in fact an unchallengeable logic! Socially Engaged Design Thinking adheres to the four pillars of sustainability: economic health, social equity, environmental responsibility and cultural vitality. Only this type of design approach can address the big issues that face us as a race. Only all four sustainability issues might have the ability to be truly democratic, create continuity, provide longevity and free economic activity from production focused on limited resources. Only this way of approaching solutions can offer us any chance to stay alive and perhaps live well. The fulfilment of these principals and the attainment of real workable solutions in this regard have been and are being accomplished at present through Agenda 21 for Culture (A21C), a model of practice promoted by United Cites and Local Governments. Although this chapter touches on some of this type of work, I would advise readers to search through the work of both the organisation and the adoptive model A21C (all available online) to find out more.

Introduction

This chapter will cover common parts of design thinking as an iterative model. The model reviewed is not exclusively a socially engaged model; rather it is the groundwork, based on the activities undertaken with the Designing Dublin project (fostered by Design 21c, Dublin City Council and the Creative Dublin Alliance), that might contribute to the more complete model for Socially Engaged Design Thinking. This chapter explores that theme and some of the potential that might help to define the core values of socially engaged design thinking. It includes:

* The basics of design thinking, how that thinking is derived and its emphasis on social engagement.
* The characteristics of design thinking that make it different from other practices, including the mechanisms that show how it is applied and how it operates.
* The structure of this thinking and a set of critical observations with a conclusion.

What is design thinking?

Many people cite IDEO's founder David Kelley as the first person to coin the phrase 'design thinking'. In saying that, he simply saw the value in the design approach and was astute enough to package it and sell it. So what is IDEO selling? "Our Thinking: IDEO's focus lies at the intersection of insight and inspiration, and is informed by business, technology, and culture."

Design thinking is a process for practical, creative resolution of problems or issues that looks for an improved future result. Unlike analytical thinking, design thinking is a creative process based around the "building up" of ideas. Note that there is an inherent failure here, in that "an improved future result"

does not take account of a past or current successful solution. That is, design thinking is future focused only, and therefore fails to fully account for the full range of possible successful solutions. It can offer, however, the opportunity to temper lateral design processes with a methodology that draws on multiple disciplines. Design thinking adds perspectives to innovation and thereby increases the potential number of correct solutions. In its application, design thinking includes a process for engagement, questioning and investigation, prototyping and the application of different and changing types of thinking.

The A/D/A and M/E/P paradigms

In organization and management theory, design thinking forms part of the A/D/A (Architecture/Design/Anthropology) paradigm, which characterizes innovative, human-centred enterprises. This management paradigm focuses on a collaborative and iterative style of work and an abductive mode of thinking, compared to the more traditional deductive thinking associated with the traditional M/E/P (Mathematics/Economics/Psychology) management paradigm.

The D/E/A paradigm

The true value of design thinking is when it is used as an engagement process for people. Then it becomes significantly different to either the A/D/A or M/E/P models. It is no longer an industry-focused or research-based model, because it has at its core values that include issues of societal democracy and empowerment, while still maintaining the perspective of innovative practice.

The D/E/A paradigm in design thinking is a creative and iterative style of work with an abductive mode of thinking, including human-centred empathy, with human-centred enterprises. The change is how human-centred enterprises are realised: At heart the paradigm maintains the essential qualities listed before but not solely to drive traditional models of economic and entrepreneurial success. Where the D/E/A model differs is that economic and entrepreneurial activities directly address issues of sustainability. Sustainability is at the core of the ethos governing the economic and entrepreneurial thinking for the D/E/A paradigm. Socially engaged design thinking adheres to the four pillars of sustainability mentioned earlier. This then is the essential difference between A/D/A or M/E/P and the D/E/A models: only socially engaged design thinking (within the D/E/A paradigm) can address the four sustainability issues via all economic and entrepreneurial activity.

Core values: Diversity in design thinking

The diverse applications of design thinking and the diversity of models within it are part of its inherent values. The value of design thinking is in the ability to pull together multiple perspectives. So too can there be, and are, different models or methods of design thinking, some regional, some national and some

corporate. Like cultural capacity, it is not the one against the other but the joining of different perspectives that creates added value.

> *Diversity, or "cognitive variety," is essential to innovation. Design in today's terms must be at once global, yet regionally specific.*
>
> Conference on Design Thinking and Innovation: Towards a
> Global/Asian Perspective 2006

Design thinking adds additional perspectives to designing and thereby increases the potential number of correct solutions. The benefit of multiple perspectives, which is one of the core values of design thinking, can also be applied to its operational application. So if multiple perspectives are a core value, then multiple levels of operation in the thinking and application of design thinking must also be considered (Figure 17.1). This will mean that short-term and long-term solutions, for example, are to be considered alongside prototyping

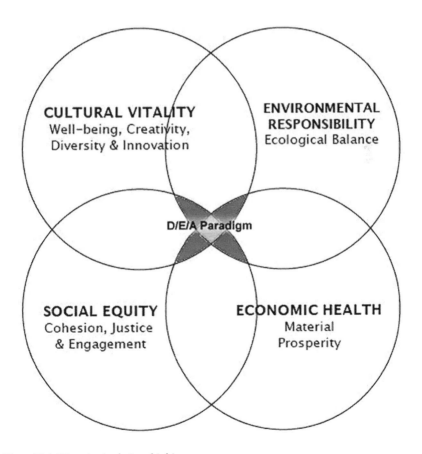

Figure 17.1 Diversity in design thinking

and tangible outputs. By inference, this also means that short-term solutions and long-term prototyping can also be included: many perspectives = many applications. Accepting the value of differential thinking and its implied understanding of different perspectives on the same topics leads us to a recognition of the next value: cultural capacity.

Cultural capacity

> *Cultural capacity is our ability to open our mind to be able to see wider and further without being restricted by cultural boundaries.*
>
> Cultural Capacity (a not-for-profit organisation)

While this statement is laudable, it would be more appropriate to say cultural capacity should take those "boundaries" and look for intersections that generate innovative solutions. It is the possibility to create something new from shared passions that generates increased capacity. We do not just recognise value in other cultures, perspectives or logic bubbles, we exploit them. In a 2007 presentation, "What are the benefits of inter-cultural dialogue,"[2] the following observations were made: inter-cultural dialogue must have a reason to exist, a shared value and a process (of exchange). When these exist, innovation can occur. This unknown capacity for innovation where one understanding meets another is a core value.

Sustainability

As noted at the start, design thinking alone should not be a dominant methodology. Ideally the core ethos governing all design should be one of sustainability, with all thinking addressing the four pillars of sustainability: economic health, social equity, environmental responsibility and cultural vitality. These four pillars cannot operate separately to one another; they only become "sustainable" when interlinked. Only design that addresses all four issues has the ability to create continuity.

Characteristics

Types of design thinking

The following are examples of some of the differences between the main types of design thinking and help to define what the core values are in each case.

M/E/P paradigm – research-based design thinking

The M/E/P (Mathematics/Economics/Psychology) paradigm is used in organizational and management design. It features centralised decision-making

processes and hierarchical communication channels pursuing specific "rational" goals. Characterized by its inward focus, special attention is accorded to costs; rules; respecting hierarchy; dividing resources into simple, specialized jobs; promoting production efficiency and combating waste; enforced standardization; and a mechanistic orientation to structural design, emphasizing high specialization, rigid departmentalization, clear chain of command, narrow spans of control, centralization and high formalization. This paradigm does not focus on a collaborative or iterative style of work and represents a deductive mode of thinking.

A/D/A Paradigm – industry-focused design thinking

The A/D/A (Architecture/Design/Anthropology) paradigm is also used in organizational and management design. This management paradigm focuses on a collaborative and iterative style of work and an abductive mode of thinking, although it is not usually or wholly democratic. While the paradigm has characteristics of innovation and sees itself as being a human-centred enterprise, it operates and searches for rule-based forecasting and validation systems based on outcomes and product. It is mostly business linked and dominated by the management imperative of an organisation by being industry biased and focused on an equation that places organisational benefit (sometimes profit) over sustainability.

D/E/A paradigm – socially engaged design thinking

The D/E/A (Design/Economics/Anthropology) paradigm values design as an engagement process for people. It is significantly different to either the A/D/A or the M/E/P model. It is no longer an industry/organisational-focused model and has as its core values of societal democracy and empowerment. It maintains a perspective of innovative practice, creativity and an iterative style of work and an abductive mode of thinking, with human-centred empathy. Its human-centred enterprises are realised via an agenda exclusively biased towards issues of sustainability, because this is the core ethos governing the economic and entrepreneurial thinking for the paradigm. Socially engaged design thinking adheres to the four pillars of sustainability. It also applies non-rule-based logic with validation by use, interest and take up. It is welfare connected, socially focused and dominated by notions falsely defined as intangible values. Advocates of this model are often unwilling to compromise or express values in economic terms. It values validity over reliability and authenticity over populism, and it is characterized by long-term vision and typified by abductive logic.

Abductive and deductive logic

As indicated previously, design thinking was invented by the pragmatist philosopher Charles Sanders Peirce. It draws its conclusions from what is happening

rather than what should happen. With deductive logic, we expect something to happen because it has been forecast. With abductive logic, we reason why something is happening because it has not been forecast. The issue with deductive logic is that it can often be surprised by what is not forecast, whereas abductive logic is always ready to reason why.

Before we look more in-depth at design thinking, it is worth noting that out-of-the-box thinking has become somewhat of a cliché. It may be worthwhile to quote the artist Banksy: "Think outside the box, collapse the box and take a f*%ing sharp knife to it."

Design thinking – characteristics and features

- Design thinking is the application of a series of tailored processes that seek to find constructive solutions focused around opportunity.
- Design thinking combines exploration, learning, fun, innovation, constructive attitudes (in that order) to the structure of task-oriented thinking.
- Design thinking invites teams to flexibly apply relevant information, emotions, critical analysis, value judgements and creativity to all stages of the research action process.
- Design thinking is not just half full or half empty, but also what glass? Why glass? Whose glass? What is full? And any other questions that need to be asked.

The main features of design thinking are[3]:

- Action focused with tangible results.
- A process dependant on the skills of multidisciplinary teams.
- It usually does not know the outcome of a process at start.
- Draws knowledge from action research practice.
- Fast tracks multiple models to test theory.
- Challenges received, perceived and existing wisdom.
- Grows in its capacity to interpret, navigate and apply new learning.
- Is adaptive and reactive to changing circumstances.
- Is typified by the search for unknown questions and the exploration thinking.

Things that are true for design thinking

- You gain when you give way to another point of view.
- Logic bubbles are doorways to new learning.
- Statements are correct only when defined by circumstances.
- Forever is ok until a new forever can be understood and advanced.
- Gentle processes gather greater information than do aggressive processes.
- Aggressive processes increase the dynamic strength of prepositions.
- Challenge must be accompanied by a strong alternative.

- There are many interpretations for the same information and all are correct when viewed from inside a logic bubble.
- Pre-formed ideas are the children of individuals, constitute only information and are often formed from opinion.
- "Many" and "most" are preferable to the term "all".
- Certainties must be diligently criticised.
- Looking at future rather than current possibility increases potential.
- Notions of what is the best set of solutions have a hierarchy which is based on functional or aesthetic necessity.
- Speculation, practice and understanding increases possibility.
- Exploration and analysis are more important than advancing an opinion or a perspective.
- New ideas are enjoyable.
- Difference of opinion is a basis for investigation.
- Opinion is open to change and subject to change in knowledge and comprehension.
- All design is hypothetical and subject to proving in the real world.
- New information is the most powerful cause for change of design and process.
- Comments are islands of thought looking for links to mainland thinking.

Learning to learn

The concept of lifelong learning is not new. It can be traced back to authors such as Basil Yeaxlee and Eduard Lindeman in England in the 1920s, who understood education as an ongoing process. In recent years, changing patterns in careers and work have made these observations practical imperatives. Former or traditional learning patterns would be characterised by slow graduated learning curves and plateaus of learned practice, with slight increases in learning as time and experience increase.

For those of you with the inclination, I would recommend that to understand design thinking and learning to learn, it's much easier to just read chapters 1 and 2 of *The Little Prince* by Antoine De Saint-Exupery – a children's book for adults. It's succinct, needs no elaboration and is just a two-minute read.

Design thinking and circular learning

Design thinking has a steeper learning curve than does the traditional learning model, with an attainment of a perspective which challenges the need for a single professional dogma. Design thinking requires the subjugation of individual competencies to the potential of multidisciplinary perspectives. The steep learning curve with no plateaus challenges received, perceived and existing wisdoms. It grows in its capacity to interpret and navigate new learning.

At the point of realisation, learning becomes circular and accumulative and can be applied or tailored to circumstances, problems and issues. This circular learning will increase but not exponentially, and the growth over time will be less significant. Other professional and information-based agencies and individuals will impact, directly and indirectly, the learning bubble.

Strata of design thinking operations

INNOVATIVE THINKING

Innovative thinking will form part of the thinking for all members of a group and can reside with individuals, sub-teams and the group at large. Unhindered, it has the potential to be destructive to working processes and the group dynamic. When used objectively, it can be the single most positive influence on new idea generation and team cohesion (Figure 17.2).

Innovative thinking will:

• Always look for new, creative and unusual ideas and interpretations. (Again, the inherent failure is to look for the now and the past.)
• Often look beyond the solution and at the consequences and what the alternative scenarios may offer.
• See new ideas as provocation for new avenues of thinking.
• Sometimes make it difficult to engage in proving ideas.

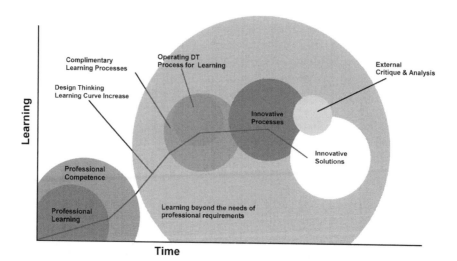

Figure 17.2 From design thinking to innovative solutions

- Allow some team members to temporarily engage and disengage in sub-teams, processes and action.
- Can often be bored by conventional opinion and standard canons of argument.
- Create ideas that are free and do not need to be defined by individual ownership.
- Generate disparate and free radical ideas that seem unconnected to topic or focus.

Advice for innovative thinking:

- Follow all discourse closely to ensure your challenges and prepositions are objective.
- Avoid negative enthusiasm and take all ideas as new.
- Designs and ideas are easier to understand when clearly connected to the objective of a process or the focus of a project.
- Free radical ideas must be questioned, analysed and if unconnected stored for later use.
- Argument is an exceptional tool for challenging ideas and exposing new ones.
- Avoid ownership and support communal acquisition of ideas and processes.
- Beware of chasing the new while the good dies.
- Understand the stigma of big thinking and always project humility.
- Positive innovative thinking will undertake occasional shepherding actions.

SUBLIMATIVE THINKING

Again, this thinking can reside with all, some or just one member of the group. Sublimative thinking is an objective analysis of possibilities, seeks to gain access to the logic of the process at hand and is focused on the questions rather than the solutions. During sublimative thinking processes, individuals will address functionality over innovation.

Sublimative thinking can subjugate thinking to function and should be governed by the caveat that best is a subjective analysis of function. Ergo, the best route from A to B is a subjective function: best can be the most aesthetic route, the fastest, the safest or the choice not to go at all.

INTUITIVE THINKING

Considered as "spontaneous", "innate" or "shrewd", the value of intuitive thinking is its ability to bring new perspectives often linked closely to the process or issues at hand. It is often insightful and when analysed, the supposed innate understandings can be qualified and often become the distinct focus of an action or process. Intuitive ideas can occasionally seem to be oblique responses

to thinking in general terms and may seem to give irrational, or more precisely, unconnected answers. The response of the group at large can be a good indicator for valuing these answers, as a positive response to a seemingly unconnected answer will indicate a high value to an intuitive answer.

Mechanisms

Part 1 – Processes

Process is a method for groups to engage directly in the early design stage focused around specific topics. They are a discursive and open method of analysis designed to extract as much honest and useful information as possible from the participants as well as searching for new ideas. They are often designed to ensure maximum engagement and ownership with the topic or theme for all participants.

The method, dynamic and structure of process must be outlined for all participants at the start. A process leader should be named and they will shepherd all participants through the four stages.

Four stages

STAGE ONE

A process should include as many methods of recording information as possible; for example, play, conception of pre-existing ideas, and introduction of feelings, intuition, opinion and vision form the first stages of group processes. Tools like play, which facilitate these first-stage investigations, can be most effective in breaking down professional resistance to opportunities and offering opportunities for inhibitive, reserved or introverted people to engage. Care should be taken that extrovert personalities do not dominate the results of these early questioning processes. Leaders should set the parameters early with invitations such as "I would like to hear from you all" and should support the equity of the discussion by asking for those who have not spoken to comment as often as possible.

STAGE TWO

Deepening questions which attempt to open logic bubbles or source evidence for information from stage one form the second phase of the process. They include questions that allow access to the perspective of a logic bubble and may start with questions, such as "Why do you think this is so?" and "how have you arrived at this conclusion?" In the later stages, deepening and more substantive questions can sometimes be asked, such as "What evidence do you have to support your opinion?"

STAGE THREE

Stage three is the "what if?" stage and deals with possibilities, giving free range to all ideas. It will address ideas raised by the deepening questions and ask the group to consider alternatives. As with all stages of a process, an opportunity exists to change the dynamic of the group by providing interesting and alternative ways to answer; again play is often the most valuable vehicle.

STAGE FOUR

Stage four is a birthing phase, where tangibles are discussed and advanced. Ideas should not be strongly challenged at this stage, as ideas (possible solutions) are still delicate and subject to evidence-based research, expert advice and real-world prototyping. These "solutions" are a means for positive engagement and allow participants to consider issues beyond the supposed impossible.

Note: The traditional method of finding champions early on should not be the only or ideal method used. Indeed, it can prove counterproductive and contrary to the potential of idea flow. Look for occasional, cerebral and intuitive champions who advance innovative approaches and help create a vision without undertaking its realisation. Immediate debriefing for process leaders and hosts must take place at the end of the session to gather as much evidence as possible. At this point, everyone usually needs to lie down and have a rest.

When it all goes a bit sideways

If a process seems to be intractable and participants are unable to positively engage with the issues being discussed, the process leader can address this question to the group. A pause should be called. The group should be asked to rate the progress of the process in terms of their own personal satisfaction. Those individuals that indicate significant dissatisfaction must be asked what could be done to make the process more satisfactory or what issues are not being addressed. If agreeable to the group, these issues may then form the core of the rest of the session. In some cases, specialist teams, such as the Kayos Pilots from Denmark, design and lead these processes.

Finding the individual passion

Beware, it is not usually the job a person does that defines them. Passions will change with time and can often be hidden under professional image or ego or behind a humble exterior.

Passion will exponentially increase the level of joy that each individual will experience through an engagement with the design process.

Don't confuse professional fervour with individual passion. A good worker can bring commitment to any profession but will carry a passion between them all.

Part 2 – Questioning and investigation

When undertaking initial research, a positive twist to the investigation method, questions and syntax can offer more affirmative results than a resolution-based approach. The couching of questions as to what can be investigated rather than what can be fixed will yield more solutions. "It is broken, how do I fix it?" is a resolution-based question. "It is broken, we can't fix it, but what can we do?" is an affirmative question based in positivity. "It has failed, can we understand why?" is a last question and is the positive mature stage of design thinking questioning.

Advice for questioning:

- Don't ask questions just because you think you know the answer.
- Create a free and equitable platform for all questioning.
- Ensure that everyone has had the right opportunity and environment in which to be heard.
- Always ensure that everyone has had the chance to comment.
- Record all answers and use these as a base for your prototypes.
- Offer hope but don't make promises.
- If the process of researching and questioning is creating argument, dissention and camps of opposition, offer the opportunity for re-evaluation. Direct the focus of your questions at the disappointed and ask what could be done to make the questioning better.
- Always allow the dissenting voice to express positive solutions.

Part 3 – Prototyping

Earlier we read that "All design is hypothetical and subject to proving in the real world". This is not only a true statement, but also an instruction. Prototyping is the fulfilment of this instruction.

> Visualising ideas takes them from concepts that could mean different things to different people. Creating even a crude prototype makes an idea tangible and allows you to get feedback on an actual thing in order to revise and refine with a user-centered process.

Things to do when prototyping

Prototypes should not look finished and should offer the opportunity for users to actively engage with reinterpreting, renovating and ultimately owning the prototype.

- Remember a prototype is not real but it could be.
- Remember people will forgive a prototype.
- Realise that prototypes are many and products are singular.
- Even a conversation is a prototype.

- Prototypes live outside of the studio and die inside the studio.
- Prototypes are intimate failures but should not be forgiven.

Things to watch out for when prototyping:

- Don't place the hypothetical in the driving seat.
- Don't disregard hypotheses for practical or functional solutions only; hypothetical and crazy can create new.
- Rip it up; it's only a prototype.
- It's not what you say but what you do that defines you.

Champions

Champions are the people who will lead and follow ideas through from the conceptual stage to execution and proliferation.

A champion will often conform to one of two types:

- The first will be someone whose professional life will be best served by championing a new idea or project.
- The second will be an individual whose passion runs concurrent with the goals, aims and aspirations of an idea or project.

Champions are best chosen by themselves, but may not always be recognised or appear at the start of a design process.

Team exercises

Important note

It is important to note that overly prescriptive engagement in the following exercises can become regimented and stagnant.

As with free play, these are *guidelines only* and must be supplemented with totally free and democratic alternatives that are not tailored to group engagement and allow for individual relaxation.

Quiet time, periods for individuals to escape the group and new forms of free exercises must take precedence over the following prescriptive exercises.

Cleansing exercise

When a new group comes together, a cleansing exercise can often be helpful. The aim of this exercise is to expose and separate preconceptions and opinion, cleansing creative thought so that it is easier to undertake new thinking. Many tools can be used, but discussion-based processes are time consuming. Tools that enable a rapid exposure of ideas and create the maximum distance between starting ideas (typified by preconception and opinion) will enable the greatest opportunity for the maximum number of new ideas to be exposed. The tool

chosen must be significant and not insurmountable (as would be asking a team to come up with 100 ideas each around a topic).

Defining idea exercise

Defining idea exercises are focused on individuals and allow them to rapidly define and identify themselves within a group. These exercises are a good mechanism for groups under time pressure and aid in the early setup of group dynamic and cohesion.

Groups may also use this exercise to define objectives and form cohesive statements about activities.

Examples:

- Asking each person to bring a creative and defining object to be shared with the group.
- A shared building exercise followed by discussion and response.
- Who am I? roundtable introductions.

Examples for groups:

- Breaking up into sub-groups to define shared aspects and then return to share.
- Shared individual statements followed by voting process to agree and define. The outcome of these voting processes may be governed, overturned or discarded by the artistic director/group leader, subject to the methodology employed.

Energy exercise

Energy exercises (EEs) are intended to address physical and mental lethargy as well as acting as bonding exercises. They are typically short physical tasks that are easily understood and require group participation. Fun and play are the operative words for these activities. Shared shouting and calls also allow for the expulsion of dynamic tension.

Examples of energy exercises:

- Passing and throwing
- Short building and imagination
- Hackas
- Mexican wave
- Power Ranger moves

Free play

Free play is the opportunity for all members of the team to take part In a play activity. Play is a core requirement of all design thinking teams and must form

part of the studio and activity set up for the team. *There are no circumstances in which free play should not be available.* Free play is the main opportunity for indirect thinking and is the main valve for venting mental pressures, bonding and having fun. Free play is the core activity for a group to enjoy.

Free play includes:

- Board games
- Table tennis
- Ball games
- New team games

Structure and teams

There are two standard structures for design thinking teams: They can be either temporary or permanent but are usually assembled to work towards a new design or service or can be focused around positive social/human engagement.

Leadership model

In the leadership model, a group of multidisciplinary people receive direction from a designated leader. The leader may also hold a veto over all work, research, direction, products and teambuilding, including the types and composition of teams.

Democratic team model

Often known as self-directed or self-managed work teams, a group of multidisciplinary people in the democratic team model share a common mission and values and collectively manage their own affairs within predetermined boundaries.

Deconstruction

In deconstruction, design teams must be able to deconstruct and reconstruct around different ideas and travel between ideas, models and prototypes. This is a key element to a design team's ability to apply multiple perspectives and to continually question prepositions.

Know the team you work for

It is important for both leadership and democratic team models that the process of engagement and decision-making is clear. It may not matter that the hierarchy of a team is flexible or changeable or that the team places or designates responsibility or authority in one person – all these can be effective models. What matters is that the process of management and decision-making is clear to all and agreed by all. If this is not undertaken at the start, then dissatisfactory notions of inequitable voting and a sense of a false democracy may abound.

Team working and agreement – "Say it back"

Agreement can be defined as a negotiated settlement. This should not mean that the understanding by all parties is the same, especially for design teams. Working through a process dominated by oral settlement means that all agreements must be re-voiced to the team, with each person saying what they understand as the agreement.

This process is not essential for all working but must be undertaken at critical times, such as before a group presents its ideas to an external critic.

The process is also invaluable for gaining access to individual logic bubbles and potentially exposing new and exciting perspectives.

Creating a physical prototype will also allow a team to manifest agreement around the act of creation.

Artistic directors

The artistic director (AD) will shape the direction of thinking and action for a design team by addressing discussion and process in terms of the principal focus. The AD will apply open questions which invite and reintroduce the focus and maintain direction, shepherding thoughts and action back to core themes.

The principal is the focus of a process. If the process is around "the hidden potential of place", for example, then the focus of return for all action, thinking and research is to the principal: "the hidden potential of place".

Note: Innovative thinking must attempt to bridge the distance between the modus of innovation and the task at hand.

Artistic directors of design thinking teams will:

- Define the sequence volume and suitability of action research processes.
- Shepherd teams through difficult processes.
- Set and govern scenarios for critical discourses and appraisal.
- Articulate the many different understandings of the design process to different audiences.
- Facilitate the search for real unknowns.
- Enhance the creative capacity and exponential learning curves of team members.

A short word on inspiration:

Design inspiration can come from anywhere – geography, art, life, shopping, fun, the pub! For design thinking, it appears that three core elements help more than most. In this case, inspiration is made up of the following core elements: people, place and fun. Inspiration is an associative operation; it exists at the intersection of these three elements, often in the small spaces where they have moved apart but still overlap (Figure 17.3).

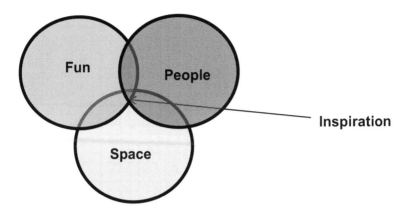

Figure 17.3 Inspiration

Critical themes on design thinking

Below are some of the main critical themes around design thinking. They are followed by some short observations (rather than a rebuttal) and the chapter's conclusion.

Design thinking is driven by an unknown power

Inevitably, design thinking will be ineffective if applied in isolation to the problem of creativity. Designers must consider what role power plays in an organization's inability to create innovative products. But more importantly, designers must be prepared to identify and name power and its sources (e.g., the pursuit of profit at the expense of innovation). They must not simply use ethnographic techniques to uncover "unmet needs".

Design thinking is thinking rather than doing

I think that design thinking is regressive and risky for design since it is placing thought ("define") always before action ("prototype") and analysis ("research") as the precursor to creativity ("ideate"). I simply don't believe the wheel was created through this process. In fact, the real challenge designers face is the opposite − a recognition that action (prototyping, sketching) often proceeds thinking and many products, inventions and great companies were born out of a burst of creativity and not through a regimented thought process. Furthermore, the notion of linear process as the absolute gold standard for proper management and creativity is, in reality, one big fallacy. Linear processes are seldom the way the world works. The non-linear and even chaotic nature of creative thinking is curtailed by a false presentation of a squeaky-clean linear process.

Design thinking has nothing to do with real life

I find it disingenuous to retroactively assign the "design thinking" label over the work of some of our best entrepreneurial thinkers. The design thinking community is full of that. I recently read in a blog that both Steve Jobs and Philippe Starck are among the top 20 design thinkers. These are two great creative individuals, yet we simply don't know if they are design thinkers. I would be more than surprised to find Starck's legendary quick artistic process is actually a premeditated act of design thinking. Steve Jobs is obviously one of the best technology leaders we are blessed with. Jobs's Apple is a brilliant continuum of visionary business leadership, yet it could be called design thinking only through an act of jarring revisionism: the Apple or Macintosh platform was not envisioned by a declared design thinker, following the process mentioned above. So the problem here is simple – where is the proof for design thinking efficacy? It would be nice to see real examples of true design thinking processes succeeding in real life, delivering the true proof for the efficacy of design thinkers as business leaders.

Design thinking is just innovative thinking by another name

Third and last is the hidden definition – what is not said clearly and is not discussed openly is quite obvious, that design thinking is a marketing slogan adapted by a very large and influential innovation consultancy to redefine its services to be somewhat similar to business consulting. There's nothing wrong with that, except that it's not clearly discussed and acknowledged. The transformation of a message from "innovation" to "design thinking" is therefore also an amazing business strategy transformation through PR and marketing campaigns.

Nailing down design thinking is dangerous

The drive to nail down design thinking has the same normative flavour that has restricted the spread of systems thinking. The urge to create a framework that specifies what and how a design thinker proceeds seems not just futile but dangerous to the survival of a movement aimed at expanding the kinds of thinking that managers, policy makers and citizens engage in.

Observation

Design thinking operated by organisations is driven by a known power; just read the manifesto or whatever the company states as its vision. Couple that with objective questions: "Is this a business, an NGO or an ethical company?" and that will tell you what the focus is and where the power lies. However, the pursuit of profit is not exclusively at the expense of innovation nor does it exclude ethics and sustainability. Design thinking can include "bursts of creativity",

"prototyping before or preceding thinking" and "a chaotic approach to creative thinking". It is also suggested that being tied down as a "linear process" is a failure to acknowledge the inherent question that focuses all creative output: Can it be replicated? Design thinking may actually have nothing to do with real life, if, as a percentage, we recognise that most ideas generated via the design thinking process are cast aside, then most design thinking is just that, thinking. But this is not how it should be measured – it should be measured from its take up and usefulness. Design thinking is innovative thinking. It is also a marketing slogan adapted by a very large and influential innovation consultancy to redefine its services. But that doesn't mean it cannot be of value outside that world. To suggest that would be like saying, "I won't use a spoon for my soup because the spoon has connotations I disagree with." Don't worry about the message that comes with the spoon; just eat your soup.

Conclusion

The last critical theme on innovation and design thinking is perhaps the one that speaks the most to what was driving so much debate around the idea of design thinking, as well as associated concerns about who owns it. In answer to the last notion that "Nailing down design thinking is dangerous" – No, it's not! What on earth are we afraid of? Just because one person says what they think it is doesn't make it a set of rules! It appears that the "survival of a movement" has more to do with our concerns for ethical thinking and the challenges we see "hiding" around the corporate corner than it has to do with reality. I have noted earlier that the true value of Design thinking is when it is used as an engagement process for people. Then it becomes significantly different to an industry-focused model, because in that way it maintains some core values including democratic engagement, citizen empowerment and a strong socio-cultural focus, while still maintaining the potential of innovative practice. Design thinking applied in this way could be extremely successful in addressing issues of sustainability, especially in terms of local self-sustaining initiatives. However, because it avoided an ethos and refused to be "nailed down", it was misread as industry focused. If we are to address issues of sustainability and find solutions, then there must be an ethos governing innovation, and socially engaged design thinking and the D/E/A paradigm must be at the heart of all innovative process.

Notes

1 Designing Dublin, www.designingdublin.com
2 Presentation of research by the author at the EU Diploma in Cultural Project Management, 2008.
3 The following nine items are interpretations taken from Edward de Bono's *How to have a beautiful mind*: de Bono, E. (2004). *How to have a beautiful mind*. London: Ebury Press.

Part III
Innovation and the arts

18 Making space for values in the commerce of culture

Priyatej Kotipalli

What is important to you? Is it money, is it economic growth or is it about cities that want to be viewed as being creative? The question gets various answers depending upon whom you ask and from what institutional setting.

What matters while answering this question depends upon the framing from which his/her worldview is informed. Of the various framings that are possible, economic framing is the important institutional setting from which we approach this chapter.

The framing for economics is informed by the conversation among economists in their conferences. In such conferences topics related to economics are debated, talked about and disseminated where the underlying theory and assumptions that form the understanding of economics remains static, whereas the methodological underpinnings to explain and make sense of the economic world keeps getting more sophisticated.

A 1987 study of six top-ranking graduate economics programs[1] showed that the perception of the students varies according to the pedagogical inputs[2] they have received. The paper states that the scientific status of economics is in doubt among the students. The difference is seen in the distinction between positive and normative economics and the agreement on fundamental issues. Four out of the six major programs (except MIT and Harvard) have some agreement on the fundamental issues.

This study was replicated in 2005 with the addition of Princeton to the survey. The paper concludes that while there have been changes in economics, the differences seen 20 years earlier still exist.

Economics as a field of study to outsiders might look to be a unified body of knowledge, but factually it is a social science of various schools of thought. These schools of thought have their own ideas about the economy and how individuals behave in it. Economists acquire their knowledge through the crucible that is the graduate school at the university where they are indoctrinated in the finer points of the school of thought. This pedagogy provides the would-be economist with methodological grounding and the tools with which he/she interprets the world.

Economists' worldviews are influenced by rhetoric, which has many layers. There is the visible layer of the rhetoric of the dominant school of economic[3]

thought and the way it is presented to the public and policy makers about what is important. Then there is the rhetoric of the school of thought even if it is not mainstream, followed by the personal rhetoric of economists. The personal rhetoric is presented as the everyday conversations in the lives of economists and this (the way they argue with themselves in their own minds and in seminars) may differ from official rhetoric. McCloskey says it is necessary to be aware of the differing rhetoric, and that economists should be more self-aware concerning their personal rhetoric, as this would enable them to find the reasons why they agree or disagree with the official rhetoric. This makes them less likely to be dismissive of others simply on the grounds of methodology. In other words, its makes economists more inclusive of diverse ideas to explain what happens in our world.

A positivist understanding of the world

The official methodology of economics is modernist, and economists tend to take a positivist approach towards the world. While positivism in economics focuses on statements of "what is", the alternative to be normative, which focuses on "what can be". Positive statements can be broken down to cause and effect. Whether the effect is desirable is a normative question that will depend upon the subjective opinion of those affected. Economists practicing positive economics can help analyze the effects in greater detail by breaking them down into positive and testable statements. They can advise policy makers in government, business and other organizations both on the effects of specific policies and on the specific policies that need to be implemented in order to achieve desired effects. However, it is ultimately politicians and managers, and the people who empower them, that decide – on the basis of normative judgements – what is "desirable" and what is not.

It is important to realize that economists practicing positive economics do, however, make value judgements. Any analysis involves an element of subjectivity. In the first place, even what to analyze and how to analyze it often depends upon the subjective views of the analyst regarding what is, and what is not, important. Economic decisions have many different effects, and it is rarely possible to examine them all in detail.

The pervasive presence of positive economics is what legitimizes economics as a science, and it follows the modernist construction. The dominance of positivism is complete in economics textbooks, and this is limiting the role of economists (Boland, 1991).

Colander (2000) tries to give a better understanding of standard economics thinking[4] by explaining it in terms of the following attributes. The first attribute of the school is understood from the definition of Lionel Robbins (1932): "Economics is the science which studies human behavior as a relationship between ends and scarce means which have alternative uses."

This standard definition of economics forms the building block for the construction of this school of thought. Demand and subjective choice theory are

the other features of the school. The focus of the school is on marginal trade-offs and assumes farsighted rationality in its structuring of economic problems. The school is accepting of methodological individualism[5] and finally neoclassical economics is structured around general equilibrium.

Economics and culture

The current underlying thought (theory and assumptions) that informs our worldview is given by the standard economic framing. The underlying assumptions of such an economic thinking at its core is the principle of the rational human being whose functions are profit or utility maximization. Those who participate in this framing have no place for culture in their conversation to explain humankind's economic behavior.

In such a framing, the goods that are important are understood to be private or public in their ownership. In other words, the logic of where these goods and services can be exchanged follow either market or governmental logic (and now increasingly with neoliberalism, the government uses the vocabulary and language of the market). The underlying institutions are therefore set in such a manner that promotes this worldview.

Culture in such a framing is reduced to being understood as a price that one is willing to pay in a market for cultural goods or services. In such a case, culture is used as a marketing tool (e.g. using terms such as "handcrafted", "heritage" and so on). The same terms are also used as rhetorical tools when used to gather support in an argument for governmental subsidy as a matter of public policy.

However, is a more holistic aggregation of the economic value of culture possible, and if so, how? The question comes with issues that relate to the underlying theory and assumptions of the framing through which we understand the world.

If the current dominant economic theory is one that advocates rational choice and maximization of profit or utility within a modernist mindset which seeks a positivist approach to science, then it is indeed very difficult to approach a more holistic understanding of economic value of culture, as there is no room for a discussion for the intangibles that culture produces.

When there is room for a broader interpretation of the term "value" in economics, then the current reductionist interpretation which equates value as price can expand to a broader understanding of the value of culture in terms of economics, economy and society.

"Let us assume"

To further our conversation, let us assume that values are important, as is the culture that produces them. This position allows for us to explore the role that culture plays in our economic behavior. This is a departure from standard economics, as we are replacing rational choice with the realization of values as being central to explain economic behavior.

The consequence of this position is that culture is not in the margins of economics but is all-encompassing. Economics is embedded in culture. This is the position advocated by Arjo Klamer, with the idea of a value-based method for economics (Klamer, 2016).

Based on the assumptions made of replacing rational choice as the guiding principle for economic behavior with the realization of values, our understanding of economics changes. It shifts from being a study of the allocation of scarce resources to that of individuals in search of ways to realize their values.

It stands in contrast with standard economics, which is concerned with the market as a means of allocation of scarce resources, to a position where individuals are in search of means to actualize their values. The value-based method therefore gives more weight to culture, which forms the environment where these processes can happen.

Klamer (2016, p. 8) provides clarity about culture by explaining it in three terms which he labels as follows.

C1 which is understood to be culture in the anthropological sense, i.e. as material culture that develops from the interaction of humans with their surroundings and each other in social settings.

C2 which is understood to be culture in the civilizational sense, which is the acumination of culture, traditions and practices that define nations. This is to be understood in terms of what makes up an Indian or an Italian, German or Japanese.

C3 is understood as the market for cultural goods and services. This is seen in myopic terms of standard economics as what it contributes to the economy versus what its fiscal costs are in trying to provide for it.

The statement that economists do not see culture as a factor for economic decision-making is a broad claim and comes with some qualifications. We need to understand the various other positions that are possible when talking about culture and economics to understand the context of the claim.

Culturalists are those who study culture from the perspective of C1 and C2 – they are the anthropologists, sociologists, historians and so on. They are the professionals who make sense of the world around us by studying it and help to build the cultural picture. For culturalists, the market and by extension economists do not understand culture, and even if they do, it's about developing the market for cultural goods and services. However, an interesting proposition is that culturalists almost always mistake economists for businesspeople and policy makers.

Economists are the other group who try to understand the relationship between economics and culture. The view that culture does not play an important role for economics is a dominant view which stems from standard economic framing. However, in the relation between economics and culture, economists[6] provide reasoning/rationale/argumentation for supporting culture. By applying standard economics principles to the cultural sector C3, they provide reasoning ranging from arguments for the public good to those of considering culture as a lagging sector and therefore in need for support (e.g. Baumol's [1967] cost

disease). These rationales have been used both by policy makers and by the culturalists as arguments for providing support to the cultural sector.

The connection between the cultural sector C3 and that of the economy is that culture is important for the creative economy.

Therefore, under the umbrella of standard economics, the two tenable positions concerning the relationship between economics, economy and culture is that of:

- Standard economics being applied to culture (C3) to allow the operation of the market for cultural goods.
- The positioning of the cultural sector C3 as a legitimate and fast-growing sector of the economy.

A greater role for culture: making space for values in heterodox economics

While the standard economic approach does not really consider the "cultural dimension" at its core, there is space for such conversations in the recent developments in heterodox economics.

The cultural approach to economics deals with the interplay between informal and formal institutions along with its cultural and cognitive perception. Under the heterodox school of economics, three areas have emerged that envisage the role of culture in economics (Goldschmidt, 2006)

- Institutional economics as a theory of institutional change as established by Douglass C. North (1990).
- The evolutionary approach to economic and social philosophy in the tradition of Friedrich A. von Hayek (2012).
- The behavioral economic theory related to sociobiology, evolutionary anthropology, evolutionary psychology and so on.[7]

Culture is an important feature for all of the above heterodox schools of economics. What makes the value-based method nuanced enough to be considered a new school is the fact that it makes a claim that economics and the economy are embedded in culture. In the case of North (1990, p. 3), institutions are understood as the "rules of the game in the society or, more formally, are the humanly devised constraints that shape human interactions". The idea of "rules of the game" was originally introduced by Adam Smith, a fact that was cited by von Hayek in Goldschmidt (2006, p. 176).

North's central point is the proposition that a framework of institutions structures the human "playing field" and this results in a "proper method of playing". This positions institutions as key to altering human behavior. This also means that for a just outcome of the game, there has to be a fair structure. This positions the history (perhaps in the context of C2) and culture (in the context

of C1) that need to be taken into account as they lead to path dependence in framing the game.

The social philosophy of F.A. von Hayek (2012) includes a section on "the progress of cultural evolution" in trying to clarify the term "cultural evolution"; the relationship between culture and economics is explained by him. He explains, "culture is neither natural nor artificial, neither genetically transmitted nor rationally designed" (von Hayek in Goldschmidt, 2006, p. 178). Further, he clarifies that

> cultural evolution is not the result of human reason consciously building institutions, but of a process in which culture and reason developed concurrently, is perhaps, beginning to be more widely understood. It is probably no more justified to claim that thinking man has created his culture than that culture created his reason.
>
> (von Hayek, 2012)

It is summarized by Goldschmidt (2006, p. 178) as "culture is a human phenomenon, and only a human phenomenon is a process that runs parallel to the evolution of mankind". The key assertion that one concludes is that for a proper understanding of human development a cultural context is necessary. To that extent culture is the key variable that elucidates human behavior as distinctly human behavior. This leads to the conclusion that if economic phenomenon develops out of activities of man through time then it becomes clear why the examination of economic processes has to be understood as a cultural phenomenon as well. In the case of von Hayek, the understanding of culture is distinctly civilizational, i.e. C2.

The nuance of the value-based method: a new school in heterodox economics

The value-based method to economics as mentioned is an alternative perspective on economics. It is unique because unlike the other heterodox schools, it proposes that the realization of values explains human behavior.

The method proposes that people's economic behavior is the consequence of them trying to realize their values. However, such values are within a cultural context. This cultural context is formed in the combination of C1 and C2. The commerce of culture in C3, i.e. a cultural sector, is where they valorize their values.

Culture in the sense of both C1 and C2 produces the cultural context within which these values are produced and consumed. In such a world, the object of cultural consumption becomes a medium to exchange values. The point where values are realized through the cultural good, it produces goods that are of higher order, which Klamer (2016, p. 89) calls the "goods to strive for". These goods have the ability to form practices on four axes of social, societal, personal and the transcendental goal values.

The just outcome in such a system is dependent on people being aware of their values and their ability to work with them through a developed sense of phronesis in being able "to do the right thing".

However, this happens within a cultural context that forms the reference by which values are realized. In doing so, the production of the higher order goods adds to the cultural context, thereby reinforcing and validating them further.

Therefore, we can summarize that the economics of the value-based method is embedded in culture and that when people participate in the cultural sector they are validating their culture.

$$C1 + C2 \leftrightarrow C3$$

Key takeaway

The objective of this chapter is to make people aware of the preconditioning that standard economics has placed on us in trying to answer to the question of what is important to us. In the cultural sector, the conversation about economics is limited because of the application of standard economics principles. There is a need to look beyond this preconditioning and understand what is really important to us. In other words, if income is not the criteria for defining a good life and good work, would the cultural sector still be considered lagging, or is participation in the cultural sector in itself a means to a good life and good work? To realize the answers to this question we need a broader idea of economics. Therefore, the chapter is an invitation to readers to explore the question of what is important to them, to be aware of it and to act in a manner that reflects that reality, breaking out of the rhetoric placed on us. The value-based method to economics is being offered as normative approach to economics, which intends to cut through the clutter to help us in doing the right thing.

Notes

1 University of Chicago, Columbia University, Harvard University, Massachusetts Institute of Technology, Stanford University and Yale University.
2 This informs their framing about how they understand the world.
3 The official rhetoric, to which they subscribe in the abstract and in methodological ruminations, declares them to be scientists in the modern mode. The scientific method is a composite of logical positivism, behaviorisms, operationalism and the hypothetico-deductive model of science. McCloskey (1983) declared the official methodology of economics to be modernist and that the mainstream economic framing shows the prevalence of this modernist thinking. She explains the outlines of this through ten dictums which define the framing.
4 In many cases, it's understood to be neoclassical economics.
5 Methodological individualism has no universally accepted definition (Hodgson, 2007). However, the origins of the term are traced in its original context to Schumpeter in his 1909 *Quarterly Journal of Economics* paper, "On the Concept of Social Value" (Udehn, 2002). It amounts to the claim that social phenomena must be explained by showing how they

result from individual actions, which in turn must be explained through reference to the intentional states that motivate the individual actors. (Heath, 2015).

6 As is expected, they have a positivist outlook and try to remain objective to remain scientific.

7 This will not be explained in greater detail.

References

Baumol. (1967). Macroeconomics of unbalanced growth: The Anatomy of urban crisis. *The American Economic Review*, 57(3), 415–426.

Boland, L. (1991). Current views on economic positivism. In D. Greenaway, M. Bleaney and I. Stewart (eds.), *Companion to contemporary economic thought* (pp. 88–104). London: Routledge.

Colander, D. (2000). The death of neoclassical economics. *Journal of the History of Economic Thought*, 22(2), 127–143.

Goldschmidt, E. A. (2006). Culture and economics. *Intereconomics*, 41(4), 176–199.

Heath, J. (2015). The Stanford Encyclopaedia of Philosophy. [Online]. Available from: http://plato.stanford.edu/archives/spr2015/entries/methodological-individualism (Accessed 2016).

Hodgson, G. (2007). Meanings of methodological individualism. *Journal of Economic Methodology*, 14(2), 211–226.

Klamer, A. (2016). *Doing the right thing: A value based economy*. London: Ubiquity Press.

McCloskey, D. N. (1983). The Rhetoric of Economics. *Journal of Economic Literature*, July XXI, 481–571.

North, D. (1990). *Institutions, institutional change and economic performance*. Cambridge: Cambridge University Press.

Robbins, L. (1932). The nature and significance of economic science. In *The Philosophy of Economics: An Anthology*. s.l.:s.n., pp. 73–99.

Udehn, L. (2002). The changing face of methodological individualism. *Annual Review of Sociology*, 479–507.

von Hayek, F. A. (2012). *Law, legislation and liberty: A new statement of the liberal principles of justice and political economy*. London: Routledge.

19 Film heritage and innovation

Luca Antoniazzi[1]

Introduction to film heritage and innovation

The debate about arts and innovation revolves around the contribution that creativity can potentially make to strengthen the cultural economy and the economy *tout court*. In recent times, European Film Heritage Institutions (FHIs) have been affected by such ideas in relation to the digitisation of their holdings. In this chapter, I will explore the potential contribution that the digitisation of film heritage (FH) can bring about in order to enhance innovation and competitiveness within the film industry. In this introduction, I start by defining what FH is; I then briefly explore the debates surrounding technological innovation and the arts; finally, I shall put forward my own arguments and observations. In the subsequent sections of the chapter, I shall provide some evidence to support these arguments.

FH includes film collections and related materials which are safeguarded in light of their cultural importance. In Europe, they are largely preserved by public institutions, which started to appear in the 1930s.[2] One could briefly conceptualise the practice of FH management in terms of three building blocks: acquisitions, preservation and dissemination of film culture [Edmondson (1995); for a concise account see also Goldman (1994)]. The vast majority of FHIs safeguard film materials for which they do not hold the copyright. In-house access to collections is normally permitted under appointment. Low-quality digital copies might be created for researchers if requested. Films are normally screened in the institutions' premises and circulated within networks of institutions, normally part of the International Federation of Film Archives (FIAF) or independent film theatres (FIAF, 2015). Some institutions, both regional and national, also release DVD series and license footage to filmmakers or broadcasting companies. Now, given the topic of this chapter, it is useful to recall that, besides their cultural mission, FHIs also fulfil a number of economic functions, which are:

(1) Preserving materials that small-scale or temporary film companies have no resources to preserve, so that they can be redistributed;
(2) Contributing as a source of inspiration to new productions by providing access to a broad range of audiovisual materials (the contribution of the

Cinémathèque Françoise to the birth of the *Nouvelle Vague* being the classic example);
(3) Providing footage for new audiovisual productions, such as historical documentaries or TV programs.

This way of thinking derives from the diffusion of the Schumpeterian ideas in cultural policy – namely the creative industries school (Winseck, 2011). Schumpeter argues that "technological innovation is the motor of competition in capitalist economies" (Winseck, 2011: 25), in that such innovations can generate big profits for those who own or control them. This process is triggered by the process of "creative destruction"; the act of destroying the "old" and replacing it with the "new" or, to put it differently, of asking original questions, and answering them using new ideas (Howkins, 2011).[3] Such creative destructions and their economic implications are generated by the activity of entrepreneurs, a special kind of human being keen to take risks and to "overcome the psychological and social resistance which stand in the way of doing new things" (Sweezy, 1943: 94). Thanks to such individuals, innovation occurs, competitive advantages might be gained and economic surpluses might be generated.

As far as the arts are concerned, the debate started when some writers identified them as the core of the creative potential of society (Throsby, 2008). The argument articulates at two different levels: firstly, the "culture of innovation" is good for the cultural institutions as "new technologies open up possibilities for more effective pursuit of organisational goals" (Bakhshi and Throsby, 2012); secondly, the arts are good for the economy *tout court* as they nurture creativity, which is key to stimulate its vitality via entrepreneurs' "creative destructions" (Potts et al., 2008; Throsby, 2008). The latter debate is often associated with economic instrumentalism, as cultural policy becomes *de facto* economic policy (Palmer, 1998). Indeed, in public policy one normally refers to instrumentalism as the tendency towards "a diversion of the primary intention away from the core specifics of a policy sector towards the interests and concerns of other policy sectors all together" (Gray, 2008: 4). If one follows Holden's (2004) cultural value model, instrumentalist culture policies systematically prioritise non-cultural objectives (e.g. the good of related industrial sectors) over intrinsic values (e.g. aesthetic values) and/or institutional values (e.g. number of admissions). Besides the ethical questions that instrumentalism raises, Oakley (2009) has also argued that the potential of the arts to contribute to the economy by encouraging innovation is sustained with dubious and weak evidence.

As far as FH is specifically concerned, the push towards a Schumpeterian public policy is formulated most concisely in the European Parliament's *Recommendation on Film Heritage and the Competitiveness of Related Industrial Activities*.[4] The argument is presented more or less as follows [all of the following statements are taken from the text of the document (European Parliament, 2005)]:

• The development of the European film industry is of vital importance for Europe in view of its significant potential in the fields of access to culture, economic development and job creation.

- Full achievement of this potential requires the existence of a successful and innovative film industry in the Community. This can be facilitated by improving the conditions of conservation, restoration and exploitation of film heritage [. . .];
- The conditions for the competitiveness of these industrial activities related to film heritage need to be improved, especially as regards better use of technological developments such as digitisation.
- The gradual switchover to digital technologies . . . [besides improving the film industry innovation], [it] will create new opportunities for innovation in the field of protection of film heritage.

Here we see a Schumpeterian argument clearly emerging: technological innovation in relation to FH (such as digitisation) helps to increase industry competiveness, while at the same time technological innovation is vital to improve the performance of individual institutions.

In France and the UK, public funding has been allocated to help the private sector to carry out digitisation projects for redistribution. As far as France is concerned, the *aides à la numérisation et à la diffusion des œuvres cinématographiques de patrimoine* made available 400 million euros to finance film digitisation for redistribution purposes.[5] The UK has put in place the initiative *Unlocking Film Heritage* in the context of a bigger project called *Film Forever*. Around £5 million will be made available for digitisation over a timeframe of 4 years.[6] So is digital technology increasing the business opportunities for the film industry in relation to FH? To what extent could such potential trigger innovation processes to strengthen the competitiveness of the film industry?

In the remainder of this chapter, I look at some evidence collected during my own doctoral research, in order to answer these questions. I will articulate my argument around the dichotomy theatrical/non-theatrical as challenges and opportunities seem to be of different kind. The argument goes as follows: although some statements found in the policy documents are overoptimistic and not evidenced, they are not completely without merit. Although the business potential of the digitisation of FH, as precondition for innovation processes, seems limited, we can see some potential. In particular, innovative initiatives in relation to theatrical distribution, which can lead to a change in cinema going as a social practice, seem promising. This is of course not meant to be a prediction of the future. Indeed, robust (risky) investments and political will are indispensable. Although often mentioned as a key factor of innovation, online distribution is still economically marginal. It is therefore hard to see a substantial change in the ways and the degree in which the industry already exploits such collections.

Non-theatrical dissemination

The Internet, which is often portrayed as a key innovation driver, is still economically marginal for FHIs and classic film distributors. DVDs are still the most important non-theatrical distribution channel for classic films, as they

benefit from consolidated marketing strategies (Dale, 2015).[7] FHIs have developed a number of useful websites with information about their holdings with no direct access to collections (e.g. screenonline.co.uk or filmarchives-online.eu). Besides these, AV materials from the collections are available in a variety of platforms, which we can classify into four categories:

(1) Websites which fulfil the function of footage libraries which are therefore mainly devoted to commercial users (e.g. IWM Film launched by the Imperial War Museum in 2014);
(2) Heritage-focused platforms not directly managed by a single institution, but instead as collective shared projects (e.g. European Film Getaway linked to Europeana);
(3) Channels within non-heritage and commercial AV platforms (i.e. YouTube or Vimeo);
(4) "Video on Demand" platforms for the general public, such as the BFI Player – the only VoD platform that has been carefully devised to monetise a film collection (DCMS, 2014).

Two factors impede the development of rich online catalogues, which could trigger an increase in demand for access and reuse: strict copyright legislation, the economic restrictions of FHIs (with exceptions), and weak demand for pay-per-view. Here I will focus on these issues.

Most FHIs in Europe do not hold the copyright of the materials they preserve. The recent Orphan Work Directive is a useful but ultimately weak tool.[8] This is honestly no surprise due to the weak political position in which FHIs find themselves in relation to governments and to the cultural industries and their lobbying power (Hesmondhalgh, 2013: 157–165). Copyright law, which is shaping the way in which funding is provided for the digitisation of archival holdings (see DCMS, 2009; CNC, 2012), will not change in the foreseeable future. In Europe, where legislation is fragmented and where the structure of the industry is fairly volatile, the cost of clearance is often decided case by case. So, copyright clearing becomes a laborious process; a process which can be both time-consuming and expensive for FHIs. It suffices here to quote the *Comité des Sage* report; "the BBC has calculated that clearing rights for the whole BBC archive would cost 72 million pounds for staff costs alone" (Niggemann, De Decker and Lévy, 2011: 11). Even those institutions who received public funding to create digital surrogates cannot provide online access to the majority of such materials. In the report of the major Dutch digitisation project Images for the Futures we read:[9]

> The original objectives regarding accessibility are not yet achieved satisfactorily at the end of the project. Of the total of 138.932 hours of digital AV materials, only 15% is currently available for education and 2.3% on demand for the general public.
>
> (Consortium Beelden voor de Toekomst, 2015: 28)[10]

FHIs are historically underfunded institutions, and it is difficult for them to sustain both the costs of digitising materials and curating online access. Monetising over digital access to amortise such costs seems challenging. Indeed, materials are often expected to be accessible for free in the online world. David Walsh, for example, took as an example his own institution, the Imperial War Museum (IWM) during an interview I conducted with him. The IWM in London is one of the few institutions in this context to hold or administer the copyright of its own collection.[11] This pushed the archive towards a very proactive access strategy to generate economic gains.[12] Walsh stressed the fact that developing infrastructures and building up business models is a very difficult task that requires skills and resources. In the face of this, these investments generate incomes that can only cover a small proportion of the running budget of the archives. The same preoccupations appear to be confirmed by the failure of Ximon, a platform aimed at the general public. The platform was closed as the VoD market did not grow as fast as they thought.[13] Weak demand for paid access is also testified by the following passage in the interim evaluation report of the aforementioned project Images for the Future:

> Since the emergence of such platforms as YouTube, it has become customary for digital audiovisual services to be available free of charge. Within the world of education, there is little willingness to pay for services, partly because the government has now focused its policy on the free availability of publicly-funded learning resources.
> (Consortium Beelden voor de Toekomst, 2010)

The BFI has put in place a VoD platform, the BFI Player, to gain economic incomes, but the capacity of obtaining such gains is still to be demonstrated. The institution invested around 100.000£ to launch the platform, and another 500.000£ has been provided from the Department of Culture, Media and Sport (Cox, 2013). It constitutes the core of the BFI digital strategy. Although numbers seem to be encouraging, it is at present impossible to evaluate the economic impact of the project, both on the institution and on the broader industrial context (BFI, 2014; 2015; 2016; DCMS, 2014). To be kept in mind is that if the material for online access increases to a considerable extent, we would possibly see a substantial decrease of DVD sales, and therefore the income they generate.[14]

Although digital platforms may not yet be economically valuable as an income generator, we can say that they can potentially improve the services FHIs offer to the industry. An example is found in Sweden with filmarchivet. se. Online access to low-quality files is free, but reuse is not permitted prior to copyright clearance. When a company decides to acquire the content for reuse, it pays a fee to the copyright holder. A success story to mention is that some footage initially consulted on filmarchviet.se was used to produce the Swedish box office success *Palme* (2012).

In light of the above, it is difficult to understand how online digital access to film collections can realistically trigger a process of innovative change that

can enhance the competitiveness of the film industry. There is a huge amount of investment required to digitise materials and to develop associated business models; however, modest economic gains are expected from online sales or general public access.

Theatrical exhibitions

Some film distributors (such as Gaumont, Pathé, Park Circus) were already involved in the theatrical redistribution of classic films before the "digital era". Digital technology opens up further business opportunities, as the cost of distribution of digital copies is much lower than of its analogue equivalent. Some FHIs appear to be more interested in theatrical distribution, and this may attract further investment in the coming years. We read in the BFI *Annual Repost and Financial Statements* 2015 that this approach is among the priorities of the institution:

> Core to the strategy of working with widest possible range of venues across the UK was the rerelease of Ridley Scott's Director's Cut of dystopian masterpiece *Blade Runner* (1982) and a nationwide re-release of Stanley Kubrick's visionary *2001: A Space Odyssey* (1968), which alone reached audiences of more than 65,000 across 170 UK venues. We secured a host of special guests, including the film's stars Gary Lockwood and Keir Dullea and a great panel which included Professor Brian Cox.
>
> (BFI, 2015: 15)

An interesting project was undertaken by the Cineteca di Bologna (Italy), a relatively small organisation but a prestigious one, called Cinema Ritrovato al Cinema which started in 2013. The project aims at systematically redistributing restored classic films of the calibre of *Amarcord* ([1973)] 2015) or *Des Cabinet des Dr. Caligari* ([1920] 2016). Data from 2013 shows that the average attendance for each screening was above the national average: 32 admissions against 44 (SIAE, 2014). The average box office income for each of the first three titles was around €8.000 (Acerbi, 2014). However, the last four films distributed by Cineteca di Bologna, at the moment of writing, had an average box office income of about €42.018 (from cinetel.it).[15] The project was possible thanks to two conditions which were not present a few years ago. Firstly, the Cineteca changed its legal status from a public to a private non-profit organisation, which allowed it to operate in the commercial market. Secondly, as I mentioned at the beginning of this section, the project was encouraged by the low cost of reproduction and transportation for digital copies. Once a DCP (digital cinema package) of a given title is generated, reproduction (making copies) and transportation costs are fairly low for distributors (hard disks are far less cumbersome than are film reels). In 2013, the Cineteca started by making 20 copies of each title. The total amount needed to make those copies and deliver them has been calculated at about €3.000 (Acerbi, 2014). These costs may decease even more in the future.

The Swedish Film Institute (SFI), for example, has recently announced an initiative to distribute its recently digitised films via fibre optic cable, by paying a fee to the telecommunications company (Unique Digital, 2016).

These encouraging, although still quite modest, data from ticket sales and specialised events attendance (e.g. film festivals) further encouraged a potentially ground-breaking investment (around 6,5M €) undertaken by the French company Gaumont-Pathé. The newly refurbished *Les Fauvettes* cinema reopened on the 6th of November 2015. It is currently the only 'for profit' multiplex (five screens) in the world that will exclusively screen restored films. Also, the success of the *marché du film classique* (classic film market), started in 2013 in the context of the Lyon Film Festival, appears to be pointing towards an increasing attention to film heritage and its possible theatrical implementation. However, in 2012 the French box office market share of classic films was no bigger than 4% of the total admissions, and it still does not seem to be growing (leParisien, 2013, 2015). Despite this, one positive case comes from the US. Turner Classic Movies (Time Warner) and Phantom Events, a company which broadcasts live shows in movie theatres via satellite, has signed an agreement to bring classic films to almost 500 screens (Lafayette, 2015).

In order to gain a sufficiently large portion of the public, cooperation and collaboration among the major players is fundamental at all levels, both within the private sector and also between the private and the public sectors. Hopewell (2016) has argued that "[w]hat international markets need are more private-sector local companies involved in the distribution of their film classics." As far as the public sector is concerned, public-private partnerships might be useful tools. Jan Christopher Horak has noted that theatrical distribution can offer some good opportunities as "[t]he ability to amortize the preservation costs through a DVD or Blu-ray release is becoming less and less likely" (Horak in Keslassy, 2013). However, in recent years, frequenting the cinema with the intention of seeking an experience akin to that of a fine art museum is still a niche social practice. Transforming this experience of cinema into a more popular (and thus frequent) habit can perhaps only be achieved in the long term. Digital technology surely makes it easier than in the past, but this is of course not sufficient.

Conclusion

In this chapter I answered the following two questions: *Is digital technology increasing the business opportunities for the film industry in relation to FH?* and *To what extent can such potential trigger innovation processes to strengthen competitiveness of the film industry?* In light of the above, claims which draw too heavily on techno-euphorically assertive arguments surrounding the potential of both digital technology and FH for economic growth must be avoided. DVDs are still the most profitable sector for classic films. Online platforms presently do not offer a solid business model. However, digital theatrical distribution could potentially have a relatively strong business case, and could contribute to film market and film

culture innovation. Indeed, it seems that the business potential for theatrical dis-
tribution of film materials is increasing, thanks to the substantially lower distri-
bution cost of digital copies. FHIs could develop private-private partnerships to
gain some economic resources through such projects in order to amortise the
skyrocketing cost of (digital) preservation. Indeed, in order to establish such a
market, substantial investment in marketing and promotion would be necessary
which, realistically, only an alliance with the private sector can make possible.
Numbers are encouraging, but we will only find out in the coming years what
the impact will be on the film industry and in particular if the film industry will
decide to exploit their archival assets with more intensity.

However, the potential slide towards a dissemination strategy impounded by
a pure market logic must be avoided, as this might ignite an unfortunate process
of heritage commodification. Most of the European film productions are in fact
largely publicly subsidised in light of the cultural and public value of cinema as
a form of art and social practice.

Notes

1 PhD, University of Leeds.
2 A list of the major FHIs is available here: https://ec.europa.eu/digital-single-market/
 sites/digital-agenda/files/institutions.pdf
3 In Howkins's (2011) opinion, the creative class is becoming more powerful than the
 "people who own machines" (viii). From here, the expression "creative economy".
4 To be more specific, the document includes a number of useful and thoughtful recom-
 mendations on copyright clearance, collaboration with other sectors, and film archiving
 process.
5 Available from: www.cnc.fr/web/fr/aide-a-la-numerisation-et-a-la-diffusion-des-oeuvres-
 du-patrimoine-en-video-et-vad (20/10/2016)
6 Available from: www.bfi.org.uk/sites/bfi.org.uk/files/downloads/bfi-film-forever-2012-
 17.pdf
7 Macchitella et al. (2005) identify two market strategies for archival products. The "train-
 like strategy" is based on attaching non-marketable products to highly marketable ones
 that are "able to pull along a certain number of cars" (10) – e.g. packaging a famous film
 in a DVD box set with less famous ones, or with "behind the scene" materials. The sec-
 ond, which the writers are proposing, is called the "bundling strategy". This consists in
 attaching a number of non-marketable products to a "bundle" such as a particular theme
 (e.g. footage of Italians in Argentina), a genre (British horror short films of the 80s)
 or a director (e.g. "Hitchcock in England"). Another strategy is to market classic film
 products with non-film materials such as publications, or by providing extra materials
 that talk specifically about the version or the edition in question (e.g. an interview with
 the restorers). What we might call "intellectualisation" is a very important feature of the
 package, as such products are addressed to film-educated clients who are often looking
 for highly contextualised experiences. This model is even utilisable to promote theatrical
 screenings of classic films (Chiche in Hopewell, 2016).
8 This allows to place in the public domain materials which copyright status is unknown
 or right holders cannot be identified after a diligent search.
9 For more about the project see Oomen et al. (2009).
10 Original text: "*Van de in totaal 138.932 uur aan digitaal AV-materiaal is op dit moment 15%
 beschikbaar voor het onderwijs en slechts 2,3% on demand voor het algemene publiek.*"
11 Interview with the writer.

12 The archive won in 2012 the "Best Use of Footage in a Home Entertainment Release" award assigned by FOCAL (Federation of Commercial Audiovisual Libraries).

13 See the website here: www.ximon.nl/

14 This might result in Blu-rays becoming the chief medium for non-theatrical offline distribution as they assure the highest visual quality.

15 This is not really enough to cover the cost of preservation and restoration of each of the feature films, but those incomes can be used to amortise those costs.

References

Acerbi, C. (2014). *Film restaurati in sala: Il progetto di distribuzione della Cineteca di Bologna*. Master's Thesis. Università Ca' Foscari Venezia. Available from: http://dspace.unive.it/handle/10579/4508 (05/07/2017).

Bakhshi, H., and Throsby, D. (2012). New technologies in cultural institutions: Theory, evidence and policy implications. *International Journal of Cultural Policy*, 18(2), 205–222.

BFI. (2014). *Annual report and financial statements*. [Online]. Available from: www.bfi.org.uk/sites/bfi.org.uk/files/downloads/bfi-annual-report-and-financial-statements-2013-2014-07-24.pdf (20/10/2016).

BFI. (2015). *Annual report and financial statements*. [Online]. Available from: www.bfi.org.uk/sites/bfi.org.uk/files/downloads/bfi-annual-report-and-financial-statements-2014-2015-08-17.pdf (20/10/2016).

BFI. (2016). *Annual report and financial statements*. [Online]. Available from: http://www.bfi.org.uk/sites/bfi.org.uk/files/downloads/bfi-annual-report-and-financial-statements-2015-2016-v1.pdf (05/07/2017).

Consortium Beelden voor de Toekomst. (2010). *Consortium Beelden voor de Toekomst*. [Online]. Available from: www.beeldenvoordetoekomst.nl/en/news/images-future-interim-evaluation.html (20/09/2016).

Consortium Beelden voor de Toekomst. (2015). *Aanbieden tussentijdse evaluatie project Beelden voor de Toekomst*. [Online]. Available from: file:///C:/Users/csal/Downloads/rapport-zelfevaluatie-beelden-voor-de-toekomst%20(2).pdf (20/09/2016).

Cox, D. (2013). *BFI online player to screen new and archive British film*. [Online]. Available from: www.theguardian.com/film/2013/oct/02/bfi-internet (23/09/2016).

Dale, M. (2015). *Lumière fest: DVD sales remain core business of France's classic films distributor Malavida*. [Online]. Available from: http://variety.com/2015/film/global/lumiere-fest-dvd-sales-remain-core-business-of-frances-classic-films-distributor-malavida-1201618679/ (20/10/2016).

DCMS. (2014). *Triennial review of the British Film Institute*.

Edmondson, R. (1995). The building blocks of film archiving. *Journal of Film Preservation*, 50, 55–58.

European Parliament. (2005). *Recommendation on film heritage and the competitiveness of related industrial activities*. [Online]. Available from: file:///C:/Users/csal/Downloads/9c2004f0-2677-4870-b6f4-1c27c2ff4226.en.pdf.pdf (16/08/2016).

FIAF. (2015). *Statutes and rules*. [Online]. Brussels: FIAF. Available from: www.fiafnet.org/images/tinyUpload/Community/STATUTESandRULES_2015.pdf (17/05/2016).

Goldman, N. (1994). Organization and management of film archives and libraries. *Collection Management*, 18(1–2), 41–48.

Gray, C. (2008). Instrumental policies: Causes, consequences, museums and galleries. *Cultural Trends*, 17(4), 209–222.

Hesmondhalgh, D. (2013). *The cultural industries* (3rd ed.). Thousand Oaks, CA: Sage.

Holden, J. (2004). *Capturing cultural value: How culture has become a tool of government policy* (pp. 31–36). London: Demos.

Hopewell, J. (2016). *Lumière fest's 2016 classic film market hikes attendance, panels, practical, marketing focus.* [Online]. Available from: http://variety.com/2016/film/festivals/classic-film-market-hikes-attendance-panels-marketing-focus-1201883600/ (20/10/2016).

Howkins, J. (2011). *The creative economy: How people make money from ideas.* London: Penguin UK.

Keslassy, E. (2013). *Classic films get a market of their own.* [Online]. Available from: http://variety.com/2013/film/markets-festivals/classic-films-get-a-market-of-their-own-1200703035/ (20/09/2016).

Lafayette, J. (2015). *TCM putting classic films in movie theaters.* [Online]. Available from: www.broadcastingcable.com/news/currency/tcm-putting-classic-films-movie-theaters/141581 (20/10/2016).

LeParisien. (2013). *Les films classiques ont maintenant leur marché.* [Online]. Available from: www.leparisien.fr/flash-actualite-culture/les-films-classiques-ont-maintenant-leur-marche-16-10-2013-3230689.php (20/10/2016).

LeParisien. (2015). *Les films classiques au cinéma, un marché en essor mais fragile.* Available from: www.leparisien.fr/flash-actualite-culture/les-films-classiques-au-cinema-un-marche-en-essor-mais-fragile-18-10-2015-5197383.php (05/07/2017).

Macchitella, U., Provera, B., Ietto, P., and Giustino, F. (2005). Unveiling the "hidden value": A model for the economic evaluation of film libraries. *Working Paper.* Università Bocconi.

Niggemann, E., De Decker, J., and Lévy, M. (2011). *The new renaissance.* Report of the 'comité des sages' on Bringing Europe's Cultural Heritage Online.

Oakley, K. (2009). The disappearing arts: Creativity and innovation after the creative industries. *International Journal of Cultural Policy*, 15(4), 403–413.

Oomen, J., Verwayen, H., Timmermans, N., and Heijmans, L. (2009). Images for the future: Unlocking the value of audiovisual heritage. In J. Trant and D. Bearman (eds.), *Museums and the Web 2009: Proceedings.* Toronto, Canada: Archives & Museum Informatics.

Palmer, I. (1998). Arts managers and managerialism: A cross-sector analysis of CEOs' orientations and skills. *Public Productivity & Management Review*, 21(4), 433–452.

Potts, J., Cunningham, S., Hartley, J., and Ormerod, P. (2008). Social network markets: A new definition of the creative industries. *Journal of Cultural Economics*, 32(3), 167–185.

Sweezy, P. M. (1943). Professor Schumpeter's theory of innovation. *The Review of Economic Statistics*, 25(1), 93–96.

Throsby, D. (2008). The concentric circles model of the cultural industries. *Cultural Trends*, 17(3), 147–164.

Unique Digital. (2016). *An unrivalled library of outstanding Swedish film now available on movie transit™ at a cinema near you.* [Online]. Available from: www.uniquedigitalcinema.com/deluxe-technicolor-digital-cinema-and-unique-digital-create-digital-cinema-distribution-alliance-copy-2/ (01/10/2016).

Winseck, D. (2011). The political economies of media and the transformation of the Global Media Industries. In D. Winseck and Y. J. Dal (eds.), *The political economies of media.* London: Bloomsbury Publishing.

20 Festival les instants vidéo

The line of attempt is implausibly utopian

Naïk M'sili[1]

> The line of attempt is implausibly utopian. It certainly dreams. It dreams with open eyes. . . . An attempt is a small premature event. While significant political events require a certain maturation, regarding a very particular element of the State's time-making and of the strategy of assumption of power in developing political projects, emerges an extremely precarious initiative that takes form and persists.
>
> (Fernand Deligny, 1980)

When Biljana invited me to write on the issue of innovation in a video arts festival, I wondered what it would really mean *to innovate* in the world of cultural economy (industry), entrepreneurship, creativity, audience rating, entertainment, etc. Do we necessarily need to link the innovation issue to an economic rationale? What if innovation was a question of attitude? A form of thinking? In other words, what if today *to innovate* was the translation of solidarity, sharing, collaboration. And in that case, isn't a festival guided by long-term interests a successful innovative initiative? "A *precursor* is *someone* of whom *we only* know after that he came before" (Georges Canguilhem, quote in Morin, 1994).

The *Festival Les Instants Vidéo*, a festival of the humanities and a "public(s) matter", began in 1988. It is dedicated to video art, and its Fluxus origins ("Fluxus" is an energy, the flow of life which goes through everything) make it a fundamental *un-discipline*. We used to say that video art is an impure art, a hybrid art which uses all kinds of supports, like music, dance, poetry, painting, science, technology. . . . According to Fluxus, art is right on the place where you work, where you are asserting your existence, your being in the world, where you dwell instead of being dwelt. Art is therefore a territory that makes it possible to dwell in the world and oneself actively. It is a space where one can make encounters. It is not a pre-built space but an ever virgin ground, which has to be re-invented continually.

In 2017, it will be its 30th edition.

"Many festivals resist because they are enchanted interludes, social usefulness worlds, ephemeral small republics"[2] (Emmanuel Négrier, 2015). Is there a recipe for success? Certainly not. But we can try, however, to give a list of the ingredients we put together to concoct the festival, the same way as *Donkey*

Skin does for her *Love Cake* to her *fiancé*.[3] The proportion and mixing of components will be a matter of taste.

Choose the *basic raw material*

Choosing video art and the new visional machines does not come down as deserting the battlefield where blood-soaked conflicts throughout the world crystallise into language. It rather comes down as lurking close to the television which screens our understanding of the political issues of today's world, next to the new digital networks of communication that tragically virtualise our relationship to reality.

The video works we are discovering together are to be apprehended as narrow escapes from or indeed breakaways from the political, geological, sensorial, and philosophical turbulences we're living through daily. These videos stand as traces of what is alive within ourselves.

Select carefully *artists* and *artworks*

The festival is based on a high artistic requirement, where internationally renowned artists (like Marina Abramovic, Anne-Marie Jacir, Bill Viola, Nam June Paik, Mounir Fatmi, Ko Nakajima, Gianni Toti, Robert Cahen, Wolf Vostel, Chris Marker, les Vasulka, Marianne Strapatsakis, Catherine Ikam, Esther Ferrer . . .) meet with artworks that are more fragile, still in progress, delicate.

We like the works of art we show and the artists we welcome. Therefore, we do not want to organise any competition. And along with Edouard Glissant, Patrick Chamoiseau, Ernest Breleur, Serge Domi, Gérard Delver, Guillaume Pigeard de Gurbert, Olivier Portecop, Olivier Pulvar and Jean-Claude William, we call "for politics to be elevated into an art, with the individual, and the individual's relation to others, at the core of a common project that gives pride of place to life's highest, and most intense, and most radiant exigencies"(Glissant et al., 2009).

Season with a *language concern*

Conscious of the responsibility we bear as an event, that is to say, which talk is spread in public space, we pay special attention to the words we use. Every year, we give a title to our festival like one does for a collection of poems (. . . *and we are beautiful!/Man is earth walking/Have you seen the horizon, lately?* . . .). It is not a theme, but rather a direction that echoes our current concerns. Artists can seek inspiration in it, or not.

Furthermore, we say creation rather than creativity, journey rather than project, person rather than individual, language rather than communication, cooperation rather than franchise, electronic poetry rather than contemporary art (contemporary with what?), laboratory rather than objectives, relationships rather than network, living together rather than public relations, identities

and debates rather than consensus, future rather than innovation, constellation rather than globalisation.

And we also say interwoven lands, nomads, songs, wandering, exile, borders crossing and fall of walls, women, men, wine, save refugees, dreams, deep, long-term, complexity, forced migrations, etc.

Spice with an *artistic parti pris*

"*The common element* connecting art and politics is that they are both phenomena of the public world." That is, to have an interest in art *in a political way* is to be someone "who knows how to choose his company among men, among things, among thoughts, in the present as well as in the past" (Arendt, 1972, emphasis added).

To build a screening program is the act of creation of someone who has an interest in art, *politically*. It consists in a precise intertwining, exploring questions such as: How can the artworks dialogue together? Where can they meet with the spectator, on intellectual, sensitive, and emotional levels? How can a program broaden our vision of the world? We broadcast artworks for ourselves as well as to submit them for consideration by others, thus looking for what we want to discuss or which sensitive experience we want to share.

Sprinkle with *palaver trees*

To give a form and a framework to spaces for conversation raises a number of issues that are necessary to deal with. Thus, the festival develops next to formal spaces of dialogue, some more informal situations that favour the expression of the doubt, of the fragile or the intimate. Special care is given to moments of conviviality (welcoming, aperitif, dinner . . .) because what is at stake in formal exchanges may then be forgotten for the benefit of more natural and unforced interactions between persons with multiple identities. From diversity can arise the desire of being together, encouraging reaching out to others as well as to oneself, as an interlinking of uniquenesses.

Flavour with a *buvette*

The *user-friendly secret* of the festival consists in its *buvette*, always open, with fair prices and good quality local produce, no VIP service, and not profit-oriented. This is the place where the experiences of the encounters with the artwork are being discussed and confronted. The artwork is no longer this very distant object but a questioning force on what we live every day. It is the space of the well-being, where

> as Edgar Morin proposes, living for the sake of living or solely for one's own sake can open out on no plenitude – for plenitude requires giving a

lifelong lease of life to what we like, to those we love, to the impossible, and to our aspirations to surpass ourselves.

(Glissant et al., 2009: 3)

Dress with *free* entry and *swap*

Our catalogue specifies that the entrance is "free because we deem art as price-less, because we are rather demanding and expect quite a lot from the sensitivity and attention of our guests." But indeed, this is not enough to make the festival more accessible. Aware of being a non-profit organisation with an artistic project legitimised by institutions (we receive public grants) and the loudest cultural milieu, we must take into account the symbolic violence that the presentation of contemporary artworks can involve. Here is why we based the encounters under the sign of exchange and swap. We are not only expecting to share the artworks we love and consider (according to our standards) as pearls of the contemporary artistic thought, but also to share other sensitive and sharp views of the world. These inter-cultural encounters will enable *us* (us the cultural actors) to change, to modify our mind frames, our attitudes, our views of the world and why not art itself. Sharing and encounters are not possible without risk-taking.

Sprinkle with *curiosity* (care) to the world

We are following Bernard Stiegler, who

advocates for *curiosity* to the world, and points out how large is the responsibility of the arts and culture sector in these times of turmoil: to *analyse* the changing of the world (to *understand*), in particular through works of art, and to stimulate a *new critique* within artistic creation (every real work of art is in itself a criticism).

(Carasso, 2012)

Combine video art *awareness* workshop *conversation* tour

We intend to leave no one aside in the process of circulation of ideas and artworks. Being an *event* is not sufficient to raise the interest of *all* the audiences. To develop awareness is a long-term process and requires more discreet and intimate relationships. Before the festival, we organise workshops within social and educational organisations, choosing to go on the participants' familiar ground, and reaching as well the professional teams (social workers, teachers, secretaries . . .). These *critical eye and voice* workshops are made as an introduction to an audiovisual poetic and sensitive language, away from film and television mainstream offerings. We believe that in raising curiosity and stimulating the overcoming of clichés which hinder inter-cultural encounters, we will make it easier to join the festival and enter *Friche la Belle de Mai*, a space of artistic excellence.

In addition, for the three weeks of the festival we offer conversation tours of our exhibitions, *conversation* because rather than giving an expert interpretation of the images, we engage a dialogue with the visitors in their journey of discovery of the artwork we exhibit. And there, it is not only the eyes and ears that will be stimulated, but the whole body will be at work.

Stir gently a *special day*

As mentioned above, the festival is always in the process of creating conditions for its different audiences (nonspecialists, artists, students, volunteers . . .) to meet, to discuss, to exchange, to cross-fertilise ideas, encouraging free and fluent expression. This is why our *Special day* was built. The idea is to work a whole day on a specific issue (for instance in 2014, it was *For a free circulation of bodies and desires*) through the prism of art (screening, performance, exhibition . . .), and then to address it under different forms (conversation, debate, conference), different rhythms and spaces (in the large auditorium, behind the screen seated in circle on comfortable sofas, or at the *buvette* for a more casual moment).

Incorporate (video and performance) *popular art gallery*

During the festival, we bring video arts out of their conventional spaces of presentation (gallery, museum . . .) hoping its *usual* audience will follow, by opening *popular art galleries*. Together with our partners from the social field, we imagine how to present an artwork under the best conditions, in a social organisation that is for the occasion transformed into an art gallery. In situ, a public encounter with the artist(s) is organised.

Spoon *hospitality* on top

Experiencing hospitality gives us a deep insight into the kind of society we should strive for. It diverges from a vision of life strictly productivity oriented and utilitarian.

Hospitality and hostility are derived from the same etymological root, a Latin word "enemy" (*hostis)* and "host" (*hospes)* or "lord of stranger".

Hospitality means to welcome the Other home or to enter the Other's home. Dialogue and hospitality call on each other. Dialogue draws greater force from a welcoming environment. The festival is the highlight where we can fully express our determination for a supreme hospitality.

Add a good measure of *cooperation*

Cooperation is in the genes of *Les Instants Vidéo*. Guided by a constant *curiosity to the world*, we never stop weaving links with cultural organisations and artists, in France, in Europe, around the Mediterranean, in South and North America, in Asia, etc.

With our (inter)national partners, we believe that the artistic language enables us to overcome physical and mental borders, to build meaningful and lasting relationships between people of different cultures, who live in different social and political situations.

Yet we must be on our guard at all times. Art is not intrinsically *good*, and culture and the fact of being *cultivated* never represented a protection against inhumanity.

Now just savour the *constellation*

From the beginning, the association makes sure that the form of relations between its members (as well as with its partners, artists, and audiences) is in accordance with the poetic and politic substance of its project, keeping in mind that the journey is more important than the destination.

As an association, volunteers are involved with the staff, on the board, and also in the festival itself, in a process of combination of skills and thoughts for a project.

With this ability to gather together to act, the festival wants to be an *ecosystem* — that is to say, a community of living organisms (here cultural operators, actors of creation, civil societies) in conjunction with the nonliving components of their environment (art forms, political, economic, social and cultural issues . . .), interacting as a system. In a sustainable society, all the elements of the ecosystem must be preserved for the generation of today and of tomorrow.

In the preceding lines, I tried to explain what the *Festival les Instants Vidéo* is made of, an array of flavourful ingredients (surely a nonexhaustive list) which, mixed together, turn into a festival of the humanities. We may now say that this festival is an innovative initiative, that is, a small *premature event*, where art is a *first need product* and which produces a (will to) living-together (a moment of art).

More than 8,600 joined us for our 28th festival edition, under the title, *You wanted me a virgin, I wanted you less dumb!* Shouldn't we see here a need to draw other perspectives, another vision of the world, a need to invent situations opening to possible social changes?

Thus, and after the poet and philosopher Friedrich Hölderlin, we shall ask ourselves: "How can we dwell in the world poetically?"

> We do not want a world
> where men can surround themselves with artworks
> we neither want a society where everyone is a painter, poet or musician.
> We want a world where everyone
> perceives the world as an artist,
> enjoys the sensitive
> with a painter's eye
> with a musician's ear
> with a poet's language

<div align="right">Marc Mercier</div>

Notes

1 Co-director of the association *Les Instants Vidéo Numériques et poétiques.*
2 Quoted by Emmanuel Négrier on the *Télérama* website, June 8, 2015. Available from: www.telerama.fr/
3 Read the fairy tales by Charles Perrault or the French musical film directed by Jacques Demy (1970). The extract is available here: www.youtube.com/watch?v=1HysasPjF84

References

Arendt, H. (1972). *Between Past and Future.* Paris: Gallimard.

Carasso, J-G. (2012). Rencontre avec Bernard Stiegler. *L'Oizeau rare* (blog). Available from: www.loizorare.com/article-rencontre-avec-bernard-stiegler-113646866.html

Deligny, F. (1980). *Les enfants et le silence,* Galilée Spirali (ed.). Paris: AbeBooks.

Glissant, E. et al. (2009). *Manifesto for "products" of high necessity.* Paris: Edition Galaade, 11.

Mercier, M. (2013). "Cultural cooperation in the time of Mediterranean revolutions." *Festival les Instants Vidéo.* Available from: http://www.instantsvideo.com/blog/wp-content/uploads/2013/10/InstantsVideo2013eng.pdf

Morin, E. (1994). *La complexité humaine.* Paris: Groupe Flammarion.

Négrier, E. (2015). *Télérama.*

21 The truth is "out there"

Stakes and responsibilities of rhetoric's within contemporary culture's design realm

Freek Lomme

'I don't read books by people who have betrayed the Motherland. In the modern world, those who are weak will get unambiguous advice from foreign visitors which way to go and what policy course to pursue. In many countries today, moral and ethical norms are being reconsidered; national traditions, differences in nation and culture are being erased. We must stop using the language of force and return to the path of civilized diplomatic and political settlement. Europeans are really dying out!'

'The taste of 34% curvy carrot, 40% awesome apple, 12% beautiful banana, 2% loving lemon, 12% optimistic orange': 100% best drink ever. The sublime-sepia landscape-window comforts custom-style as the 80%-electronic car slides through. The car says I should not get too excited, as my increased heart-beat got noticed. Am I dreaming my dream . . . 'if not now, then when'. So 'let's celebrate the new'. 'Persistence is fruitful if you follow your gut'. 'There is much beauty in loss'. 'Trust strangers'. 'Make your own reality'. 'Harness nature's hidden superpowers'. 'Nature is everywhere; we just need to learn to see it'. 'The next manufacturing revolution is here'. 'We can learn from shortcuts'. 'Better tech protects us from distraction'. 'Math is sexy'. 'Barbershops keep man healthy'. 'We can reprogram life'. 'Less is more'. As I close the screen of my laptop, I fall asleep.[1]

The above story does not acknowledge the daily routine that determines our life: the need to work – in order to shop – in order to serve ourselves food – in order to sleep well – in order to work well. Moving beyond the day-to-day matters of fact filling our routine, the above text is full of claims and suggestions to truths beyond that make our days promising.[2] It is the promise beyond matters of fact that offer opportunities both to contribute to a better world and to live a better world. This is why the suggested truth beyond is more promising than the matters of fact.

In this essay I want to discuss the way truths are sourced and how this sourcing reflects the foundation of our contemporaneity, consider its vitality and, accordingly, consider how to approach this.

First of all, I will do so by proposing two forms of truth, the 'innovative truth' and the 'open truth' as a think model to think through and re-experience the motivation wherein we are inclined to portray and engage our reality. As such, it anticipates to the gut of our lower belly, in an attempt to inform and inspire.

'Innovative truth'

Some sources of suggested truth are good at producing a truth of social construction, of societal feasibility. This is the domain of structural planners and producers: sociologists, architects, politicians and industrial designers. They make 'our world' (the horizontal world of all people) vertically better. These paternalists guide our path, by professional capacity and by sincere commitment.

This truth I would like to label 'innovative truth', as it is a prophesy of improvement, sparked by professional development. It only exists within the public domain, as ready-to-feed rhetorical prophesy of populism immersing concerned target groups. As such it might be segregated in its approach to various audiences, yet is horizontal, as all masses, at any societal layer, might have succumbed. It leaves promoted 'innovation' a static conception of truth; passive to those entangled in its web. The innovative truth is a paternalistic truth appropriated to fit the elite's agenda, be it for better or worse. My problem is not so much the positive or negative result it might produce but rather its fundamental working.

'Open truth'

On the other end there is the 'open truth'. This is a truth at best: an experimental truth and therefore a truth of a dynamic order. This truth is, surely in the public arena, to be approved rather than proven. It is vertical in itself, as it is to be contested at all times, yet it is available to all and in that fundamentally horizontal.

The face of truth encountered here has not been produced but is to be produced; it is process based, sparked by the quest to find and experiment rather than fixate and impose. Living this truth, we become artists and philosophers. It is a moral truth that roots in opportunities for emancipated citizenship and living, be it for better or worse.

Changes

Around the turn of the millennium, our conception of truth started to change. By connecting databases, the complexity of the growing knowledge economy grew further and further from the average person, alienating everyone from self-governance in society compartmentalised by virtually connected networks. No one, not even politicians supposed be generic control freaks, could follow up. In our wish to contribute to feasibility for the better, we started Googling and checking upon YouTube tutorials. The amateur-professional became a societal actor. Independent vlogging took over the signalling role of independent research journalism, medical advice was to be found online, political debate moved to the domain of 'reaguurders' (ed. Dutch word for Internet forum bashers). It wasn't that information democratised, but rather the network for

producing and using information – the 'library', so to say – that democratised. In this, the authority of academia fell. A rise of anti-intellectualism resulted. Yet – and this is fascinating – access to information fell in its 'public' cause (public as in 'public library').

Sources

The new 'public library' was taken over by two major power blocks, which unfortunately did not deliver a site for and of an 'open truth' . . . On the one end there came global capitalism with Google, Baidu, Facebook and all alike, segregating along the currents of its content, preaching to the likes. This eradicated conflict and diversity and an economic exploitation along a global levelling of identity. All coffee bars worldwide are covered by wood sanded in some half-done manner, labelled by a kind of early industrial typeface and such. The standardised prophesy of wellbeing is the supposed truth sold as capitalisms' wet dream, leaving indoctrination to the users. This global economic imperialism imposes capitalist culture worldwide.[3]

On the other end, in opposition to capitalism, we see the rise of strong leadership promoting the geopolitical by naturalistic right. Proposed by incapable politicians, unable to overcome the globalisation of networks within their little geopolitical nation-states, they promote their story equally narrow-mindedly.

Both the retro rhetoric of geopolitical-local roots and the futurist rhetoric of *Gleichschaltung* for capitalist well-being scales up the prophesy of 'innovative truth'. We all feel threatened by these supposedly independent forces. This threat to truth is even reaching a level wherein conspiracy theories of the most insane kind are becoming accepted.

Vitality

Uncertainty is not convincing, I know. Yet we need to build in more uncertainty within our culture and the economy that produces it. We need places where we can talk about doubts, expand upon doubts, produce doubt better and so on. We need to live an open truth as true innovation lies outside of the box. Politics and commerce are highly unlikely to invest in this. Patents, copyrights and the like hold back on open access (increasing the distrust to power and intelligentsia). It is vital to find access to information in the independent. Art to produce cultural experience and academia producing cultural thought. It is here that the independent becomes a vehicle in parallel to politics and capitalism: a platform able to distribute opportunity to explore the contemporary, both in hindsight and towards the days and future to come, as well in local as global perspective.

For this reason, we have to distrust the creative industries, as it is there that 'creativity' becomes a rhetorical vehicle producing a participatory rhetoric of bread and play – as is most evident in the style of capitalist social housing companies gentrifying neighbourhoods. This is applied almost by naturalist law, as

the strong and powerful survive. On the other hand, 'creativity' lies in the capitalist sales of feminism conditioned by Beyoncé, of design-craft conditioned by Pharrell Williams or of anarchy conditioned by H&M. By the sheer force and mass of their productive capacity and reach, the independent and thus an open truth is not allowed access to the market they promote. And more, the legal system does not compensate as politicians and their administration make the law to the system they produced: this is the reason why neoliberalism failed its regulative prophesy.

On 10/31/2016 19:41 Studio XXX <studio@XXX.com> wrote:

Hello Freek,
Thank you so much for coming back to me:)
I'm writing you from the art fair in Cologne where project XXXX are exhibited
* among 10 the finalists of XXXX Art Award.*
You can see how it looks on my Instagram: XXXX
If you don't mind I have few questions and your answers would help me a lot:
1. What would be your advice for a young artist to start with? What is the way of
* showing your work and getting noticed by curators?*
2. I believe that one of the best ways to get visible is taking part in Art Competitions,
* Awards, etc. Could you name a few that are worth checking?*

All the best,
XXXX

On 10/31/2016 21:31 PM, Freek Lomme/(in)dependent curator and writer wrote:

i don't care about awards to be honest. I simply want to consider the quality of work. You did not ask me a question in your first email and did not describe the work but only stated that it was widely covered and such non-information. Just say what you do, what you want your work to do, show it in the documentation, possibly supported by experiences of users/audience/professionals. References without motivation are bullshit as well. People who follow authority are stupid. If you want people to suck up, you make the world a worse place. Personally i do not like arrogant people as well, because that complicates an open conversation. I prefer specific questions that challenge me within the field i cover and feel it is most relevant to contact me with such questions. Your question is very generic, so the fact that i answer shows my respect for a question asked.

So my suggestion to young practitioners in the end is to make relevant work, do it well and propose to specific people with clear questions.

it is a pity that capitalism turns creative people into showoffs of finished accomplishments. Creativity is open, is tolerant, is dualistic, is dynamic, is never finished . . .

greetings
Freek

Approach

Again, we are living a bipolar international arena wherein two regimes are in friction to one another, each on its own held together by indoctrination. If the consumer within capitalist society does not capitulate first, then the citizen within a political society will. Under the semblance of being locally anchored and globally positioned, excluded from an open truth, people should take charge over systems again. This ignites by informing ourselves on the literacy of its rhetoric, expands by distributing the information on rhetoric more widely and, finally, by reconstructing the order by takeover of its rhetoric. There are still opportunities for humanist dissent and independent production. The enlightenment produced by emancipation[4] very much rests on fundamental knowledge produced in a vibrant sphere in Kaliningrad: a city whose citizens are currently troubled by EU borders in their drive to neighbouring city Gdansk. These citizens could possibly become Estonian e-citizens though.

There is no responsibility to the rhetoric of a system. Responsibility is reserved to an open structure, an agora; built upon an inclusive diversity of people.

Notes

1 The italic part consists of quotes from Wladimir Putin, juice packaging, Titles of TED-lectures, Dutch Design Week promo-slogans and some little sentences to fill up the story.
2 At least if we are one of the lucky few celebrating a 'good life'.
3 Now, this is typical Dutch: we are highly developed technocrats by centuries of colonialism and post-colonialism. We are silenced by '*gezelligheid*' (unique untranslatable Dutch word for something like indifferent social cosiness) and we are obsessed by 'making things better' (former Philips slogan fitting Dutch culture that has no problems because we are problem-solvers . . .).
4 Emancipation implies that the accomplishments were produced through an "open truth".

22 The top 10 cultural and creative economy facts and 10 questions that you might ask

James E. Doyle

Most of the following statistics are taken directly form the *Orange Economy* written by Felipe Buitrago, in which he encourages us all "to share essential knowledge"; it is with that invitation that I have included them here. While the "Manual", as Buitrago calls his publication, is largely concerned with the creative economy, both his manual and this book draw on the cultural economy for much of their evidence. In this book, we make no distinction between the two – the cultural economy and the creative economy are interchangeable terms.

What follows is a set of the most intriguing facts/statistics relating to the cultural economy and some of the questions that they have generated for me. I hope that they will generate similar, and no doubt more insightful and fulfilling, questions for you and perhaps encourage you to find a solution to the same.

1 The global cultural and creative economy is worth US$4.3 trillion every year; that's two and a half times the world's military expenditure.

 Q: How can we encourage political leaders to move investment in military expenditure into the cultural and creative economy and thereby increase overall global wealth?

2 Creative goods and services are a more resilient investment than oil. While oil exports, as reported by OPEC, contracted by 40% in 2009, creative goods and service only contracted by 12% in the same period.

 Q: If, as shown, creative goods and services are so resilient, why are they not priority investments for economic planners?

3 The entertainment industry, at the core of the cultural economy, was worth 230% of the oil exports for all OPEC countries in 2009.

 Q: Can the innovative process of the cultural and creative economies be refocused to tackle issues of oil depletion?

4 More than 25,000,000,000 songs have been down-
 loaded since the launch of iTunes in 1998, at an average
 of 99 cents per song.
 Q: How can we leverage the income from music
 downloads to directly tackle issues of low- and no-
 pay scenarios for working musicians?

5 Box office and merchandising for the 10 most success-
 ful Broadway musicals brought in $26.9 billion com-
 pared with China's expenditure of $25 billion on the
 Three Gorges Dam.
 Q: If musicals received greater state subsidies, would
 they be more or less successful?

6 Cirque du Soleil, an acrobatic theatre company, employs
 more than 5,000 people and reports a yearly turnover of
 over $800 million.
 Q: What is the comparative state investment in terms
 of jobs per euro for Cirque du Soleil compared to
 a similar business in the manufacturing sector?

7 It is estimated that the Rio Carnival attracted over
 850,000 visitors in 2012, and they contributed $628 mil-
 lion dollars in consumption to the state's economy.
 Q: Has the Rio Carnival the capacity and potential to
 be franchised in the same way that the Guggen-
 heim Museum has been?

8 The 12th Ibero-American Theatre Festival of Bogotá
 in 2010 estimates an overall attendance of 3.9 million
 people.
 Q: Why, when the figures are so high, does culture
 still rely on estimates rather than indicative figures?
 How much does this affect the public perception of
 culture as a real economy?

9 Nine of the artists at 2015 Venice Biennale created
 works that sold for over 1 million dollars. Five were also
 arrested for political reasons relating to their work.
 Q: If politics and fine art are so clearly connected, why
 are there so few artists in politics?

10 In 2015, over 6 million people visited the Tower of
 London with the Chester Zoo coming a close second
 with 4.6 million.
 Q: If, as it seems, we value our zoos nearly as much
 as our built heritage (albeit in an exploitive and
 voyeuristic way), can we begin to rapidly grow a
 virtuous and sustainable economic sector based on ecotourism?

Index